The

INTREPID

ART

COLLECTOR

The

INTREPID

ART

COLLECTOR

The Beginner's Guide to Finding, Buying,
and Appreciating Art on a Budget

LISA HUNTER

THREE RIVERS PRESS · NEW YORK

For Alex, who told me so

Copyright © 2006 by Lisa Hunter

All rights reserved.
Published in the United States by Three Rivers Press,
an imprint of the Crown Publishing Group, a division of
Random House, Inc., New York.
www.crownpublishing.com

Three Rivers Press and the Tugboat design are registered
trademarks of Random House, Inc.

Library of Congress Cataloging-in-Publication Data
Hunter, Lisa.
 The intrepid art collector: the beginner's guide to finding,
 buying, and appreciating art on a budget / Lisa Hunter.
 1. Art—Collectors and collecting—Handbooks, manuals,
 etc. 2. Art—Economic aspects. I. Title.
 N5200.H86 2006
 707.5—dc22 2006012675

ISBN-13: 978-0-307-23713-2
ISBN-10: 0-307-23713-3

Printed in the United States of America

DESIGN BY BARBARA STURMAN

10 9 8 7 6 5 4 3 2 1

First Edition

CONTENTS

Introduction

When I was twenty, I bought my first piece of "real" art—a Matisse linoleum print at a Paris gallery. It wasn't hugely expensive—less than $1,000—but it was a lot of money for me at the time. I had to live on powdered soup for a month to afford it. Soon afterwards, I went to a museum exhibit of Matisse prints and discovered that my version had been printed upside down! The seal and numbering were on the wrong side of the image. With some research, I figured out that I owned a posthumous reprint, not an original. Someone other than Matisse had used the artist's old printing plates to produce the print—someone who hadn't bothered to determine, literally, which way was up.

I was mortified. After all, I'd studied art history in college and thought I knew a lot about art: names, dates, historical movements, and what made a painting great. I even knew to buy from a reputable dealer, which I thought I was doing. So where did I go wrong? Somehow, all my previous museum-going and pretentious undergraduate term papers

hadn't prepared me to answer the simplest art question of all: Is it real?

A well-meaning friend tried to comfort me by suggesting that it didn't matter that my print wasn't an original Matisse. As long as I liked it, that's all that mattered. But a funny thing happens when you discover that you've overpaid or bought a fake: Suddenly you *don't* like the art anymore. It becomes embarrassing rather than pleasurable.

This experience taught me a valuable lesson: There is a lot more to buying art than simply recognizing major artists and knowing what you like. I was determined not to get burned again.

Fortunately, I had a lot of opportunities to learn about connoisseurship. For more than a decade, I worked as an editor and publicist for museums, where curators kindly endured my endless questions and even let me examine valuable artworks close up. Through writing about art, I also interviewed top experts and artists. On my own, I visited galleries and auction viewings and read the major art publications, clipping articles about connoisseurship and pricing until I had mounds of papers in boxes.

I quickly realized that every field of art—paintings, prints, photography, tribal art, to name a few—has its own quirky criteria that experts use to determine whether a piece of art is authentic and valuable. In addition, every field has its own notorious fakes and gimmicks. So every time I wanted to branch out and buy in a new area, I had to read a big stack of books and magazine articles.

I kept complaining that *someone* ought to write a simple-to-

use guidebook for buying different types of art. Most people aren't building specialized collections. They're buying art for their homes, and they may want such disparate things as vintage travel posters, African masks, and Navajo rugs. They shouldn't have to read forty specialist books to be able to decorate their living rooms. Eventually, my husband, who was tired of my grousing (and alarmed by the growing stacks of notes and articles taking over our loft), suggested that since I already made a living writing about art, perhaps *I* should write such a book myself.

Tentatively, I began to ask dealers, curators, and other experts if they would be willing to help. The response was overwhelming. Dozens of experts, people who normally spend their days selling Rembrandts or curating exhibits, graciously took the time to discuss how novice collectors with limited budgets should start building an art collection.

Why Buy Original Art?

With reproductions so readily available and inexpensive, you might wonder why you should pay extra to own original art.

Original, handmade art is special. Even in well-made reproductions, its unique qualities are lost. If you see a poster of Van Gogh's *Starry Night,* for example, it will just look pretty. The original, with its intense swirls of thick paint, is overwhelming and even disturbing. You can't take your eyes off it. Museums sell reproductions as souvenirs, to help you remember the experience of seeing the real thing, not to replace the

original. Think of it this way: Is seeing a travel poster of Tuscany as good as being there in person to admire the view? It's the same with art. You buy it for the experience, for the sensual and intellectual pleasure it gives you.

Perhaps you're also interested in buying original art as an investment. Art collecting can be both pleasurable and profitable, but you'll have to put in the same kind of research you would for any other investment. The art market is a bit like the stock market: There are "blue-chip artists" whose works are in constant demand and are generally considered sound investments, and there "emerging artists," newcomers who, like emerging stocks, may zoom up in value or fall off the board altogether. Then there are the slow-but-steady investments that have few risks but only modest increases. You'll have to decide how speculative or safe you want to be, or whether the art market is even the best place for you to invest. In the end, the purpose of art isn't to make money—and most reputable dealers will advise you not to buy art for investment alone.

On the other hand, when you're spending a month's salary for a picture, you naturally want to know what it might be worth in the future. You may be willing to spend more for something that promises to hold its value, or you might pass up a piece that's too expensive to buy just for your own pleasure. This book will help you learn to tell the difference, so you can make an informed choice.

If you have a modest budget, you might assume that art investment isn't even an option, that only the most expensive artists—the Rembrandts and Monets and Picassos—are solid

investments. This was the conventional wisdom for decades. Recently, however, a study by two economists found that the bottom third of the established art market consistently performs better than the upper two-thirds. (See my interview with Michael Moses at the end of this introduction.)

The key to making a wise investment is to buy the best quality you can afford in your price range. Being on a budget does not mean that you can't own good original art!

Becoming an Intrepid Collector

Many people—even those who love art and regularly go to museums—are too intimidated to buy original art. They worry that the art world is too snobbish for them, or that they'll be duped into spending money on something worthless. But it doesn't have to be that way. The legitimate art market is actually on your side. Reputable dealers and auction houses *want* collectors to be educated, and they have plenty of safeguards and guidelines to help you make intelligent purchases. You merely need to know what they are.

The chapters and interviews in this book take the mystery out of the art-buying process, so you'll know what to look for—and mistakes to look out for—in whatever type of art interests you. You'll learn what makes that particular type of art valuable, how authenticity is determined, and who are the most commonly forged artists in that field. You'll learn how to negotiate with dealers, how to buy in an auction, how to

preserve your art. Most important, you'll learn how to evaluate a work of art yourself, so you're not depending on the seller's word anymore.

The Intrepid Art Collector is intended as a handy reference to help you start your own collection. If you want an overview of the art market, read the whole book. If you already know what type of art you like, jump straight to the chapters that interest you. Maybe you already know a lot about, say, oriental rugs, but have never bought at auction. Feel free to skip around. Then take the book with you when you're shopping for art. When you see something you like, go through the checklist at the end of the relevant chapter to evaluate authenticity and value.

No one book can make you an art expert; but by following a few simple guidelines, you can avoid the most common purchasing mistakes. With *The Intrepid Art Collector* as your guide, I hope you will learn in a couple of hours the same information that took me years to figure out!

And that's when the fun begins. Once you've learned the basics of buying art and feel confident in the art world, then you really can "just buy what you like" and still love your purchase in the morning. Art collecting is one of the most exciting and rewarding hobbies out there. So let's get started!

TRACKING THE ART MARKET

MICHAEL MOSES
A few years ago, Michael Moses and his colleague Jianping Mei created the now-famous Mei Moses Fine Art Index, which is widely used by banks and investors to track values in the art market. He is an associate professor at New York University's Stern School of Business.

▶ *You and Mei tracked the auction prices of the same group of artworks over the past century, whereas earlier art indexes simply took an average of all sales. Why did you do things differently?*

At first, I was also drawn to studying average prices, because they're easy. But they don't tell you anything about return. If you have an auction with a lot of stars, and then six months later you have an auction of sub-stars that makes 40 percent less money, does that mean the market has dropped 40 percent? No.

Our index is similar to real estate indexes, which track how individual properties have performed relative to where they were before. We track the auction market because it's the only market where there's transparency (publicly available records) in pricing. With dealer sales, you have no idea what's happening.

▶ *Your results showed something surprising: The lower end of the market actually had better investment returns over the long run than the blue-chip artists.*

Everybody says that if you buy the best—which means that you spend the most dollars—you're making the best

investment. We were curious about whether that was true.

To find out, we looked at our overall art index and said: Let's take the lower third, the middle third, and the top third of the market, and then let's create a separate index for each one. We found that the lower third of the market kept outperforming the middle and top thirds.

▸ *Why do you think that is? It seems counterintuitive.*

I think the high end of the market is more susceptible to hype. A bidding war at auction can send the price of a painting so high that the next time it's sold, the return is lower. At the bottom of the market, growth is subject to normal growth patterns, not based on hype.

Part

ONE

What to Buy

1

Contemporary Art

Technically, "contemporary art" is recent work by living artists—or by their peers who died tragically young. Beyond that, though, contemporary art can mean just about anything: a shark suspended in formaldehyde, a photograph, a video, a ceramic bowl, a mound of elephant dung, or even a painting. That's why collecting contemporary art is so exciting—because it offers a chance to discover something new and unexpected.

Unfortunately, it's easy for new collectors to find contemporary art intimidating or merely baffling. When you're looking at something completely new, how do you tell whether it's good or not? Even more mysterious is how to tell which artists—out of the thousands now working—are the ones destined for museums and which are destined for yard sales.

Don't worry if you feel lost at first. Everyone does. Plunge in by going to galleries, museums, and art shows. You may not feel ready to buy yet, but that's okay. Most artists and dealers are very welcoming to people who are getting started. All you need is willingness to learn.

Learning About Contemporary Art

First, here's how *not* to learn about contemporary art: When I was an art history student in New York, my friends and I would dutifully go downtown to contemporary galleries (a prerequisite, we thought, to becoming "intellectuals"). Our courses on Caravaggio hadn't prepared us for anything we saw there. We had no idea which pieces were good and which were junk, but we were too mortified to admit it. Instead of asking questions, we'd walk around the galleries with a knowing air and murmur, "Very interesting." This is a dumb—not to mention boring—way to go to galleries.

You wouldn't expect to learn about any other topic without reading or asking questions. Why should contemporary art be any different?

You probably had a teacher once who told you that if you looked at a work of art long enough, you'd understand it. Not true. You could look at a pile of bricks in a gallery all day without realizing that it's a witty refutation of another artist's work, if you didn't get the reference. Ask questions! Once you understand what the artist was thinking, that pile of bricks may actually be fascinating, amusing, even moving.

A hushed gallery isn't always the most comfortable place to ask questions, especially when you're not ready to buy. If you're shy, ask to see press clippings or background materials. Many exhibitions include an "Artist's Statement," in which the artist attempts to describe what he or she was trying to do. (Artists hate writing these, but they're very helpful to new collectors.) You could also read reviews of the exhibit before you go, to get a general sense of what you're looking at.

Even better, start by going to art fairs, art shows, and open studio tours. These are more casual than galleries; they're more amenable places to ask questions and strike up conversations. So are art school exhibitions. Students *love* to give their opinions about what's good and bad in contemporary art.

Start with basic questions such as "Can you tell me about the artist?" or "Is this work part of a particular tradition?" Admit what you don't know. As long as you don't try to pretend you're a buyer when you're not, dealers and artists are usually gracious and willing to answer questions.

If you keep asking questions and engaging yourself in the work, you'll find that contemporary art is endlessly interesting. There's always something new.

Where to Find Contemporary Art

The Chelsea neighborhood of New York is the epicenter of contemporary art. A case of botulism at the local deli could knock out half the art world's power brokers. London and other international capitals—as well as North American cities

such as Los Angeles, San Francisco, Toronto, Vancouver, Chicago, and Miami—also have well-respected art galleries. But you don't need to live in a major city to find contemporary art.

Many midsize cities have lively art scenes. Minneapolis, for example, has one of the most prestigious contemporary art museums in the country (the Walker Art Center), as well as a large creative community. So does Pittsburgh, Andy Warhol's hometown.

Resorts like Aspen, Santa Fe, and Provincetown probably have more art galleries per capita than Paris.

In addition, university towns draw huge numbers of artists to study and teach. You can find innovative work all over the United States and Canada, in places as disparate as Bennington, Vermont; Oberlin, Ohio; and Athens, Georgia. If you're lucky enough to live near a major art school—such as the Rhode Island School of Design (in Providence) or the Cranbrook Academy of Art (in Bloomfield Hills, Michigan)—don't worry about saving up your frequent-flier miles to visit New York. The contemporary art world will come to you.

Even middle-of-nowhere places may have significant artist colonies. Marfa, Texas, for example, has been called "the most avant-garde art destination in the country." (Second prize probably goes to the tiny Hudson Valley town of Beacon, New York, home of the Dia:Beacon museum.) Blue-chip sculptor Donald Judd created a massive, minimalist museum in Marfa thirty years ago, and artists have flocked there ever since—even though it's three hours from the nearest airport.

Wherever you live, you should be able to immerse yourself in contemporary art. A magazine called *Gallery Guide* provides

a good way to find out about what's happening in your area. It's published in several regional editions and lists most of the major gallery shows and museum exhibits near you. (See the Resources section for details.)

The Elite Galleries

New collectors are often afraid to go to high-end galleries. They worry that the staff will intimidate them or, worse, will try to sell them something wildly expensive. Neither is the case.

At the elite galleries, the dealer isn't expecting a walk-in to be a customer. Most of the work on display was already sold through private negotiations before the exhibit opened. Sometimes the art doesn't even belong to the gallery. Top dealers frequently borrow art for exhibitions that will increase the gallery's prestige in the art world. Going to these exhibitions is like going to a museum, only without the admission fee.

In New York, you can even attend the opening-night parties and meet the artists. Very few openings require invitations; most are free and open to the public. On Thursday and Friday evenings in Chelsea, you'll see gangs of art students and collectors meandering from one gallery to another, sipping white wine in little plastic cups.

What you *won't* see are price tags. Many dealers—even at more affordable galleries—think that listing prices next to the art detracts from the viewing experience. Instead, they type up a price list, which you can get from the receptionist. It

spares you any embarrassment you might feel about asking for prices.

"Shopping up"—looking at art above your price range—is a great way to develop your taste and learn about the current art scene. If you find you really love an artist whose work is unaffordable, ask if the gallery has any limited-edition prints by the artist. Unbeknownst to many visitors, galleries have more art in the back room than on display, and it's not always expensive. Even elite galleries may have items that sell for a few hundred to a few thousand dollars. In some cases, they sell them only through their website, but it never hurts to ask. (A couple of snooty galleries—I won't name names—might try to dismiss you with the comment, "Everything is already sold." Don't take it personally. Just move along to the next gallery.)

If you don't happen to live near a large city, consider a trip to one of the major art fairs, such as Art Basel/Miami Beach in Miami or the ADAA Show in New York. These high-end fairs are a great way to see art from dozens of elite dealers, all in one place, in a limited amount of time. They're like a preview of what will be in museums ten years from now.

Finding the Next Big Thing

Most new collectors secretly hope that the contemporary artist they just bought will become the next superstar. They'll read about some other hot young artist whose work just sold for $100,000 at auction and cringe when they learn that the

same piece sold for only a few thousand dollars five years ago. They kick themselves and think, "If only I had walked into *that* gallery."

The way artists become stars is utterly mysterious to the uninitiated collector. Most people assume that dealers discover talented new artists and then display their work in a gallery where anyone with foresight and a good eye can buy it. That's not how the system works. The upper end of the art market is fixed to favor a handful of influential collectors. You can beat the system—and I'll tell you how—but first you have to understand how it works:

1. Certain elite dealers have a reputation for finding the Next Big Thing. Whenever they sign a new artist, the art world takes notice. The dealer carefully cultivates that interest, trying to place the art in important and highly visible collections. At the same time, he or she carefully controls the supply. As word spreads that major collectors are buying, other collectors start clamoring to get a piece too. And what does the dealer do then? The dealer tells most of them, "No"—they're not "important enough" to be allowed to own this artwork. Only the "best" collectors will be allowed to buy.

2. Instead of buying something else, the people who've been rejected by the dealer start to covet the art all the more. (Many are important people who are accustomed to having anything they want.) Owning this particular artist would be not only a good investment but also a huge sign of social prestige. It doesn't matter that twenty other artists' work would

look just as good over the couch. At this level of the market, a hot artist is like those shoes you *had* to have in junior high because all the cool kids were wearing them—only with more zeros on the price tag.

3. Eventually, someone takes a piece of the artist's work to an auction house to sell. For all the would-be collectors who were turned away earlier, this is their big chance. Their heads spin with visions of jealous neighbors and invitations to join elite museum boards. The bidding goes sky high.

4. Guess what happens next? Once the record-breaking auction price is made public, the value for the artist's work shoots up. The collectors who were allowed to buy early now have much more valuable investments. Newspaper and magazine articles hail the dealer's great instincts for spotting the Next Big Thing yet again. You can bet that the next time the dealer signs a new artist, even more collectors will want to buy.

Dealers aren't the only people with influence, though many art world denizens complain that they are. Sometimes an important critic, curator, or even collector can be a star-maker. A certain British collector, for example, has a contemporary art collection so highly regarded that other collectors monitor his buying habits. Whenever he buys a new artist, dozens of others rush to buy that artist too, which makes the artist's prices go up, which reinforces the collector's reputation for picking winners. This collector can't go wrong. Any new artist he buys

rises in value, because he himself is the one creating the market demand.

How can ordinary collectors get in on the Next Big Thing? Those with big ambitions and deep pockets often hire a well-connected art consultant to buy for them. If that's beyond your budget, and you haven't been the artist's best friend since third grade, you'll have to beat the dealers to the art.

Beating the Dealers

If you're buying art mainly for your own pleasure, you can skip this section. But if you have a competitive personality and a taste for speculation, you can try to get the jump on the top dealers by anticipating their next move.

Here's how:

* Buy young. Dealers are now signing artists who are still in MFA programs. Savvy collectors haunt the top art schools—especially Columbia, Yale, and Hunter—racing to find the Next Big Thing before a dealer gets there.

* Focus on artists who live in New York or another major art capital. That's where the top dealers live, so that's where they tend to look for new talent. Someone in Moose Jaw or Duluth may be a brilliant artist but is not making connections and going to the right parties. If the star-maker dealers never see the art, the big international career isn't likely to

happen. (An exception to the Chelsea-centered universe may be Los Angeles. For decades, LA had an art market the way New York had a film industry. It was respectable, with a few stars, but the real action was elsewhere. Recently, though, LA art has become more prominent on the international scene.)

★ Collect "difficult" art. If the work is gory or disturbing, most collectors won't want it hanging over their couches, no matter how many curators gush about its brilliance. These artists may need extra time to find a dealer who'll handle edgy work. If your taste is a little offbeat, you can take advantage of other people's squeamishness.

★ Go to group exhibitions where multiple artists' work is on display—particularly career-making art shows, such as the P.S. 1 Greater New York Art Show. Many top artists got their start that way. Smart collectors go on the first day, trying to find artists who aren't yet signed to a gallery.

★ Take a second look at has-beens. Some potential stars fizzle. Others alienate their dealers with youthful arrogance and become pariahs. Speculators dump these artists' works because they're embarrassed to have made a "wrong" choice. But occasionally artists make comebacks. Some of today's blue-chip stars went through a career trough when nobody was buying their work—except for a few crafty dealers who were quietly stockpiling it at bargain prices. You can too.

Look back at lists of artists who were included in career-making exhibitions like the Whitney Biennial or the P.S. 1 Art Show several years ago. Which artists were "never heard from again"? Google them. See what they're up to. You might find something amazing.

★ Buy new types of art. Whenever artists start working in a new medium or style, collectors take a while to catch on. One of the most important collections of conceptual art was assembled by a middle-class couple (he was a postal clerk, she a librarian) who wedged museum-quality art into their tiny one-bedroom apartment. When they started collecting in the 1960s, the Park Avenue crowd wasn't interested in conceptual work, so this couple could afford the best, even with modest means. Now their collection is in the National Gallery.

Keep in mind that you're not the only collector trying to get in on the ground floor. Even at seemingly out-of-the-way art shows, you may have to elbow past investment bankers to get what you want. If you do find an artist who might be the Next Big Thing, be sure to take physical possession of the art as soon as you buy. Young artists have been known to go back on a deal if they're subsequently signed by a top dealer or selected for an important show.

This beat-the-dealer frenzy isn't for everyone. It can make you feel as though you're on the trading floor at the New York Stock Exchange. The aesthetic purpose of the art can get lost. Be sure you're buying art you actually like and want to live

with. Remember: Speculative art investment doesn't always work out, even for insiders. (For a discussion of how to build a personal collection, see my interview with curator Renee Vara on page 20.)

Beyond the Art Stars

The problem with chasing the Next Big Thing is that artists become stars because *other* people like them. You're the one who will be looking at your art every day. What do *you* like?

Looking at a great work of art should feel like talking to a fascinating person—you keep learning new and interesting things. Too often, art is like someone who's beautiful but boring, or like an intellectual who talks above your head and doesn't care whether you understand or not. When you find a work of art that speaks to you and stays interesting, you've found the real thing. Discovering the real thing is what makes collecting so exciting.

Some collectors feel uncomfortable trusting their own taste, so they just go with the big names, often buying mediocre pieces for the sake of a signature. Not only will you miss out on the fun that way—you'll overlook a lot of good art.

Many artists have substantial credentials—exhibitions, prizes, and good art school degrees—without being "names." Their art sells for a few hundred to a few thousand dollars. You probably won't make a huge profit investing in their work, but you can find interesting, quality art that holds its value and

may even increase in value if the artist is savvy about promoting his or her career.

You can also find talented artists who lack any credentials at all or who are absolute numbskulls about marketing their work. Some of these artists complain that the elite New York art world is just a popularity contest. They think that their own art is just as good but that they don't have the right personality to succeed.

"Those artists are absolutely right," says Mark Kostabi, an artist as famous for his audacious self-promotion as for his painting. "Going to openings and meeting art world people is extremely important for an artist. If you're extroverted to just the right degree, it makes all the difference in the world. The more openings I go to, the more paintings I sell. If I don't go to any, I have no activity at all."

If you keep an open mind, you can find some real talent out there, and at affordable prices. Here are some types of artists you might want to take a second look at.

Regional Artists

Don't tell Woody Allen, but not everyone wants to live in New York. All around the country, artists have settled into cities and towns that offer more amenable lifestyles. Philadelphia, for example, is being called the "next Williamsburg"—scores of young artists are moving there from New York. In Dallas, Seattle, and other cities that are home to large numbers of affluent collectors, local artists can make a living without ever having to leave town.

Different parts of the country have their own regional art markets. Someone you've never heard of in Virginia may be extremely popular in New Mexico, and vice versa. Sometimes the work of local artists becomes valuable. After all, the Hudson River School painters were once "regional" artists. So was Grandma Moses. And the list goes on.

Midcareer Artists

Today's art market loves youth. Prices for twenty-five-year-old artists can zoom from four figures to six within a year. Meanwhile, forty-five-year-old artists with résumés full of exhibitions and prizes are left scratching their heads and wondering what happened. Their work still sells for four figures even though they have more distinguished track records than these new hot shots and, in many instances, were their teachers.

The problem is speculators, who buy according to potential. A young artist has the potential to become a star. As time goes by, that potential starts to diminish. Collectors start to realize that if it hasn't happened by now, it probably never will. The people who truly love the artist's work will still buy, but the speculators move on.

Instead of chasing young artists who might someday be in the Whitney, why not buy someone who's already *been* in the Whitney?

Illustrators

Illustrators—the people who make a living drawing pictures for books, graphic novels, and magazines—don't get the respect they deserve. The art world elite, if they mention illustration at all, tend to put "mere" in front of it. Part of the problem is that art schools have started dividing their students into two tracks—fine art and commercial art—which makes it harder for young illustrators to break into the gallery scene. If you see wonderful artwork in a publication, find out who the artist is; then check the Internet to see where you can buy his or her work.

Illustrators from the previous generation—such as Saul Steinberg, famous for his *New Yorker* magazine covers, and Al Hirschfeld, beloved caricaturist of Hollywood celebrities—are hugely popular with collectors. Their work sells in art galleries for thousands of dollars. There's no reason why today's top illustrators shouldn't have similar career paths.

For a discussion of comic book art and animation, see page 29.

Outsider Artists

Outsider artists are becoming so popular that they're practically insiders. The classic Outsider artist is someone with no formal training who makes art solely as a private form of self-expression, not as a career. (Often the work is discovered after the artist's death.) We're not talking about Grandma Moses

here. Outsider art is intense, obsessive, and disturbing. Many Outsider artists have been confined to prisons or mental hospitals. Pedophilia and violent sexual fantasies are common themes. The raw, emotional power of this art lures thousands of collectors to the annual Outsider Art Fair in Soho (see Resources), as well as to galleries that show Outsider art.

You don't have to go to wine-and-cheese receptions to find great Outsider work. It can be found anywhere. You simply need to keep your eyes open.

Craftspeople

Don't overlook artisans, such as glassblowers, woodworkers, or potters. Decorative arts from previous centuries are now in museums. Why should our own century's be any different? Some artisans are already catching the eye of museum curators. Recently, African American quilts from Gees Bend, Alabama, were displayed as contemporary art at the Whitney Museum. What sets these quilts apart from the hobbyist quilts for sale on eBay is that they're innovative and highly original. If you like crafts (and who doesn't?), focus on finding artists who are doing something unique—not reproducing 19th-century designs or making cutesy crafts with kitty-cat motifs.

Museums and contemporary art galleries are a great place to see innovative sculptural work made with crafts materials such as glass, ceramics, or fiber. The line between fine art and crafts is starting to blur.

"The redefinition is being pushed by young sculptors who work in materials traditionally associated with the crafts," says

Tina Oldknow, curator at the renowned Corning Museum of Glass. "Today it's easy for artists to cross boundaries and work in glass, for example. They can rent glassmaking facilities and hire glassblowers to help them fabricate their work. In the 1970s, studio crafts had a 'back to the land, made by hand' approach and it wasn't cool if you didn't make the object yourself. Now, even good glassblowers may have other people to help make their pieces, because someone else might be better at a specific technique."

Blue-chip artists like Robert Rauschenberg, Kiki Smith, Sherrie Levine, and Damien Hirst have all made work incorporating glass. Ceramics and fiber arts are taught in top art schools, alongside painting and photography. As a result of crafts' popularity in the art world, prices have risen, but it's still a very reasonably priced field compared to other types of contemporary art. The key to collecting wisely is to buy the best quality work you can find.

"I'd tell new collectors to go to the Art Basel fair in Miami—start at the top by looking at how craft-associated materials are used in the newest art and design" says Oldknow. "Then go to the leading market for fine craft, which is the Sculpture Objects and Functional Art (SOFA) show in New York or Chicago (www.sofaexpo.com). It's a great way to get an idea of the range of crafts and to find out about new people."

You might still find something wonderful at your local crafts shows, but you have to be careful about quality. "Ceramics and glass in particular have such a good market that there's a temptation for an artist to just make popular things that sell or

to make endless series of the same design," says Oldknow. "I was at a crafts show recently that had a lot of derivative pieces. That's the reputation crafts have to fight against."

To train your eye for quality, visit top-notch crafts exhibitions—whether in galleries, museums, or fairs. You might also want to consider subscribing to specialist journals about ceramics, glass, fiber arts and textiles, metals and jewelry, or whichever type of art interests you. If you take time to learn before you buy, you'll be happier with your purchases in the long run. And you might even see them in a museum someday!

Unknowns

When you buy unknown artists, you're really buying for your own pleasure. And why not? That's what art collecting is supposed to be about, isn't it? If you're not concerned with investment potential, you could collect by theme and build an interesting, coherent collection without having a single "name" on your wall.

BUILDING A CONTEMPORARY COLLECTION

RENEE VARA

Renee Vara is a private curator and dealer. She teaches art history and museum studies at New York University and the Guggenheim Museum.

▸ *How do you recommend that people build a "collection," as opposed to just making random art purchases?*

The first thing is to decide what you like. It's shocking how many collectors don't know. Many are too insecure to buy from their gut. They want to know where a piece was exhibited, where it was published, who says it's good.

In emerging markets, many people just buy what's hot. They choose art like an IPO. Chasing what's hot is not necessarily good. I saw the neo-Expressionist movement completely crash in the early '90s, so I'm leery of these "rock star" artists. Eventually art is going to have to have more than a momentary buzz. A collection that is great in ten years is never bought on buzz.

▸ *What's a better approach?*

I like to work with thematic collectors. We usually start with a list of "wants," which is based on the clients' budget, their home, and their background.

One of my clients, for instance, wanted to be an architect but ended up in real estate instead. He started a collection of drawings with architectural elements; his collection shows the relationship between art and architecture.

Another client who started with contemporary art is now moving back to the '60s to collect the artists who influenced the ones he already has. A thematic collector is very different from someone who's just decorating a house.

On the other hand, many collectors just buy what they like, and themes come out anyway because they have thematic taste or defined interests. It's kind of like your wardrobe. If you buy what you like year after year, all of a sudden you'll have a style. If you just buy what's "hot" every season, you'll have a disjointed wardrobe.

So it works both ways. Sometimes you start with your gut feeling and then look at the other elements. Sometimes you do it the other way around.

But if you just choose your art based on who was written up in the *New York Times*, your collection ends up not being about your taste. It's about what is already validated. This type of strategy is often one that makes people overpay or buy poor-quality work from a brand-name artist.

Determining the Value of New Art

Art doesn't have an absolute value. Its price is determined solely by how much people are willing to pay for it. When you're trying to evaluate the investment potential of art, you have to look beyond the object itself and think about market forces:

* How many people are interested in this artist's work? Is the artist well known regionally or nationally?
* Is the work rare? Blue-chip artist Jasper Johns, for example, makes very few paintings, so collectors have to compete for them.
* Does the artist have an influential dealer, curator, or critic promoting the work?
* Has any of the artist's work sold at auction? If so, for how much? Auction prices set the resale market.

★ Has the art been reviewed in important regional or national publications?

★ Is the current art market so high—or so low—that it seems destined for a price correction? Reading art magazines or newspapers can keep you informed of market fluctuations.

While you're at it, don't forget to ask: "Do I actually *care* whether this work goes up or down in value?" Art isn't stocks or bonds. If you fall in love with a piece that's comfortably affordable, and you don't think you'll ever need (or want) to resell it, then its value to *you* is all that matters.

Resale Value

Say you bought a lithograph in a gallery last year for $1,000. Now you see that the gallery is selling the same thing for $2,000. Has your investment doubled in value? Not necessarily. It may even have gone down.

The value of your art isn't based on how much a gallery can sell it for. It's based on what *you* can sell it for. If you take your picture back to the original gallery, they're not going to pay you $2,000 for it. That's their *retail* price. The *wholesale* price (what they pay to buy art) is much lower. Otherwise, how would they make any money?

Auction results are a much better indication of what you could realistically expect to get for your art. If you're concerned about investment potential, always check to see if your

artist's work has been sold at auction, and if so, for how much. (See Resources for details.)

Don't be swayed by slick dealers who tell you an artist's work has doubled in value. That may simply mean that the gallery has doubled its prices. If you find that auction sales are substantially below the gallery's prices, maybe you should consider buying at auction instead.

The (Relative) Importance of Signature-Style Work

Artists may like to experiment with different styles, but serious collectors prefer archetypal work—something that is recognizably in the artist's best-known style. To use a famous example, if you were buying a Chuck Close, you'd want to buy a "photorealism" painting.

Nonarchetypal work rarely appreciates as much as the artist's signature style. If you're choosing between two artworks—one archetypal, the other not—the archetypal example is usually the better investment choice. That's partly why you want to know how a particular piece fits into the artist's overall career.

On the other hand, if you really spark to a nonarchetypal style, go ahead and buy it. It's usually less expensive, and sometimes the work is appreciated later. For example, the noted photographer Weegee (Arthur Fellig) made a series of experimental "distortion" photos that collectors dismissed for decades in favor of his photojournalism. Now these distortion photos are shown at the white-hot Matthew Marks Gallery in Chelsea. Good luck trying to buy one.

Authenticity Concerns

When you buy a new work of art, you don't have to worry whether it's authentic, but you do have to worry about how you'll prove it's authentic in the future. Some collectors with great taste and foresight bought future stars early on, only to have the artist's authentication board later say it couldn't authenticate the work!

If you're buying directly from an artist, get a written, signed receipt, and keep your canceled check made out to the artist. If you're buying from a gallery, make sure you get a receipt on gallery letterhead. Do this even if the artist is completely unknown—you never know!

Special Concerns When Buying Contemporary Art

Three-Dimensional and Installment Art

Not so long ago, "three-dimensional art" meant marble statues and bronze busts. Today's three-dimensional art is harder to classify. Some artists manipulate neon lights. An artist at the recent Venice Biennale made an elaborate chandelier out of tampons. A top British artist gained fame for appliquéing a tent with the names of everyone she'd ever slept with.

Where do you display art like this? How do you dust it? What happens when the neon bulbs burn out? Collectors of contemporary art have to deal with practical issues that never

troubled collectors in centuries past. If you buy new three-dimensional art, ask the dealer or artist how it should be installed and maintained.

You also need to make sure that everyone who comes into your house understands which items are Art. You don't want party guests stepping on your art—or your housekeeper tossing it in the washing machine. (More than one art gallery janitor has inadvertently thrown out an exhibition.)

Video Art

Video art is a relatively new area for collectors, but the market for it is booming. If you're interested in buying video art, you'll need to consider a number of issues, both technical and aesthetic:

1. Can you live with the work day after day? No matter how much you love it now, can you stand to see and hear it for the five-hundredth time? Apparently some collectors of video art leave their art "turned off" most of the time. They look at blank TV screens instead of art.

2. Can you get technical upgrades? Anyone who remembers floppy disks that were actually floppy knows that technology changes. If you buy video art now, eventually the "state of the art" won't be the state of *your* art. You'll need an ongoing relationship with the artist. Ask whether the artist is willing to provide you with upgrades as technology changes.

3. What happens if the art gets damaged? VCRs don't distinguish between high art and a cassette of *Police Academy 6*. If your machine munches the tape or DVD, can you get another copy? (Another good question is whether, in future years, such copies will still be considered "original" art. No one knows for sure.)

4. How limited is the supply? Technology gives artists the capacity to make an infinite number of copies. Is the artist selling only one copy of the video art, or multiple copies in a limited edition? What happens if the artist or another collector later puts the work on television or the Internet, where anyone with a CD burner can get a copy for free?

A Final Caveat About Condition

Contemporary artists use a huge variety of materials in their work, from spray paint to Styrofoam. Not all of these unorthodox materials will hold up. Some very high-priced art from the 1980s is already falling apart.

"Crayola crayons, felt-tip pens, fluorescent paint, construction paper, newsprint, and cardboard will all deteriorate," says conservator Margaret Holben Ellis, of New York University's Institute of Fine Arts. "Andy Warhol's Day-Glo paintings, for example, will eventually lose their fluorescence and their *oomph*. That's no reason not to buy one—I would die to have a Warhol *Marilyn Monroe*—but be aware of your responsibility. You should collect it and slow down the process of deterioration."

Make sure you frame your art with archival-quality materials and keep delicate pieces out of bright light. For more information, see Chapter 14, "Art in Your Home."

Popular Art

The New York art stars aren't the only artists who become millionaires. An entirely separate market exists for "popular" artists whose works are sold at commercial art galleries around the country. Their sports scenes and sentimental landscapes are avidly collected by people who wear colors other than black.

Almost every city has a gallery where you can find work by mainstream popular artists such as Thomas Kinkaid, LeRoy Neiman, and Peter Max. New collectors often begin by buying this type of art because it's accessible—you don't need a Ph.D. to understand it. Unfortunately, some unscrupulous sellers take advantage of their clients' inexperience. Beware: This is one of the most fraud-ridden areas of the art market.

If someone tries to sell you an "original print" by a popular artist, you need to find out exactly what the seller means by that phrase. The difference between a signed, limited-edition lithograph and a signed, machine-printed poster can be thousands of dollars, even if they're of the same image. Some hucksters stretch the truth. Because a mass-produced poster (the kind you find in museum gift shops) is technically "printed," they may refer to it as a "print." Make sure you know exactly what you're looking at—and get it in writing. For more details, see the chapters on Prints and Vintage Posters.

Crooked sellers may also add a signature to a machine-printed reproduction, or they may scan an original image without the artist's permission and make new prints. Sometimes they use a new printing technology that can print a copy of an image right onto canvas, so it looks like a painting.

Always make sure the gallery is legitimate. For the most popular artists, like Kinkaid, Max, and Neiman, you can get a list of authorized dealers from the artists' websites. (For more on how to evaluate dealers, see Chapter 10, "Dealing with Dealers.")

Comics

Most of us loved cartoons and comic books when we were kids, but you never need to outgrow them. Today, original art for your favorite series can form a serious art collection. Comic book illustrations and animation cels now fetch fine-art prices at auction, sometimes topping six figures. But don't worry if you're still limited to a weekly allowance-type budget. You can find interesting work in all price ranges.

Vintage comic art commands high prices because it's rare. Until the mid 1970s, nobody much thought about collecting comic book illustrations. Artists and publishers considered these drawings to be work for hire. "Publishers would keep the art on hand for reprints, then throw it away, or even use it as a floor mat on a rainy day," says Ed Jaster, vice president of Heritage Auction Galleries.

With limited supply, collectors have to compete to own older work, which boosts prices. "Pieces of art that may or

may not still exist—like the original art from *Superman* #1—could fetch a million dollars if they ever came up for auction," says Jaster.

About 1978, copyright laws changed, so that artists—not the publishers—owned the art. Companies started returning illustrations to the creators rather than throwing them out. As a result, most illustrations from after 1980 still exist. Because they aren't rare, they aren't as expensive as vintage work. That doesn't mean, however, that the art itself isn't just as good.

In general, value is determined by four variables:

★ How important the artist is. Someone who drew an important comic will command high prices, even for his or her lesser work.
★ The iconic importance of the comic strip or cartoon.
★ How rare the artwork is.
★ The condition of the artwork.

Authentic comic art will have certain telltale signs: For example, you can usually see the original pencil drawings underneath the ink. Authentic work from 1980 or later will also have publication information, editors' stamps, and issue annotations in the margins. Fortunately, forgery isn't a major problem in comic book art. Says Jaster, "If you're good enough to fake it, you're good enough to have done it for real."

Animation

You've probably heard stories about lucky collectors finding Disney animation cels in trash bins. Until a few decades ago, people didn't think of animation as real art. Now vintage animation cels fetch thousands of dollars at top auction houses. That may lead you to think that contemporary animation art is a good investment too. It depends.

Unique, one-of-a-kind art drawn by hand is going to have intrinsic value, but a lot of contemporary animation is computer-generated. Some companies print limited editions of popular animated cartoon images, but that's not the same as an original, hand-drawn piece. These are manufactured "collectibles," with limited resale value. For collecting purposes, you want to stay with unique pieces.

Even then, you're better off buying pieces you really love, rather than trying to outsmart the market.

"Buyers tend to overspend on what's popular right now. You want to think about the long term. Where do these works stand in comparison to the truly great artists? How iconic is the character? It's hard to tell," says Jaster. That's why you should buy what you really love—and can afford—rather than what you think is going to be "hot." You'll be happier in the long run.

The Traditionalists

Some contemporary artists seem to be living in the 1890s. They paint Monet-like scenes of ladies in long white dresses

strolling through flower gardens. Or they work in the realistic style of 19th-century Academic painters who thought Monet was a dangerous radical.

These artists—and their collectors—exist in a world entirely separate from mainstream contemporary art. You won't see them in chic Chelsea galleries or read about them in *Artforum*. They have their own dealers and their own magazines, which rant about the state of contemporary art. (Traditionalists didn't become artists so they could urinate in a jar and call it Art, thank you very much.)

Traditionalist art also has different rules for determining value. Since the artists are working in an already-established style, innovation is less important than technique. If you're thinking of buying traditionalist art, look at the piece with a critical eye. Even when artists work in similar styles, some are better than others. There's no reason to buy a mediocre piece, because the supply of traditionalist art clearly isn't drying up.

Here are some questions to consider:

★ Is the image compelling or merely decorative? If you're not sure, don't buy yet. Take the evening to consider whether the picture stays in your mind or whether it starts to blur into other, similar pieces you've seen. If you can't quite remember what it looks like, it can't have had much impact on you.

★ Does the artist show a high level of technical skill? An innovator might get away with being a lousy craftsman, but an artist working in a traditional mode needs to be a virtuoso.

* Does the artist have a unique style or sensibility that makes the work special?
* Does the artist have a following—or a dealer who is devoted to creating a following?
* If the artist is established, has any of his or her art been sold at auction? For how much? (See Resources for information on how to check this.) If the art hasn't held its value but you still like it, maybe you should consider buying in the secondary auction market rather than from the gallery. You won't get as big a selection to choose from, but you'll get a better price.

Celebrity Artists

Many actors and musicians are also artists. Some are even talented. (You'd be surprised how many rock musicians went to art school.) The market for celebrity art is similar to the market for memorabilia: It's based on the fame of the performer.

Before you fork over an inflated price for a celebrity artist, ask yourself whether his or her career is likely to have staying power. Is this performer an icon people will still be talking about thirty or fifty years from now? If so, then the art will probably have some value as memorabilia. But if the celebrity turns out to be a one-hit wonder, you'd better really like the art; it may have little resale value later.

Becoming a Collector

Once you buy your first piece of art, you can get hooked on collecting. Try to resist buying a lot of art right away just because you have empty walls at home. The best collections are formed over time.

Hold out for pieces that really mean something to you. If you don't find a painting or sculpture that hits you viscerally right now, wait until one does. The great thing about contemporary art is that people are always making more of it.

CHECKLIST FOR BUYING CONTEMPORARY ART

Do you have a sense of what the artist is trying to do, how original the work is, and where it fits into the contemporary art scene?

If you're concerned about investment, does the artist have awards, exhibitions, or other career accomplishments? Does he or she have a dealer yet, or a following among collectors? For an artist's work to go up in value significantly, he or she usually has to get the attention of an influential dealer, collector, critic, or curator.

Are you buying archetypal work? The artist's most recognizable style is usually the best investment. (If you're buying for your own pleasure, this doesn't really matter.)

What secondary market—if any—exists for this
 artist? If there's no secondary market at all, do you
 still want to buy?

Is the dealer reputable? See Chapter 10, "Dealing with
 Dealers," for tips on how to tell.

Is the art well constructed out of materials that will last?

Do you love it?

EVALUATING CONTEMPORARY ART

MAXWELL ANDERSON
Maxwell Anderson is the former Director of the Whitney
Museum of American Art.

▸*Could you talk about how you evaluate contemporary*
art? I think many new collectors are afraid to buy con-
temporary work, because they don't have any guidelines
for judging it.

The predicament is that people may evaluate contem-
porary art in different ways—at times for pleasure and at
times primarily with an eye toward investment. Those two
approaches may or may not be compatible.

The top of the market is where you may see the most
financial growth, but it's very difficult for new collectors
to take part. Top dealers have cloistered access to their
artists—it's often a by-invitation-only world. Like any micro-
economy where you have demand outweighing supply, the
gatekeepers—in this case, the dealers—understandably have
a huge influence.

▸*How does that influence work? A lot of collectors—and artists—are mystified about why some artists become highly sought after and others don't.*

Power awards power. All artists are dependent on advocates. A dealer of consequence can confer power on a new artist. In addition, the opinions of critics, curators, and collectors either coalesce around the artist, or they don't.

An artwork doesn't have an absolute value. The value is based on the variable opinion of the art market. This can have the effect of pushing the museum to the side somewhat as an arbiter of taste.

▸*Collecting for pleasure sounds much simpler.*

If one is going to go about collecting art from a perspective of personal enjoyment, that's entirely different.

The world of creativity is so broad that what we call "art" now spills over to include almost any creative endeavor, which can be very exciting but also daunting.

Start with a process of finding your interests as a collector. Are you interested in social commentary? Perhaps you're interested in abstract art, so as to live with what may be a more neutral work. Some people have an approach to collecting art that's so personal they can't articulate it.

▸*What about people who aren't at that stage yet? How would you advise someone who doesn't know anything about contemporary art but is intrigued and wants to learn?*

Start by visiting your local museums that have contemporary art. Don't just go to the exhibitions. Attend the

lectures and the other programs whenever you can. Go to art fairs and commercial galleries, where you can associate with people in the art world. Artnet [www.artnet.com] can give you a good general sense of how the art world works.

You might also want to read some of the art publications. *The Art Newspaper* is an authoritative resource. *Artforum* is the most sophisticated journal but also the most rewarding in that it's a snapshot of any given moment in the art world.

The first obligation for new collectors is education. It can be fairly prolonged, but you have to go through this process of self-teaching before you can find something of value—whether personal or financial.

2

19th- and 20th-Century Art

If money is no object, buying 19th- and 20th-century art is easy: You go to a top dealer, or hire an art consultant to bid for you at auction, and *voilà!* Collecting on a limited budget is more challenging but still doable.

Not every good painting made in the past two hundred years is hanging in the Metropolitan Museum. Thousands of talented second-tier artists created hundreds of thousands of artworks during this period. What's more, some of the artists who *are* in the Met made prints that sell for only a few thousand dollars. So even if Monet is out of the question, you ought to be able to find something you like.

The downside to buying 19th- and 20th-century art is that you have to be extra vigilant about fakes. *ARTnews* magazine

recently published a list of the "10 Most Forged Artists of All Time," and every single one of them was a famous 19th- or 20th-century artist, such as Modigliani, Utrillo, and Dalí. Don't assume that forgeries happen only in the multi-million-dollar part of the art world. Fakes are common in the lower price range too because collectors are more likely to be novices and less likely to have expert advice. By following a few simple guidelines, however, you can steer clear of the vast majority of fakes.

Verifying Authenticity

The art world has a lot of jargon, but two words you really need to know are *catalogue raisonné*. A catalogue raisonné is a scholarly list of all known works by an artist. Every famous 19th- and 20th-century artist has one; prolific artists might have several, each covering a different period or medium. Experts spend years compiling these volumes, which include specific information on signatures, paper, and other characteristics of genuine work.

If a piece isn't listed in the artist's catalogue raisonné, or if a piece doesn't match the description, it's not considered authentic. Now that you know that, you can probably dismiss about half the fakes on the art market.

I know what you're thinking: What about all those artworks that were "discovered" in someone's attic, after being lost or undocumented for decades? Couldn't genuine work have slipped through the cracks?

According to art historian Gail Levin, author of the catalogue raisonné for Edward Hopper, "It depends on how quickly a catalogue raisonné is compiled. A good one takes many years of study and searching." Says Levin, "Authentic works can always turn up. It's less likely for some projects than others, but there are infinite numbers of variables: who has done the scholarship, and how well, over how many years, etc."

The other evidence that helps determine authenticity is provenance—the ownership and exhibition history of a work of art. Ideally, you want to see an unbroken chain of sales receipts all the way back to when the artist made it. If the seller tells you the piece was in an exhibition, ask to see the page from the exhibition catalog.

Many blue-chip 20th-century artists also have authentication boards that pronounce whether a work of art is genuine or not. For a discussion of how authentication boards work, see my interview with Ronald Spencer (*sidebar*).

Don't think of all this paperwork as a nuisance. It's really for your protection. If you're a novice collector, you're well advised not to take chances on any undocumented work. The found-it-in-an-attic story is a common con line. Dealers roll their eyes when they hear it. For every person who really does find authentic "lost" art by a major artist, hundreds—or even thousands—of collectors are fooled into buying fakes.

If you avoid too-good-to-be-true deals and buy only documented work from reputable sellers, you're unlikely to have a problem. Remember: The reputable art world doesn't want you to buy fakes. They hate them even more than you do. You're not in this all alone.

HOW EXPERTS DETERMINE AUTHENTICITY

RONALD SPENCER

Ronald Spencer is an attorney specializing in art law at Carter, Ledyard and Milburn LLP. He represents the Jackson Pollock and Andy Warhol authentication boards, and he has also advised the Archipenko Foundation, Robert Motherwell's (Dedalus) foundation, and the Roy Lichtenstein Foundation on authentication issues. He is also editor of the book The Expert Versus the Object: Judging Fakes and False Attributions in the Visual Arts *(2004).*

▸ *You're the attorney for several authentication boards, defending them from lawsuits by collectors whose pictures are deemed fakes. Could you explain how art authentication boards work? I think the average collector finds them very mysterious.*

There's a common misunderstanding about how these boards work. They're not sending pictures out to a conservator to have the paint tested. They're first and foremost looking at issues of connoisseurship.

Each board is different—the Pollock experts were looking for different things than the Warhol board—but they all rely on looking long and hard at a piece to judge authenticity. They're the leading authorities on their particular artist. They've trained their eyes by years of looking at the art. They know how their artist worked and what materials he used. So they rely on their eye. That's what's meant by the expression "having a good eye."

Only very rarely do boards conduct scientific tests, because all a test can do is rule something out. If you

bring in a Jackson Pollock that's painted in acrylics, for example, that's obviously not by Pollock because acrylic paints were only in use after his death in 1956. But if a test shows that the materials in the picture are the same as the ones he used, that still doesn't prove Pollock actually painted it.

Many people are also surprised to learn that boards don't pay much attention to signatures. That's not how art historians authenticate a work of art. Bill Rubin at the Museum of Modern Art once explained to me why. He said, "How long would it take you to learn to copy Pollock's signature, and how long would it take you to learn to paint like him?" For the experts and the boards, the painting *is* the signature.

▶ *Yet most people consider a signed piece more valuable than an unsigned one.*

It really shouldn't matter to the value of the work (unless the artist always, but always, signed his work). The piece either is or isn't by the artist. If the art world believes that a picture is authentic, the value should be the same—whether it has a signature or not.

Historically, there are many examples of artworks created without a signature. Sometimes an artist created a piece and, later, someone else improperly added a signature. Sometimes a successful artist may have put his signature on a work that wasn't his because he was trying to help out a friend who needed money.

▶ *Are forgeries the most common problem that collectors encounter?*

A well-known dealer once said that every major collection has a forgery in it. But the problem is usually one of misattribution. People are constantly confusing forgeries— a deliberate attempt to deceive—with misattributions.

Copying, or painting in the style of X, is done all the time, with no attempt to deceive. The ancient Romans copied Greek statues. Some Old Masters, like Rubens, had virtual factories where assistants painted at least part of a particular work. And artists have traditionally copied other paintings to study them. But today these copies can be mistaken for originals.

There aren't that many forgers who are that good. Most are obvious and easy for experts to spot. Their stories make good reading in newspapers, but in terms of the art market, forgeries are nowhere near as common as misattributions.

▶ *What advice would you give a new collector?*

Recognize that, as a practical matter, you're not going to buy a painting and then take it to the expert around the corner for authentication. You're buying based on the reputation and expertise of the dealer. That's why it's important to deal only with dealers who have a good reputation. Most reputable dealers will offer to return your purchase price if there's a real problem later.

Unfortunately no one has a sign outside that says "Reputable Dealer Here." You really have to ask around. Ask other people in the art field: dealers, art historians, museum curators, and artists. Some reputations are not good.

Beware if someone is offering to sell you something

way below market price. Who is this dealer? And why is he offering such a great deal to you? If you're getting something that sounds too good to be true, it probably is.

Paintings

It's characteristic of collectors to complain that all the good older art is gone—that it's all disappeared into museums and private collections. They're wrong. Time after time, when major artists' works become unavailable, collectors start to realize that other artists—people they overlooked in the past—were also talented. As one art market dries up, another is created.

A generation ago, for example, collectors who were priced out of the French Impressionist market started to buy the American Impressionists. Then those artists started commanding high prices too. Now collectors are looking more closely at other artists from that time period.

And speaking of time periods, be aware that 19th- and 20th-century art can go by many different names. In general, "modern art" starts with Cézanne in the late 1800s and ends around World War II. Art from the mid-1940s to about 1980 (a time period that includes Abstract Expressionism, Pop Art, and so forth) is referred to as "postwar art." Starting in about the 1980s, art becomes "contemporary." (If that's the time period that interests you, see chapter 1.)

If you're open minded, you'll find plenty of 19th- and 20th-century paintings available, even if you have modest means. Areas that haven't dried up yet include the following.

Academic Art

The 19th-century art establishment was run by classically trained artists whose paintings and sculptures have an astonishing technical excellence. Art historians haven't always been kind to these Academic artists. After all, they were the authority figures who shunned Impressionism and called Matisse a wild beast. Academic artists lost the battle between art that depicts the outer world and art that reveals an inner world, so they got left out of the textbooks.

Over the past few decades, though, Academic painting started making a comeback, as collectors yearned for the craftsmanship of traditional art. Prices are rising, but you can still find good, affordable work, because thousands of 19th-century artists throughout Europe were working in this style. (See my interview with Nancy Harrison at the end of this chapter for more about Academic art.)

Be aware that Academic paintings are sometimes "improved" to make them more marketable. A scenic landscape with horses, for example, can fetch more at auction than a landscape alone, so a later artist might add a few ponies to boost the value. The "improvements" may even include painting a new signature over the old one. Jean-Baptiste-Camille Corot's signature is probably the most commonly forged. There's a standard art world joke about how Corot painted two

thousand pictures, ten thousand of which are in the United States. That's where background documentation—the catalogue raisonné, provenance, and expert authentications—are essential.

Folk Art

In the 19th century, itinerant artists went from town to town painting portraits in a naïf style that is now treasured by folk art collectors. These paintings—along with other folk icons such as weather vanes, cigar store Indians, and carousel horses—zoomed in value during the 1980s. Today you can still find paintings for a few thousand dollars, but you have to be careful about authenticity. With high prices come forgeries, and the folk art style is relatively easy to duplicate. A reputable dealer or auction house is your best bet for finding authentic work.

If you see a supposedly antique folk painting in an out-of-the-way setting, look at the back. Is the back of the canvas perfectly white and new looking? Is it stapled to the underlying boards with new-looking staples? Are the boards themselves light, fresh new wood? These are signs of a new piece. If the seller says the new boards and staples are the result of the painting's having been re-stretched, where are the original nail holes from the previous frame? Although you won't be able to spot a really excellent forgery on your own, common sense can help you eliminate the most obvious fakes.

Buying late-20th-century folk art is less risky. It doesn't (yet) have a cadre of forgers. You can find it in specialized gal-

leries and art fairs, but finding it on your own is more fun. Self-trained artists work in every region of the country. You never know what you'll find—or where. This is one of the few areas where you really can find treasures at yard sales for $5. Some now-valuable folk art pieces were even discovered in trash bins.

Once folk artists are discovered by dealers and curators, prices for their work go up. A few Outsider folk artists —especially the late Henry Darger—have garnered all the trappings of traditional art world success: museum shows, reviews in the *New York Times,* and five-figure price tags on their art. Collectors are willing to pay more for work that has the art world's seal of approval because it seems like a good investment.

Folk art that you find off the beaten path may or may not become valuable. You probably shouldn't think of it as an investment. Even so, 20th-century folk art is a great field to buy in because prices are relatively low. You could build a fabulous collection for the price of a single modernist painting.

Religious Art

With a few exceptions—such as Chagall's biblical art— religious works from the 19th and 20th centuries have a hard time finding buyers. Many collectors are uncomfortable making a religious statement in their living rooms. If you're not, your art budget will go further. For almost any artist from this period, a religious painting will be less expensive than one with a secular subject.

Regional Art

From art history books, you might get the idea that, until World War II, artists of any merit lived in Paris and then they moved en masse to New York. Most of the major 19th- and 20th-century artists even frequented the same neighborhood cafés. Was anyone making art anywhere else? You bet.

Lots of artists from other countries went to Paris to study and then returned home. Others never left home in the first place. Wherever you live, you can find good art. Start with your local museum or historical society to find out who some of the top artists were in your region. If the government buildings have murals or statues, look to see who did them. Then look up the names on the Internet. Some regional artists you've never heard of may be popular with specialized collectors.

If you daydream about finding valuable art that other people have overlooked, regional art is probably your best bet. Because the artists aren't household names, sellers may not realize that the landscapes they inherited from Grandma Sadie are actually worth something.

Socialist Realism and WPA Art

In the 1930s, politically minded artists embraced Socialist Realism as a way to help change the world. Even artists who had dabbled in abstraction turned their talents to creating earnest, sometimes propagandistic, depictions of the proletariat.

Ironically, a lot of this art was sponsored by the United States government. During the Great Depression, the govern-

ment's WPA (Works Progress Administration) program employed artists from all over the country to decorate public buildings—perhaps to keep them too busy to foment revolution. Some of the most talented artists of the generation worked for the WPA, including Jackson Pollock and Willem DeKooning (until bureaucrats realized he wasn't a U.S. citizen). Nearly a quarter million artworks were sponsored by the WPA before the program ended during World War II.

When abstraction became the dominant movement in the art world, Socialist Realism fell thuddingly out of favor. Piles of WPA artworks languished in warehouses or were sold as scrap material. Urban legends sprang up about Jackson Pollock paintings found in building insulation.

Today, collectors have a renewed interest in art from this period. You can find WPA work all across the country. The problem is, some of it might not have clear title—in other words, the seller might not legally own it. Now that WPA art is more valuable, the government is starting to assert its ownership claims. Before you buy art that was commissioned by the WPA, check with the General Services Administration (www. gsa.gov) to make sure Uncle Sam doesn't want it back. The GSA website will have up-to-date information on the situation.

Underrepresented Artists

For most of the 19th and 20th centuries, artists who weren't white and male had a hard time getting formal recognition for their work. For example, one of Georgia O'Keeffe's art school peers brashly predicted that he would become a star

and she would end up teaching painting in a girl's school. That was how the system worked. In recent decades, though, curators and dealers began to appreciate the talent of "underrepresented" artists. Collectors now compete to buy the top African American, Latino, Caribbean, and female painters. Even so, a lot of excellent work is still affordable—and perhaps even undiscovered.

A Caveat About Art in Europe During World War II

If you buy original art that was in Europe during World War II, be especially vigilant about its ownership history.

"A gap in provenance between 1933 and 1945 is a red flag," says arts attorney Ronald Spencer, "because that's when Hitler was in power, and one of the first things he did was start seizing art collections owned by Jews. Everybody's aware of this now, but as recently as the 1970s I saw auction catalogs that listed as provenance one of the Nazi's major art dealers [who forced Jewish collectors to sell to him at below-market prices].

"In New York, the statute of limitations on Nazi seizures doesn't begin to run until the heirs of the original owners make a claim against the present possessor," says Spencer. "So even if a painting has been in a private collection for sixty years, the heirs could still make a claim, assuming they only now found the work's location and had made a reasonable effort in the past to try to locate the work."

Drawings

Many people overlook drawings, or they assume that drawings are what you buy if you can't afford paintings. Think again.

Drawings and sketches are among the most interesting works of art because they show you how the artist thought. In "study drawings" that were preparations for paintings, you can see the false starts or alternative versions. If you're interested in art history, drawings can become a fascinating, consuming hobby. Collectors who can afford to buy anything they want often specialize in drawings because of this sense of discovery.

Though work by the top names commands high prices, many drawings and sketches from the 19th and 20th centuries are still available for a few thousand dollars. Nineteenth-century art schools made all students master the art of drawing before allowing them to move on to painting, so many artists from this era drew exquisitely—even those you've never heard of before. Where have all these drawings gone? Works by lesser-known artists are still floating around auctions, specialized galleries, antique stores, and even the Paris flea markets.

If you want drawings by major artists, though, it's important to buy only from a reputable dealer or top auction house. If you can't afford to buy from a top source, don't get tempted to look elsewhere for bargains. Unvetted auctions, touristy galleries, and the Internet are dumping grounds for fakes.

Forged drawings can easily fool a nonexpert, because most of us tend to look only at the subject matter. We see a pastel of a ballet dancer and think "Degas," but we're not really *seeing*

the drawing itself. We're not seeing how it was constructed or what materials were used. (That's why some experts even suggest you examine drawings upside down, so you're not distracted by the image.)

The top dealers and auction house experts have spent years looking at drawings, and they see them in ways you and I don't. In many cases, they intuitively know the "hand" of an artist and can identify drawings without the benefit of a signature. This expertise takes years to develop and is well worth paying extra for.

Prints

Prints are cheaper than drawings and paintings, because the artist usually made multiple copies. Blue-chip 20th-century artists, whose paintings sell for millions of dollars at auction, made prints that sell for only a few thousand dollars at a reputable gallery. (We're talking about handmade prints produced by the artist, not machine-printed reproductions. See Chapter 4, "Prints," for more details.) For a relatively modest investment, you can build a fine collection.

But you have to be careful. Prints by 19th- and 20th-century artists are widely faked. The bigger the name, the bigger the problem. Daumier, Picasso, Chagall, Miro, and Warhol are among the forgers' favorites. The most notorious problem is with Salvador Dalí, who willingly signed innumerable blank sheets of paper that other people used to make prints. Some

experts estimate that half of all "Dalí" prints on the market are fakes.

Before I go casting aspersions, though, let me clarify that a print is only a forgery if it's intended to deceive. If someone has made a reproduction and sells it honestly for the price of a reproduction, that's perfectly legitimate. The problem arises when a reproduction is passed off as the real thing.

There are several types of copies, some of them better than others. For starters, prints can be made posthumously by re-using the artist's old plates. Regardless of whether these prints were authorized by the artist's estate, many connoisseurs don't consider them to be "by" the artist at all. From the connoisseur's standpoint, it's not enough for the artist to have made the plate; the artist must also have made the actual physical print—or overseen its printing—for it to be a true original.

This distinction may not influence how much you enjoy the print on your wall, but it will make a lot of difference later, if you ever try to sell. As long as you're paying a fair price and aren't expecting the print's appreciation to send your kids to college, it's fine to buy a posthumous print for your own enjoyment.

Lower down on the authenticity scale—or, more accurately, off the authenticity scale altogether—are prints that reproduce one of the artist's other works, such as a painting, a drawing, or even an original print. The artist had absolutely nothing to do with making these reproduction prints—not in making the plate, not in overseeing the printing. Amazingly, such copies get passed off as "original lithographs" all the time,

at absurdly high prices. Smooth-talking salespeople will tell you that they're "museum quality," and, actually, that's true: They're museum *shop* quality—in the same league as souvenir postcards and neckties with Egyptian cat motifs. They are nice decorations but not investments.

Before you buy any print by a famous-name artist, ask the dealer who made the print and when. Get the answer in writing, with a money-back guarantee.

Also check whether the print is in the artist's catalogue raisonné. (A good dealer ought to be able to provide you with this information.) If the catalogue raisonné says that this image existed only as a painting, you have a reproduction. If the artist made prints of this image himself, check to see what the identifying characteristics were. What size were the originals? Were they numbered and signed? Did the paper have a watermark? If the print you're looking at differs from the catalogue raisonné, walk away.

Of course, the best way to avoid trouble is to go to a good dealer in the first place. Members of the International Fine Print Dealers Association (www.ifpda.org) are top-notch. Other reputable dealers associations (see Resources) can recommend someone to you. For tips on how to evaluate dealers yourself, see Chapter 10, "Dealing with Dealers."

Sculpture

A sculpture can be a one-of-a-kind handmade piece or a multiple made from a mold. Sometimes the same sculpture can be

both—if, for example, an artist makes an original in marble, then later makes casts of it in bronze. As long as the artist made the sculpture, it's considered original, no matter how many copies he or she made.

When you're buying a sculpture, you go through the steps you take when you're buying any other type of art. If it's by a well-known artist, you want to see documentation that it's authentic. If it's supposed to be old, you want to see provenance.

You also need to understand the basics of how sculptures were made and what types of reproductions you might encounter.

Bronze Statues

Bronze statues are casts made by pouring hot metal into a mold and letting it harden. Sometimes the molds are reused to make multiple copies; other times the artist uses a lost-wax technique that destroys the mold after one use, so the resulting statue is one of a kind. A good art history book can tell you which technique your artist used.

Bronze statues are popular with collectors but can be tricky to buy. There are several different types of bronzes on the market:

1. Original casts made by the artist.
2. Recasts from original molds, often made after the artist's death. If an artist is extremely famous, assistants or foundry workers may have made spurious casts from the original mold during the artist's lifetime.

Authentication boards can render these statues worthless.

3. New casts made by creating a new mold from an authentic sculpture. These usually don't have the same sharp detail as the original.

4. Replicas made by someone else with the intention to deceive. If you compare them with known originals, they won't be exactly like the original in every detail.

5. Honest reproductions. These usually have a stamp, signature, or other indication that they're reproductions.

See why I tell you to buy from reputable dealers? Statues that look "just alike" can have wildly different values, depending on when they were made and by whom.

If you're trying to evaluate a well-known artist's bronze on your own, check an art history book—or the catalogue raisonné if one exists—to find out how many examples were made and what telltale marks to look for, such as foundry stamps (they look sort of like the indentation you get when you use a wax seal on a letter). Sometimes fakes aren't exact in every detail. In addition, if you're offered a numbered bronze, see if the catalogue raisonné mentions ownership. If you find that the real bronze with that number is in, say, the Amon Carter Museum in Fort Worth, you know you're being offered a fake. A specialist dealer or auction house will usually have references available for you to peruse. Otherwise, you'll need to go to a library.

Provenance—the ownership history—can help you ferret

out a piece that was made posthumously. A truly old piece has to have been somewhere all those years. Sometimes people really do find treasures in attics—a rediscovered Brancusi sculpture recently sold for over $27 million at Christie's—but as we've discussed, most undocumented "bargains" are likely to be copies.

Frederic Remington, for example, is one of the most popular 19th-century sculptors and also one of the most commonly forged. You can find "his" bronzes in huckster galleries and on the Internet selling for a few thousand dollars. Most, if not all of them, are fakes. Here are the telltale signs:

★ Authentic Remingtons have a foundry stamp on the bottom. Some fakes do too, but most don't have the authentic stamp. The Frederic Remington Art Museum notes that many fakes have been mounted on marble bases, perhaps to help conceal the lack of foundry mark. (The museum website, www.fredericremington.org, has excellent information about judging authenticity.)

★ The sculpture should be a piece that Remington actually made. Sounds obvious, right? An astonishing number of fake Remington aren't even reproductions of his work. They're completely new sculptures made in the same style. A few seconds with a catalogue raisonné will ferret them out.

★ According to the Remington Museum, the numbers on the base of his authentic statues aren't fractions. The first sculpture in a series was simply number 1, not 1/100. Fakes

often use the fraction system common to limited editions, perhaps to convince buyers of the rarity of the piece.

★ Genuine Remington bronzes sell for tens of thousands of dollars—and usually at top auction houses or galleries. If you find a "bargain" Remington over the Internet or in an out-of-the-way place, it's likely to be fake.

Just to make things more complicated, many "bronzes" aren't really bronze at all. They're made of a metal called spelter, a popular, low-cost alternative to bronze from the mid-19th century through the Art Deco era. It is also referred to as "French bronze" or "spelter bronze," but don't be fooled by the name. Spelter is zinc that was treated to look like bronze, and it's less valuable.

How can you tell the difference? Turn the piece over and—with the dealer's permission, of course—make a small scratch on the bottom of the piece. If it has a golden color underneath, it's bronze; if it's silvery, it's spelter.

Marble Statues

In the 19th century, a neoclassical craze influenced everything from architecture to ladies' dresses. Sculptors, inspired by antiquity, created marble statues based on classical styles, and the public loved them. So popular were these statues and busts that many less-expensive substitutes began to be made for collectors who couldn't afford the real thing. Today, if you see a statue at a flea market or estate sale, you'll need to check

whether it's really an original marble sculpture or one of the many decorative copies.

A genuine piece is always hand carved and one of a kind. It's typically made from high-quality marble, and if you look closely, you can see the indications of chisel marks. Some of the genuinely old marble statues you'll find may be copies of ancient sculptures, carved by 19th-century art students to hone their craft. These statues may be considered artworks in their own right, and they are fine to buy as long as you don't mistake them for a more expensive antiquity.

Most of the look-alike copies you'll find, though, are casts made out of a plaster enhanced with marble dust. A "seam" along the sides of the statue is a dead giveaway that a mold was used. Also look on the back or the bottom for an embedded museum or commercial logo. That's proof that the statue started its life more recently as an honest reproduction.

If you have a good eye, you'll probably notice that marble plaster doesn't have the same luminous look as fine marble. You can train yourself to see this difference either by living with superb original sculptures or by buying a couple of inexpensive reproduction casts at a museum shop. When you see something every day, even peripherally, you start to internalize what it looks like. Once you get used to what the real thing—or the fake thing—looks like, you'll be less likely to confuse them.

Finally, be aware that some recent "neoclassical" statues are made from a real block of marble but are carved—believe it or not—by a computerized drill. These reproductions are usually made of cheap marble. You can probably spot them

merely by looking; we're talking about inexpensive statues made to decorate backyards and pizzerias. But the easiest way to identify a machine-made copy isn't connoisseurship—it's the Internet. These statues are produced en masse for commercial purposes. If you Google the name of the statue and find dozens of exact copies for sale, you can be sure that's what you're getting—a copy.

Late-20th-Century Sculptures

As sculpture became more minimal in the late 20th century, forgers were delighted. It was suddenly much easier to fake a famous sculpture. The average collector can't detect a fake by its materials or technique, because a forger can work in the same manner as the artist, with the same supplies. Just to make things more complicated, collectors with extremely valuable artworks sometimes keep their original art in a vault and display high-quality reproductions in their homes, for security and insurance reasons.

You have to depend on the reputation of the dealer and the quality of the documentation to evaluate late-20th-century sculptures. If the work is by a famous sculptor, has it been published in a catalogue raisonné, or has an authenticity board approved it? Ask for proof. Where has it been since it was made? You want a paper trail of provenance.

I know all this talk of forgery might give the impression that the art market is a dangerous, sinister place. Don't worry. You won't have to walk into a gallery with a checklist forever.

The major things you need to look for—such as authenticity and provenance—are always the same, no matter what type of art you're buying. Eventually, evaluating a work of art will become second nature. You'll start asking the right questions by reflex, the way you look both ways before crossing the street.

Determining a Fair Price

Let's say you've determined that a piece is authentic—or that it's a copy but you want to buy it anyway. What's a fair price? There are several ways to find out.

For starters, you could buy one of the annual price-guide books that list recent auction sales for thousands of different artists. These will give you only a ballpark idea, because some pieces by an artist are obviously better than others, but the books are still very helpful—especially if you're looking for art off the beaten path, in places where you have to make snap decisions.

Another way is to subscribe to one of the Internet services, such as Artnet, that give auction results as well as descriptions of the work. This is somewhat better than a price guide, because it gives you more detailed information.

If you're buying a multiple—such as a print or a bronze cast—you might also want to check the Internet to see if a different gallery or auction house is offering another example of the same thing. See what they're charging.

A generation ago, you would simply have had to take the seller's word. This wealth of information wasn't available to the casual collector. Take advantage of it!

When Your Taste Is Higher Than Your Budget

Suppose you have very high-end taste: The art you covet isn't in the local gallery; it's in the National Gallery. But your budget is strictly peanut gallery. That doesn't mean you're limited to framed Monet posters forever. You can still buy real art—art that you can both enjoy and afford.

Sometimes it's as easy as looking at which artists inspired each other. Maybe you can't own Van Gogh, but you can buy one of the Japanese prints that influenced his style. Prices start at about $100. If you love the Pre-Raphaelite painters, you'll probably like Belle Époque posters that were inspired by the Pre-Raphaelites and share many of the same design elements.

You can also appease your craving for high-end art by looking for less-expensive types of art from the same era. If you love Surrealist painting, for example, consider Surrealist photography, which has fewer zeros in the price tag.

Sometimes being priced out of one type of art can open your eyes to something you didn't know about—and like just as much.

Checklist for Buying 19th- and 20th-Century Art

If you're buying a piece by a famous artist, is it in the catalogue raisonné? A specialty dealer or auction house should be able to show you.

If it's a print by a famous artist, ask whether it was made by the artist or by someone else after the artist's death. Huckster dealers like to imply that posthumous prints and reproductions are original, but many will hesitate to lie outright if you ask knowledgeable questions. After all, you might be an undercover investigator. Always get the answer in writing, and with a money-back guarantee. Also see Chapter 10, "Dealing with Dealers," to help make sure you're buying from someone reputable.

Are you buying a widely forged artist, such as Dalí, Picasso, Miró, Warhol, or Chagall? With any famous-name work, you'll need more than the dealer's own certificate of authenticity. You'll want to see provenance. You'll want to see the work in a catalogue raisonné. If the artist has an authentication board, you'll want to see its seal of approval. If the seller balks, don't buy. Famous art without documentation is suspect.

If it's a bronze statue, have you made sure it's really bronze, not spelter? If it's by a well-known artist, such as Remington, have you compared it to the catalogue raisonné or an art history book? Did

the artist actually make it, or is it a posthumous cast or copy?

Does the deal sound too good to be true? Fishy stories about how the piece was found in Grandma's attic are a red flag. So are hardship stories about why the seller has to unload this "valuable" art for a fraction of what it's really worth.

Are you buying from a reputable dealer or auction house?

Do you love it?

REDISCOVERING 19TH-CENTURY ACADEMIC ART

NANCY HARRISON
Nancy Harrison, now a private art consultant in Manhattan, was Director of 19th-Century European Paintings, Drawings, and Sculpture at Sotheby's, New York.

▶ *You often recommend 19th-century Academic art for new collectors. Why?*

Academic art is really "the *other*" 19th century. It's not the Impressionists you studied in Art 101. It's hundreds of thousands of other artists who were painting diligently, not only in France but in other countries throughout Europe.

These well-crafted works were based on the rigorous French academic system—one that required an art stu-

dent to draw statues and live models for years before being allowed to put brush to canvas. This system also expected a familiarity with subject matter from the Bible and classical antiquity, as well as an emulation of the techniques and styles of the Old Masters.

These works, especially those with more readily accessible subject matters, often appeal to new collectors because it doesn't take a lot of art historical knowledge to recognize that a work is superbly painted and of good quality. Later on, collectors may want to branch out into other areas, but this is a place where many people start.

▶ *What kind of 19th-century art is still available for collectors who don't have museum-level budgets?*

You can get an enormous amount of work at the lower, less-expensive level. You won't be able to buy good examples by Corot or Courbet, but if you're careful about quality, you can still find some fine French paintings by secondary artists at reasonable prices.

Some of the other areas that I think are undervalued right now are 19th-century Scandinavian painting, as well as the work of the French realist school, which depicted humble peasants and interiors with an earthy palette and sympathy for their artistic predecessors, Chardin and Murillo. Works by some of the more subtle yet elegant Belle Époque artists are desirable and still readily affordable.

French plein air [out-of-door] sketches are also good value. A recent Christie's New York auction had a fine series of French oils on paper from the estate of John Gaines, a Kentucky collector with a keen eye, abundant pocketbook, and zeal for Old Master and 19th-century

drawings. The oil sketches that appeared in this sale were real collector's pieces, culled with a connoisseur's eye, but they sold for only a few thousand dollars each. For someone who wanted to collect intelligently, something like that would be a good choice.

▸ *Are certain subjects more popular than others?*

Pretty women, sumptuous interiors, depictions of children at play, seascapes, boating parties, and anything highly finished and elegant does well. Paris street scenes, Italianate views, and scenes of Venice are consistently popular.

▸ *And animals too, right?*

Certain kinds of animals. There's a set of people who collect paintings of horses, or of racing, hunting scenes, and sporting dogs. These pictures appeal to the type of people who own horses—or want to. Pictures of cows are harder to sell. . . . Americans don't like to think of themselves as having peasant roots.

Religious scenes are also hard to sell. It's odd— Old Masters collectors buy religious works as a matter of course, but 19th-century collectors often want lighter subject matter. Often they are furnishing their homes and want art with decorative appeal.

▸ *How important is condition?*

Condition is paramount in 19th-century art. At the major auctions, things that are "tired" or in bad condition go unsold, so you have to consider resale value when you buy. But there's no reason to buy a piece that isn't in

good condition. I'd rather just pass and wait for the next sale. There was a huge proliferation of painting done in this time period, so you can really find many works in pristine state, often in original frames. It's worth waiting for "finds" like this from estates and old collections.

▶ *What about forgeries? Is that a problem with Academic art?*

It's one that exists in every field of art. Certainly it happened in the 19th century. Remember, these artists were wildly popular in their lifetimes. They're not household names here necessarily, but in their home countries they were sometimes so well known that 19th-century and later art dealers were motivated to perpetrate fraud to increase sales—from the ubiquitous fake Corots that are legendary, to the garden-variety chromolithographic prints touched up to resemble original paintings or watercolors. These knockoffs were made and disseminated into the households of the burgeoning middle class at the time.

The reason you don't hear much about the problem is that forgeries get routinely rejected by specialists at the major auction houses and by knowledgeable dealers. There's a lot more expertise out there than there was when I was starting out at Sotheby's. Back then, for some of the lesser artists, you had to judge a work solely on the basis of your eye and experience. Now there are abundant experts who have devoted their lives to even the lesser-known artists, and comparative [sales price] data is readily available on the Internet.

▶ *So what happens to all the fakes? They must go some-where.*

The fakes end up in the secondary sales rooms or in country auctions, or being sold online. Sometimes these auctioneers don't have the expertise or time to research their lots, and the unsuspecting buyer can often be duped. It's often the case that people think they can "score" bargains armed with only cursory knowledge about the field or an artist.

▶ *I suspect many novice collectors go to these places because the big sales at Sotheby's and Christie's can be intimidating.*

There is "threshold anxiety" for many about going to one of the premier auction houses or dealers. It's a shame, because there are so many wonderful examples available at these sales, some quite affordable and most fully vetted. Extracting them from the big sales can, however, be overwhelming for the layman.

Before you go to the viewing, make notes in the catalog and refine your search to things in *your* price range. If you can, try to go back several times—you can't hope to absorb these big sales all at once. If something grabs you, see if it still does the second or third time. Then talk to one of the experts, or research comparable works on Artnet.com or another online resource. If a piece has been shopped around or has been in a prior sale, you might want to avoid it, unless the estimate was pegged too high the first time and it is more reasonably estimated now.

I advocate using the expertise of the auction houses

or the dealer. Ask them as many questions as you can before buying. The good news is that there aren't that many dealers who specialize exclusively in 19th-century art, so you can get to know most of them. If you're buying something expensive, hiring a consultant to guide you in the collecting process can be money well spent. There are a lot of "broken gavel" (former auction house) specialists out there who can give you sound advice.

▸ *How should new collectors develop their eye?*

Go to museums, the international art fairs, and both major and minor sales rooms and *look!* It's very important for a collector to see the "big" artists, to train your eye and know what constitutes real quality. Even if you can't buy the best that's out there, buy the best that *you* can afford, and stretch your budget if necessary to acquire the right work. It's better to have one good picture than a collection of mediocrity.

3

Photography

There's a saying in the art world that the best thing a collector can have isn't money or taste—it's a short memory. If you start remembering all the things you could have bought at bargain prices, you'll drive yourself crazy. This is probably truer in photography than any other field of art.

Photography used to be the neglected stepchild of the art world. Painting and sculpture got all the attention. If you wanted to see great photography, you'd have to seek it out in specialized galleries or in out-of-the-way museum corridors next to the bathrooms. In the early 1970s, a middle-class person could have assembled a world-class collection. Dealers were happy to get a few hundred dollars for photos that now cost six figures.

That doesn't mean it's too late to start collecting. Actually, now is a great time. Many of today's most interesting artists are choosing to work in photography rather than painting or sculpture. And not all vintage work has been absorbed by museums—yet.

Compared with other art forms, photography is still relatively inexpensive. Don't be scared off by the high prices at the top of the market. For a few hundred dollars, you can buy an original print by a contemporary photographer. For a few thousand, you still can find authentic photos by master photographers.

Choosing What to Collect

A photography collection is intensely personal in a way that a collection of abstract art probably isn't. It tells a lot about your personality and your interests.

Some collectors buy everything they can by their favorite photographers. Others collect by theme, seeking out pictures of Paris, sports, the Southwest, Hollywood stars, or some other subject that has personal meaning to them. Of course, you can also just buy pictures that appeal to you, without worrying about how they go together!

You probably already have some idea of what type of photography you like. Your home is full of reproduced photographs—on note cards, posters, and calendars, and maybe even fridge magnets.

That begs this question: Why pay for an original print

when you can get a copy for a couple of dollars? An original print is special. It's not only an investment—it also has aesthetic qualities you can't get from a reproduction. For example, the clarity and tonal subtleties in an original are hard to re-create. (I recently fell in love with a vintage André Kertész photo that I couldn't afford, so I bought a coffee table book about his work instead. Even though the book is by a top art publisher, the reprints don't have the same oomph.) Photographs created in a darkroom are made one at a time—often over days of trial and error. Each print has its own unique characteristics.

In the abstract, these differences may seem too subtle to matter. But the next time you're at a museum exhibit of photography, buy a few reproduction postcards in the gift shop and compare them with the originals. You'll instantly see why the originals are special.

What Makes a Photograph Valuable?

A great photograph is like jazz—you know it when you see it. One of the pluses of collecting photography is that you've already spent years developing your eye. The photography *market,* however, takes some effort to understand.

If you look at auction results or gallery prices, the market will look absolutely nutty. You may see a vintage photo selling for a six-figure sum, while another photo of the *same image*

is selling for only a few thousand dollars—or even a few hundred dollars. Why is that?

When we look a photograph, most of us notice only the image. When evaluating a photograph, connoisseurs look also at the physical qualities of the print: the paper, the printing process, and even which negative it was made from. They also pay careful attention to when the print was made, and by whom.

If you want to look at photographs like a connoisseur, here are the major things to look for.

★ *The Image*
(This is the easy part.) Is it beautiful or striking? Is it memorable? Does it have art historical importance?

★ *The Photographer*
If a photographer is famous or well regarded by connoisseurs, the price of the photograph tends to be higher.

★ *Rarity*
How many copies of a particular photograph exist? Because few people collected photography at the time, many early photographers made only a few copies. In many cases, nobody knows exactly how many copies were made. Today's photographers often intentionally limit the number of prints they make, because collectors want to feel they're getting something that will hold its value.

That doesn't mean that a rare print is "better" than a

more common one. It simply means that collectors have to compete to own a rare print, so the price goes up. Unless you take special pride in having something that other people can't get, rarity has no impact on how much you will actually enjoy the photo—just on how much you pay for it.

★ *Condition*

You obviously want your photograph to be in the best possible condition, with no rips, scratches, fading, or fold marks. But the importance of condition is relative. The older and rarer the photo is, the more collectors will allow for wear and tear. A contemporary photograph, however, should be pristine. You also need to consider future condition. Some printing processes—such as C-prints (high-quality, darkroom-produced color prints) and platinum prints—are more stable than others.

★ *When It Was Printed—and by Whom*

The key issue is whether the photographer made the print or at least supervised its printing. If someone else made the print without the photographer's involvement, it's worth less. From an authenticity standpoint, supervision is as good as physically dipping the paper into chemicals. Many contemporary photographers don't do their own printing, and neither did some early masters such as Henri Cartier-Bresson. The work is still considered authentic if they oversaw and approved the final print.

The next most important issue is when the print was made. Connoisseurs *strongly* prefer prints made soon after the picture was taken. You have to be very careful about the printing date when you're buying vintage photography. (I discuss this in more detail later in this chapter.)

⋆ *Subject Matter*
Beautiful or historically important subjects are worth more than others. Similarly, you pay a premium when you buy a photo of a popular icon. A blurry, tatty picture of Babe Ruth—if authentic—will still cost a bundle.

⋆ *Provenance*
Has the photograph been in documented collections? If it was in an important collection, you're buying the prestige of that collection, as well as the implied assurance that you're getting something authentically old. A photograph with no history may be a new copy.

⋆ *Materials*
Believe it or not, a photo's value is partly based on the paper it's printed on. When photographers make fine prints, they use the best paper available to get a desired result. But when they're making a quick proof, they may use lower-quality paper that doesn't produce as fine an image. That's one reason why proofs are worth less. Another reason is that, with proofs, photographers don't spend time trying to make the image look exactly right.

The printing process itself can also influence value. Among vintage photographs, platinum prints are prized for both their beauty and their stability.

★ Market Factors

When a contemporary photographer has a major museum show or is signed by a top gallery, the work often gets more expensive. The same is true when an influential curator or dealer takes an interest in an earlier, underappreciated photographer.

With vintage work, a forgery scandal can cause a market to tank as skittish collectors worry about authenticity. Recently, a huge number of Man Ray photographs were unmasked as fakes, and prices for Man Ray's photos dropped across the board.

If you're buying something for investment as well as pleasure, check Artnet (www.artnet.com) or another news source to see if the market for your photographer is undergoing a major change. (For a list of art publications and websites, see the Resources section.)

Vintage Photography

New collectors sometimes assume that a "vintage photograph" is an antique. It isn't. In this context, the term *vintage* means an older picture that was printed soon after the image was taken. You can have a vintage photograph from the 1890s or the 1960s.

Many of the most desirable vintage photographs were made in the early 20th century, when photography was still a relatively new art form. Photographs by early masters such as Man Ray, Atget, Steichen, and Weston are now in museums, but some of their work is still available—and even affordable.

As I'm writing this, the Museum of Modern Art is selling off its duplicate Eugene Atget photographs. You can't get a more distinguished provenance or photographer—or better proof of authenticity—yet several of these vintage photos are selling for as little as $3,000. "Our purpose is to sell within the existing market. We aren't trying to change the market," says Peter Galassi, MoMA's chief curator of photography. To set prices, the museum asked two leading photography dealers who knew the Atget market well to come in—independently of each other—and evaluate each photograph.

Why did the dealers give certain photographs $150,000 price tags, while valuing others at only a few thousand dollars? According to Galassi, the dealers considered several factors, including the photograph's attractiveness and its art historical importance: "When it's a beautiful view of a park that *also* has art historical importance, it's worth more. Rarity is also a factor. If you have all three, that knocks the price up a notch— or a whole string of notches."

The dealers also evaluated the quality and condition of the photographs. "A richer and more artistically successful print," says Galassi, "is more valuable than one that isn't as rich—or one that has faded or discolored."

Later Prints

Sometimes a "vintage photograph" is affordable because it isn't really vintage. Technically, only prints made within a few years of the original photo shoot are considered vintage. Anything printed after that is considered a "later print." You'll find lots of them on the market.

For much of the 20th century, photographers simply reprinted an image whenever somebody wanted to buy it— even decades after the original photo was taken. Ansel Adams, for example, printed his famous *Moonrise* more than a thousand times over thirty years, until he decided he wouldn't make any more.

Thousands of dollars can hinge on when a photo was printed. Connoisseurs strongly prefer vintage work, which they feel has special intrinsic qualities. (For a discussion of this topic, see my interview with Robert Klein at the end of the chapter.) Because of this preference, "later prints" usually cost substantially less. That's why it's still possible to afford the work of many top photographers—especially if they made large numbers of later prints.

There's nothing wrong with buying a later print. It's still authentic; it's made from the original negative; and it's printed or approved by the photographer. Indeed, some collectors

think the distinction between early and later prints is silly—
or a venal attempt to manipulate market prices. They happily
snap up later photos at low prices.

Later prints are really a problem only if they're sold as more-
expensive vintage prints, so that you overpay. When you're
buying something from the early 20th century, signs of genu-
ine age may be evident in the print itself. Things to look for
include:

★ *Vintage paper*
In the mid- to late 1950s, paper manufacturers introduced
optical brighteners to their papers. It's the same chemistry
as laundry detergent that brightens your clothes. If you
shine a black light on a photograph made after the mid-
1950s, the paper glows, similar to the way a white shirt
glows under a black light in a nightclub. Paper that doesn't
have the brighteners absorbs the light and looks dull. That
means that if you find a photograph supposedly made be-
fore 1950, but it glows under a black light, it is almost cer-
tainly a later print.

Reputable photography dealers will happily black-light
a vintage image for you, as will the top auction houses. If
you're looking for photography from less lofty sources, you
might want to invest in your own handheld black light. You
can get one at hardware stores or Radio Shack for about $15.

★ *Silvering*
Many vintage black-and-white photos were made with
a process called silver gelatin (the image is formed by

microscopic bits of silver held together by a gelatin). Over time, the silver may oxidize. If you look at the photo at an angle, the silver seems to be "on the surface." You won't see silvering in every vintage photograph, but when you see it, it's a good indication that the photo is genuinely old.

Posthumous Prints

When a photographer dies, his or her negatives live on. Heirs sometimes allow professional printers to continue making photographs from the negatives. (If you believe nasty art world gossip, some heirs even try to pass them off as originals.) Connoisseurs don't consider posthumous photographs to be "real" examples of the photographer's work, but many collectors buy them anyway. After all, the prints are made from the original negative, and they're usually well produced.

They're also much less expensive. Some cost only a few hundred dollars (though prices for certain photographers are sky high, even for posthumous prints). If this is the only way you can afford a picture you love, then go ahead and buy it. Just don't expect it to be a lucrative investment. The important thing is not to mistake one of these prints for a more valuable original. The difference is often thousands of dollars. Posthumous photos usually have some type of estate stamp or other indication that they're posthumous. The words "authorized edition" are another clue.

Reproductions and Fakes

Well-known images—like Man Ray's *Tears* and Steichen's *Flatiron Building*—have been widely reproduced. Museum shops and art book publishers have printed thousands of high-quality copies. Even though these copies were never intended to deceive, they can still turn up on eBay or at a flea market posing as the real thing. How can you tell the difference?

First of all, check to see if it's really a photograph! Most reproductions weren't printed one-by-one in a darkroom; they were mass-produced on a printing press. If you look through a magnifying glass, the reproductions will have regular rows of tiny dots. To see what I mean, look at any magazine cover under a magnifying glass. You'll see a distinct dot pattern making up the image. That's what you *don't* want to see in a "vintage photograph."

Another dead giveaway is a copyright notice on the front or back of the picture, with the words "by permission of" the photographer or a museum. No photographer needs permission to print his or her own work!

Some reproductions, though, are actual photographs. They're made from duplicates of the original negative or by photographing the original picture and then printing a photo of the photo. A copy made for honest purposes will often have a stamp on the back or other indication that it's a reproduction. A scurrilous print won't. If someone offers you a photo that seems too good to be true, take a close look at the following:

★ *Clarity of the image*

A photo made from an original negative is crisp and sharp. With pictures made from duplicate negatives or photos of photos, the image will be fuzzier. Some of the detail will be lost.

★ *Provenance*

A photograph that's decades old has to have been some-where all this time. If it was "found in an attic" last week, it may have been *printed* in an attic last week.

★ *Authentic paper*

A catalogue raisonné can tell you if the original paper had a watermark or some other identifying characteristic.

Contemporary Photography

At the top contemporary art galleries, you'll see photography as often as you see painting or sculpture. It's an exciting time to start collecting, because so many talented people are work-ing in the medium. We've come a long way from the days when skeptics would ask, "But is it Art?"

Only, we haven't exactly . . .

Today there's a major distinction—don't laugh—between classically trained photographers and "artists who make photo-graphs." The self-described artists don't consider themselves the heirs of early photographers like Stieglitz or Weston. Their

inspirations and influences are entirely different, and they show their work in art galleries, not photography galleries. They may even work in other media as well. For them, photography isn't a calling; it's just a tool they use to express their artistic vision.

"This division started to happen in the mid-1980s, with the whole school of artists—like Richard Prince, Cindy Sherman, Sherrie Levine, and others—who were using photography," says Chicago dealer Catherine Edelman. "They came onto the scene via painting dealers and don't align themselves with photography galleries. Some of them aren't schooled in photography and have someone else operate the camera."

What does this mean for the collector? Plenty. The contemporary art market is white hot right now. Prices for artists who use photography may be substantially higher, and more speculative, than prices for equally talented, traditionally trained photographers.

Conservation is also an issue. Photographers are trained to think about the longevity of their work. Artists using photography aren't. In the past two decades, digital printing technology allowed artists to make large-scale color prints without ever setting foot in a darkroom. Some of the prints from the 1980s already have serious conservation problems.

Fortunately, the newer papers and inks for digital printing appear to be stable and long lasting. Today, artists and traditional photographers alike are making digital prints.

"They look just like C-prints [high-quality color darkroom prints]," says Edelman, who trained as a photographer

and whose gallery specializes in contemporary photography. "For my clients, digital prints aren't an issue at all."

Limited Editions

We all know that rarity can make a work of art more valuable, but with contemporary photography, genuine rarity is, well, rare. Before digital technology and ink-jet printing, the number of photographs was limited by how many a photographer could—or would—make in the darkroom. Now photographers can make an infinite number of identical copies.

But fortunately, they don't. Most contemporary photographers self-impose a limit on the number of copies they make. They sign and number their prints the way an artist might sign and number a lithograph.

Limited editions are increasingly important to photography collectors. Theoretically, nothing stops an unscrupulous printer from making hundreds of knockoffs. The photographer's signature and numbering—as well as the dealer's reputation—are your protection against unauthorized reproductions.

That doesn't mean, however, that the photographer will never print *another* edition of the same photo. Some do—often in a different size or with other slight variations. The idea behind multiple editions comes from the rare-book market, where a first edition is more valuable than a second edition, and so on. Ask the dealer if the photographer has made other editions of this print or plans to. If so, you may not be getting as "limited" an edition as you think.

Is It a Good Investment?

With vintage photography, you already know how big the market is for a particular photographer; his or her popularity is already built into the price. You can also look back at old sales records and see how good an investment a photographer has been over the years, although, as stock brokers caution, past performance is no guarantee of future returns.

With contemporary work, you're on your own. You may love a particular photo, but its monetary value in the future depends on whether *other* people will love it too.

Most dealers caution collectors never to buy solely for investment, and they're right. Still, when you're forking over $3,000 for a picture, you naturally want to know what you're getting yourself into. If you're trying to guess the market potential for a contemporary photographer, you'll need to look at more than whether his or her pictures are good. Here are some other things to consider:

1. Does the photographer have a dealer? If so, how important is the gallery? A top dealer helps create a market for the work.
2. Has the photographer's work ever been sold in the secondary (auction) market? If so, for how much? (You can check this on the Internet—see Resources for details.) Auction prices are a better indicator of resale value than the dealer's price.
3. Has the photographer won a major award or been

featured in a prestigious exhibition? If these accomplishments are recent, his or her career may be on the rise.

4. Have the photographer's pictures been published or reviewed in important magazines or newspapers?

5. Does the photographer seem savvy about marketing and promoting the work?

It's fairly easy to find the answers. Galleries and art shows usually have copies of the artist's CV and press clippings that you can review. Don't be shy about asking for them.

But don't buy something just because the photographer or artist has "buzz." You're the one who's going to live with the art.

Not everything you like will be a good investment, and not every good investment will be something you like. Try to resist the temptation to buy mediocre pictures by famous names. Chances are, if you buy photographs that really captivate you, they'll have the same effect on someone else later, if you want to resell.

CHECKLIST FOR BUYING VINTAGE PHOTOGRAPHY

Who is the photographer, and how important is he or she to the history of photography?

Did the photographer print this image or supervise its printing? If not, it's not considered in the same category as the photographer's own work.

What kind of print is it? A high-quality print made for an exhibition, or a quick-and-dirty proof made on flimsy paper?

Is the image sharp and well detailed? Reproductions may look "fuzzy."

When was the picture printed? For a piece to be "vintage," it must have been printed within a few years after the negative was made. "Later" pieces usually sell for less, even though they may be of very good quality.

Is it in good condition?

Who owned it before you? Can the dealer account for where it's been all those years? If not, it may be a later copy. Insist on seeing other proof that the picture is genuinely old.

When you shine a black light on the photo, does it glow? If it does, that's a sign that it was printed later than the mid-1950s.

Checklist for Buying Contemporary Photography

Is the image fresh and compelling? Does it stay
with you?

If the photo is in color, how long does the dealer
estimate it will last before it starts to fade? New
prints will probably be long lasting. The projected
longevity of color prints from the 1980s and 1990s
depends on whether the photographer/artist was
concerned with it. Quality C-prints are expected to
last one hundred years or more. Primitive ink-jet
prints may have problems after only twenty-five.

Is this a limited edition? If so, is it signed and
numbered? And is it the *only* limited edition of this
image? If not, is it the first edition or a later one?
When multiple editions exist, the earlier ones are,
in theory, more valuable.

Does the photographer seem to be on a good career
track? Indications include having a reputable dealer,
winning awards, and being included in major
exhibitions. (Career track is relevant only in
determining investment potential and how much to
pay. If you spark to the work of an unknown
photographer and the pictures are inexpensive, by
all means go ahead and buy!)

Do you love it?

WHAT MAKES A PHOTOGRAPH VALUABLE?

ROBERT KLEIN
Boston dealer Robert Klein is President of the Association of International Photography Art Dealers (AIPAD).

▸ *Why are vintage prints so much more valuable than later prints of the same image made from the same negative?*

There are two main arguments for why that's the case. The first is craft, technology, and materials. A photographer is knowledgeable about the particular paper available, and he may calibrate the exposure and development of his negative according to how that paper will print. If years later that paper is unavailable, it's not as well matched.

The second reason is psychological or creative energy—which is a bit more of an abstract idea. Creating a photograph, or a painting or other work of art, takes inspiration to create a fully realized result.

Some photographers will say, "Hey, I'm better now technically than I ever was," but they would rarely want to sell their old prints for the same price as they're charging for the new ones. Even before photographers knew vintage photographs were going to be valuable, deep down they must have known they were special.

▸ *What about contemporary photographers who use professionals to print for them?*

In the early days of photography, the photographers were the master printers, because there was no industry.

Some photographers today believe that professional printers have much better equipped darkrooms and are more skilled than they are. But they oversee the process.

An image will go through multiple drafts before the photographer says, "Yes, that's what I wanted." Their interpretation is going to be different from the printer's in terms of shadow, detail, and contrast, and that's critical. In this case, the printer is the extension of the photographer's hands and eyes.

▶ *Some photographers sign and number their prints, and others don't. Can you explain why—and whether it matters?*

The issue of [limited] editions is generational. Photography permits unlimited reproductions, and some early photographers felt that the medium should be utilized to make photographs that many people could buy. Exclusivity was not a concern.

As photographers started identifying themselves as artists, some got more ambitious. To give an example, Edward Weston felt that by numbering his photographs, people would feel that there was a rarity to them. He decided fifty was a reasonable number for an edition and started numbering his prints 1/50 and so on. This gives you the impression that there are fifty prints made. The problem was, he never printed fifty. He never printed more than about fifteen!

Later photographers—people who are in their sixties now, like Bruce Davidson and Elliot Erwitt—thought the idea of a limited edition was fictional. They said, "We don't work like lithographers, printing an entire edition in two days. We print our photographs one at a time." So they didn't number their prints.

Younger photographers today do sign and number their prints. The pressure to do that comes from the market.

Collectors have embraced photographs as limited-edition works of art.

So what a collector encounters is really a hodgepodge. That's why a new collector really benefits from an experienced dealer, who can explain the relative importance of signatures and edition numbers on various photographs.

▸ *Why does the type of printing process affect the price so much? For example, why is a platinum print more expensive than a silver gelatin print?*

From connoisseurship standards, it's more beautiful. A platinum print is capable of rendering a broader grayscale—there's much longer gradation from black to white. Platinum prints involve brushing a mixture of platinum and palladium chemistry onto a fine watercolor paper in order to create the light-sensitive emulsion. The result is a tactile quality, which gives you a sense that the photo *is* the paper. It's a little like the sense that you get from a watercolor, where the paint penetrates the paper and the paper is an important part of the surface of the painting. Also, platinum prints are more stable.

If money is no barrier to your acquisition ambitions, then you really want the best example of the earliest print—with no visible scratches, repairs, or defects—on the best paper you can find.

▸ *How big a difference does paper make?*

A proof that a photographer made to give a printer for reproduction might be on single-weight, glossy paper, called a ferrotype. These pictures look like the glossy promotional photos movie studios used to send out of

movie stars. If a vintage platinum print costs $100,000, a ferrotype of the same image might be $25,000 or even $7,000.

Again, the guidance of an experienced dealer is invaluable in explaining the relative values of different papers on which a given photograph might be printed.

▶*What do you think about posthumous prints that are authorized by a photographer's estate?*

With very few exceptions, I don't sell posthumous prints. Back when I started, it was hard enough to convince people that photographs were valuable. You couldn't say that a photo was $30,000 because the photographer was dead and wouldn't be making any more, and then say that the estate had printed a version for $900.

Diane Arbus is the exception. Her work has the biggest impact on the market—initially because there were so few vintage prints, and she cut her life short. Now even posthumous prints go for over $100,000.

I started showing Diane Arbus in 1982 for $350 each. The most I ever got from her work was maybe $5,000, which seemed extraordinary at the time. I wish I had kept some of them for myself!

▶*Do you think that—with the art market so high—the photography market still has room to grow?*

Yes. It seems to be nonstop.

4

Prints

Warning: Many otherwise level-headed people have become utterly addicted to print collecting. It starts innocently. A couple casually buys a print and hangs it on the wall. It looks lonely there all by itself, so they find another print by the same artist, or of the same subject, to keep it company. That looks better. Then they see a third one . . . Before you know it, they're trying to assemble a comprehensive collection of botanical orchid prints, Edvard Munch woodcuts, or Victorian fashion illustrations. If their enthusiasm is unchecked by financial constraints, soon they're running out of wall space and storing prints in boxes under the bed. Museum directors start inviting them to lunch. Don't say you weren't warned!

Prints are the most popularly collected of all art forms—

and perhaps the most confusing. The word *print* is used very broadly—encompassing everything from Old Masters to *Dogs Playing Poker.* In everyday speech, we even use it to describe a machine-printed reproduction. Let's get our terms straight right now.

In the legitimate art market, *print* never means a modern reproduction. It means either a "fine art print" or a "vintage popular print."

A fine art print is one made personally by the artist—whether you're talking about Rembrandt, Picasso, or a kid just out of art school. The artist doesn't draw directly on the paper, however. Instead, he or she creates the design on another surface—the "matrix"—which is then inked and pressed to paper. The inking step may be done either by the artist or by a master printer supervised by the artist. If the result is successful, the artist approves the print. That's what makes a fine art print authentic: the artist's hands-on involvement from start to finish.

Popular prints—which were originally intended as inexpensive decorations for middle-class homes—were produced somewhat differently and have different standards of authenticity. Though they used many of the same printmaking techniques, artists for popular prints rarely had the same oversight role as those who made fine art prints. Instead, the publishers—such as Currier and Ives, to use a famous example—were the masterminds, often dictating the subject matter. In many instances, an artist produced only the illustration; the publisher hired other people to make the plate,

print the sheets, and color the images. Even so, popular prints are still considered authentic if they are from the original print run(s). Many of them have become quite valuable.

How Prints Are Made

Over the centuries, artists have used dozens of different techniques. For example, an artist may carve a design in a block of wood (a woodcut), etch it in a metal plate (an etching), or draw it on a stone using a waxy water-resistant crayon (a lithograph).

Explaining what each type of print looks like would take an entire book, and several excellent ones have already been written. If you're interested in knowing the difference between an intaglio and a mezzotint, see the Resources section for a list of easy-to-understand references. The International Fine Print Dealers Association also has definitions and descriptions on their website. (If you're a new collector, the IFPDA website, www.ifpda.org, should be your first stop. Membership in the association is vetted and highly selective, so you can trust these dealers to sell you the real thing.)

From an average collector's standpoint, it doesn't really matter which technique an artist used. A woodcut isn't inherently "better" than an etching, or vice versa. What matters is that the print is authentic—not a modern reproduction— and that the method used was successful for expressing the artist's vision.

Older Fine Art Prints

For hundreds of years, artists have made original fine art prints. And for almost as long, other people have made copies of them. There are several types of copies you may encounter. Some are valuable in their own right, but others aren't.

Posthumous Prints

Many of the affordable prints by famous artists on the market are posthumous—made after the artist's death. When a major artist, such as Rembrandt, died, his assistants often continued to print from his old printing plates. These "later prints" can be mere ghosts of the originals, because as a printing plate wears out, its detail is lost. To sharpen the image, printers frequently recarved the plate, to the point that little was left of the original. That's one of the reasons later prints are less valuable.

Another, more recent type of posthumous print is the "authorized edition." In the past century, several artists' heirs have allowed publishers to produce "limited editions" of posthumous prints. Sometimes these are even signed by an heir, to give them marketing cachet as a "signed print." They're very popular with middle-class buyers who want a big name on their wall but can't afford an original.

Be wary, though. Although posthumous prints may sell for several thousand dollars, they're not necessarily good investments. Many connoisseurs don't even consider posthumous prints to be authentic. In their view, the artist must have not

only created the image but also overseen the actual, physical print. (See my interview with David Tunick at the end of the chapter for a discussion of this topic.) The price difference between a print made by the artist and the same image printed by someone else can be thousands of dollars. Always ask who made the print and when, and get it in writing.

Antique Copies

For centuries, other artists have made their own versions of the most famous prints. If these copies are themselves old, you could easily mistake them for originals.

Some of-the-period copies were made by artists who glued an original print onto a block of wood and hand-carved a new printing block. How can you spot one of these prints? You'll need to compare it with a known original. (Since you probably won't have an original version handy, as museum curators do, use a good art history book.) This type of copy will be a mirror image of the original because the plate was carved "backwards."

Other artists simply drew a new version of the original print, freehand, onto a printing block. Their prints look "just like" the originals at first glance, but if you compare them under a magnifying glass, you'll see subtle differences. Look at a minor detail of the print—one that the artist would not have labored over. Backgrounds, draperies, and other small details are often different. Also, if the later artist used a different printing technique, the copy will look different under magnification—and sometimes even to the naked eye.

What is tricky for novice collectors is that experts consider these antique copies to be authentic prints in their own right. Reputable dealers and auction houses will sell them, with no intention to deceive. Be sure you know what you're buying so that you don't overbid at auction—or get disappointed later when you find out that a perfectly good (and perhaps even valuable) print isn't what you thought it was. Always ask the seller who made it, and when.

The Print Council of America maintains a public website (www.printcouncil.org) that tells you whether there is a catalogue raisonné for your artist. Some catalogues raisonnés include information about copies and forgeries. You can usually find a catalogue raisonné—or at least a good art history book about the artist—at a large public library or a university library.

Modern Reproductions

Antique prints are in the public domain, so anyone can legally reproduce them. Some reproductions are of high quality, particularly the ones that were made for art books. Serious forgers use authentic methods and materials to try to fool you, but most modern copies weren't intended to deceive. Nonetheless, you may see them on eBay or at flea markets mistakenly described as the real thing. Here's what to look out for:

★ *Offset lithographs*

Offset lithographs cause no end of trouble for novice collectors. For starters, the name sounds like a type of original handmade print, but it's not. An *offset* lithograph (as opposed to a regular lithograph, chromolithograph, or "stone" lithograph) is a mass-produced, machine-printed copy. The fact that this is the same printing technique used to produce *People* magazine should give you an idea of exactly how rare and valuable offset prints are. Unscrupulous sellers sometimes try to pass them off as "original lithographs," so be careful!

Always look at the print through a magnifying glass first. In a color offset lithograph, you'll see tiny dots in cyan blue, yellow, magenta, and black organized in a rigid, evenly spaced grid (exactly the way a magazine cover looks under the magnifying glass). A black-and-white offset lithograph is harder to detect, because several engraving techniques use patterns of tiny dots to shade the image. The key difference is that the dots in handmade prints typically follow the shape of the image, whereas in a machine-printed copy, the dots are in uniform straight lines all across the page. If you can't tell the difference, ask for other proofs of age and authenticity before buying.

★ *Photocopies*

At first glance, high-quality photocopies can look like authentic black-and-white prints—especially if they're printed on old paper. Budget decorators use the Xerox-as-art technique all the time, sometimes even putting copies

in old frames, so don't get too excited when you see valuable-looking prints at flea markets or garage sales. Look at the print under a magnifying glass. A photocopier copies more than the image. It also copies the little flecks of dust that have accumulated on the glass of the machine.

Some of the newer, more sophisticated printing technologies make it hard for novices to recognize reproductions. But if you always make a point of looking for the characteristics a genuine print is supposed to have, you can detect the difference. For example, an authentic print may have an indentation around the image from where the printing plate pressed against the paper, but a machine-printed reproduction won't. Similarly, if the catalogue raisonné says the paper of the original print has a watermark, look for one on the new piece. Unless you're dealing with a very crafty forger, the paper will be different. Another potential giveaway is reduced or enlarged size. If a piece is well known, check an art history book or the Internet to find out how large the original is supposed to be. Finally, a sure-fire way to tell a modern copy is by the copyright information underneath the image. Whenever you see the words "courtesy of," "from the collection of," or "by permission of," you're looking at a modern copy.

Contemporary Fine Art Prints

Contemporary prints are an affordable way to buy artists who may otherwise be out of your price range. Someone whose

paintings sell for $1 million might make an original print that sells for $1,000. That doesn't mean that prints are second-rate. Some artists even prefer printmaking to painting. What makes prints less expensive is that multiple copies are produced.

Prints are also an inexpensive way to take a chance on new, undiscovered artists without investing huge sums of money. At one of the Affordable Art Fairs (see Resources) and many art shows, you can buy prints by emerging artists for as little as $100.

Contemporary prints are also easy to collect. You don't need a lot of specialized knowledge and, with very few exceptions, you don't have to worry about fakes.

Limited Editions

In olden times, artists kept making prints until the plates wore out. Today most artists decide in advance how many copies they're going to make—whether just one (a "mono-print") or several hundred. Whenever there is a predetermined limit to the number of prints made, you're looking at a limited edition.

Why do limited editions matter? The rarer something is, the more collectors have to compete for it—which means they'll have to pay more. All else being equal, a print from a small edition will cost more than one from a larger edition.

When print runs are finished, contemporary artists usually destroy or "cancel" their printing plates to make sure no one can ever make more copies. They do so to preserve their market and protect their collectors. The contemporary artist

James Grashow once devised a unique method for canceling an old printing block. When I visited his studio, he was using one of his most painstakingly detailed woodcuts as a dog gate to keep his Jack Russell terrier out of his studio. With all the canine scratches, that block was certainly never going to be used again!

You can tell how big an edition is by looking for a fraction written at the base of the print. The bottom number in the fraction is the total number of prints. The top number tells you which copy this particular print is. In other words, if you see 39/100, that means you are looking at the thirty-ninth print in an edition of one hundred.

Some collectors mistakenly believe that having a low number in a limited edition is better—that 3/50 is more valuable than 49/50. It's not. This prejudice probably comes from the market for antique prints. Back when artists kept making prints until the plates wore out, the later prints lacked most of the fine details and were definitely inferior. That's not an issue here.

Limited editions aren't entirely trouble-free, though. There may be more copies of a print floating around than you think. Artists usually make a few additional prints for their own use. These are called "artist proofs" and are marked "A.P." to indicate that they're not part of the numbered series. It's a standard practice and rarely an issue for collectors. Occasionally an artist abuses this practice and makes large numbers of A.P. copies to sell. If a dealer offers you a new A.P. print, ask how he happens to have it for sale—and how many other A.P.s there are.

Some artists—or more typically heirs of artists—may make more than one "edition" of the same image. Erte's Art Deco prints are the most notorious example. (Erte is dead, but the prints are made posthumously.) Let's say you're interested in an Erte print with a green background. The dealer tells you it's part of an edition of one hundred copies. You'd be forgiven for thinking that only one hundred copies of this image existed. Alas, no. The very same image might also have been printed in different editions with a red background, a blue background, a gold background, a black background . . . Instead of one hundred copies, there might be several times that many.

In some states, the dealer is required by law to tell you how many copies exist. In other places, you're on your own. Always ask—and get it in writing.

This doesn't mean, however, that you should dismiss a print you love just because the artist made a lot of copies. The size of the edition has absolutely no bearing on how good a print is—only on how much it ought to cost, and on how valuable it will become in the future. As long as you pay a fair price, you can buy whatever you like.

Giclee Prints

A relatively recent technology called *giclee* sprays ink onto paper to create high-quality prints. It's similar to a desktop ink-jet printer but much more sophisticated.

You have to be careful about authenticity when buying a giclee print. If a contemporary artist made the print from a

digital image that he or she created, it's original art. If someone else scanned one of the artist's paintings or drawings to create a giclee, that's a reproduction. (If the artist died before digital printing technology was invented, you know for sure the giclee print is a reproduction.) Always ask the seller who made the print and how. Many original giclees are signed and numbered and may even have hand-drawn elements to make them unique.

Authenticity Concerns with Contemporary Prints

If you're buying directly from the artist or the artist's own dealer, you have no authenticity problems—though you'll want to keep the original sales receipt so *you* can prove authenticity later. If you're buying a piece that has been previously owned, use sensible precautions. If the artist is famous, you'll want a paper trail of sales receipts back to the artist's original dealer. If you can't get them, check with the artist's dealer to make sure the work is authentic. Even the "latest" artist can be forged.

Vintage Popular Prints

Ever since printing became economical, publishers have produced inexpensive "popular" prints for people who couldn't afford paintings but wanted something artistic to decorate their homes. Today, prints that once hung in modest surroundings can be worth hundreds or even thousands of dollars.

A good dealer is your best bet for authentic antique prints. Original owners didn't expect these prints to become valuable, so you won't find the kind of documentation and provenance you'd get with a fine art print. What's more, the most popular prints have been widely reproduced. Dealers roll their eyes when they hear stories about how someone found an original Redouté at a garage sale.

If you see famous popular prints at the neighborhood flea market, don't get your hopes up. You can eliminate many modern reproductions on your own, by knowing what to look for.

Currier and Ives

Currier and Ives prints are famous for their sentimental and historic scenes of 19th-century America. Contrary to popular belief, Currier and Ives weren't artists themselves. They were printers who hired artists to create thousands of different prints. At the time, these prints were intended for common households and were often sold by pushcart vendors on the street for a few coins. Today, the small ones sell for hundreds of dollars, and the large ones can cost several thousand.

The value of an individual print largely depends on its subject matter. Americana and sailing ships are particularly popular, so prices for them are higher than for many other types of scenes.

Because Currier and Ives prints are so popular, they're widely reproduced—and have been for decades. That means you can find reproductions that look genuinely old but aren't authentic. How can you tell the difference?

Most genuine Currier and Ives prints were hand-colored (though a few were printed with chromolithography). There are several ways to tell if you're looking at a hand-colored print: For starters, the paper surface looks different where the color was applied. If you hold an authentic Currier and Ives at an angle under a light, the colored areas look duller than the paper. Another way to tell is to use a magnifying glass. Hand-painted color rarely stays perfectly within the black outlines. Third, most reproductions are printed with offset lithography, which, as we've discussed, has telltale, regularly spaced dots of blue, black, magenta, and yellow under a magnifying glass. Beware, though. Some high-quality 20th-century reproductions are hand-painted too. That's where a reputable dealer comes in handy.

You can also tell a lot by reading the fine print. Most Currier and Ives prints include the title of the piece, along with the name and address of the firm underneath the image. (The company had several addresses, on Nassau, Fulton, and Spruce Streets in New York.) You can look up the individual print in an art history book or on the Internet to see what the original text said. If you see anything else printed underneath, such as "from the collection of" or "by permission of," you're looking at a reproduction.

Japanese Prints

Japanese prints have been popular in the West for more than a century. They were a strong influence on early modern painters—especially Van Gogh, who frequently used Japanese

motifs and painted Japanese prints in the background of his portraits. These prints, like Currier and Ives, were originally intended as inexpensive decoration for the common people. That's why an impecunious artist like Van Gogh could afford them. Today, Japanese prints are highly collectible but still affordable. For a discussion of Japanese prints, and why some are more valuable than others, see my interview with Carolyn Staley (*sidebar*).

The most famous Japanese prints have been commercially reproduced by means of offset lithography. Again, you can spot these copies by looking through a magnifying glass. Real Japanese prints never have the telltale dot pattern that an offset litho has.

THE ART OF JAPANESE PRINTS

CAROLYN STALEY
Carolyn Staley, whose eponymous Seattle gallery specializes in fine Japanese prints, is a member of the International Fine Print Dealers Association.

▶ *What determines the price of a Japanese print?* You can buy some types of prints with the cash in your wallet. Others are the price of a car or even the price of a house.

There is good quality at all price levels. You can get a small print for $50 or $100. It won't be by a famous artist, but you can still have a good print.

The specific image and its popularity is what usually determines price. Hokusai's famous image *The Great Wave,* for example, is very valuable. Even a late impression of it might be $100,000. If you found a fragment, with a chunk missing and its colors faded, it could still be $3,000.

Sometimes price is related to the artist. There are a handful—such as Hokusai, Utamaro, and Sharaku— whose works can be very expensive. If you found a really fine print by any of these, it could cost a quarter of a million dollars.

Printers also used special techniques with some of their earlier impressions, when the publisher was trying to develop a market for them. They might have polished the black area of the print (this is called a "lacquer print"), or they might have used special embossing techniques, or powdered metals like gold, silver, bronze, or copper. These prints are usually more expensive than other versions of the same image.

▶ *Gold and silver? I thought Japanese prints were an art form for the common people to buy inexpensively.*

Japanese prints *are* the art form of the general public. People who had little money to spend would have paid pennies for their prints—they were very cheap at the time. But some of the special-technique prints seem to have catered to a wealthier public.

▶ *When did the prints become popular outside of Japan?*

The West didn't have access to Japanese prints until the 1850s, when Admiral Perry forced Japan to open trade with the West. (It had been closed for two hundred

years.) Afterwards, Japanese objects were shown around the world at trade fairs—in Europe, Brazil, everywhere. These trade fairs were where Westerners saw Japanese prints for the first time, and many thousands of prints were taken out of Japan and purchased around the world. In Paris, artists saw them, and they became a big fad. The prints influenced almost everybody in modern art.

The world market for Japanese prints has grown a lot since then. Japanese collectors who often ignored this "low class" art form in the past are now trying to collect their own heritage.

▶ *Is there a simple way for a novice to understand the different categories of prints?*

There are two kinds of Japanese prints: the older, traditional ones and the later ones.

The older prints are called *Ukiyo-e,* or "floating world pictures." They were made at a time when the emperor had absolute authority. People had very little control over their own lives, so they lived for the day. You see this attitude in the subject matter: courtesans, theater, and kabuki. The prints of women show the most famous prostitutes of the day; their new hairstyles and fashions often became fads because of the prints.

At the turn of the 20th century, Japanese artists were exposed for the first time to what Western artists were doing. You start to see Western perspective in the prints, more abstraction, thicker lines, and bigger, heavier paper. Artists began doing every step of making their own prints, from creating their own designs to doing the carving and painting—although some artists have continued to work in

the traditional way, providing the design but using others [artisans] to carve the blocks and do the printing.

With the older prints, publishers didn't keep track of how many copies they printed, so we're not sure how many there really were of the older ones. They just printed a particularly popular design until the blocks wore out. In Japanese prints from this century, it's common to have a set number on an edition.

▸ *What advice would you give to someone who wants to collect Japanese prints but doesn't know how to get started?*

Find your area of interest. Some people collect prints of actors, landscapes, or beautiful women. Others collect birds or animals. Japanese war prints—from the country's wars with China and Russia—are also becoming collectible. Ten years ago you could get them for about $150, and now they're $500 to $750.

Always buy from a reputable dealer who will give you a money-back guarantee. From the 19th century on, people were making copies of the most popular prints, like *The Great Wave.*

Avoid prints with faded colors, tears, or holes, and don't buy prints that are all red and blue—a sign that the piece has lost its other colors. There isn't much market for a print that's in poor condition—sometimes there's no market at all. Always buy the best that you can afford, in whatever price range that is.

Prints from Rare Books

Many valuable prints began their lives as book illustrations. Curators and rare-book collectors bemoan the practice of cutting up antique volumes to sell the individual prints, because once a book is dismantled, it's nearly impossible to put back together. Never cut up an old book yourself, unless you're sure it's not valuable. When in doubt, check with a rare-book dealer before you take out your scissors.

In many cases, though, the prints were dismantled long ago. Your challenge is to find out which edition of the book the print is from. It makes a big difference in price. To give you an example, let's consider John James Audubon's *Birds of America*—one of the most popular illustrated rare books.

Birds of America illustrations are so popular that the Audubon Society is named after the artist. Originally bound in books intended for wealthy naturalists, many of these illustrations have since been sliced out for sale as individual prints.

At first glance, the prices for Audubon prints make no sense at all. Some sell for six figures, while other prints of the same image are only a few thousand dollars, or even a few hundred dollars. It all depends on which edition you have. Several different versions exist:

★ *First-edition "double elephant" prints*
These are the most valuable of all Audubon prints. Prices can go from a few thousand dollars to over $100,000, depending on the image. The pages are huge—about 39 inches by 26 inches—because Audubon wanted to show his birds

life-size. Prints of the largest birds take up nearly the entire page; a print of a tiny bird has a lot of white space around it (unless it's been trimmed).

These first-edition prints were hand-colored, so each one is unique. Just outside of the image, you should also be able to see and feel a ridge where the printing plate pressed against the paper, unless you're looking at one of the very large birds whose image went nearly to the edge of the paper.

The easiest way to identify a first-edition Audubon, though, is by the paper's watermark. If you see a "J. Whatman" watermark, you have the real thing.

★ *Second-edition "double elephant" prints*
The second edition of *Birds of America* was printed in the same large size as the first, but the images are chromolithographs, not hand-colored prints. They were made by Julius Bien, and they may have his name on them. Second-edition prints sell for several thousand dollars; the most desirable ones go for five figures. (This is merely a ballpark guide. Always check Artnet.com or a pricing guide for current figures.)

★ *"Octavo" prints*
Audubon also made a smaller, more affordable edition of *Birds of America*. His "octavo" prints are small—roughly the size of this book. These are substantially less expensive than the large-format prints. Later octavo versions may be

only a few hundred dollars and are readily available in the marketplace.

★ *Facsimile editions*
Because of the popularity of Audubon's *Birds of America,* certain publishers have made high-quality facsimiles of the prints. If you see a watermark for "G. Shut and Zonen Audubon" or the "Audubon Society Abbeville Press," you're looking at a high-quality facsimile. These prints have value in their own right but are nowhere near as valuable as originals.

★ *Modern reproductions*
As you can tell by visiting museum gift shops, Audubon prints have been widely copied for decorative prints and posters. These copies have no investment value. You can identify them in three key ways: Originals were printed on a dull matte paper, so if you're looking at glossy paper, it's a reproduction. Also, originals were made only in elephant folio and octavo sizes. Anything in between is a reproduction, unless a large original has been cut down. Finally, if you see wording such as "by permission of," you know you're looking at a modern copy.

Many other rare-book prints have multiple versions too. A good dealer can help explain what the differences are— both aesthetic and financial. If you're on your own, do some investigation on the Internet or in a reference book before you

buy anything expensive. As you can tell by the Audubon examples, prices of rare-book prints vary hugely between different editions.

Condition

With any print, condition is critical to determining its value. Serious collectors shun faded or damaged prints and hold out for prints in the best possible condition. You should too, whenever possible. With prints, you'll often have a chance to purchase a better version of the same image later on.

Experts always recommend taking a print out of its frame to examine it for problems. The most common issues you'll encounter are creases and folds, foxing (brown age spots), rips and tears, fading, and damage from nonarchival materials such as tape. Trimming a print to fit into a frame may constitute a condition problem, especially if the watermark was cut off, making it harder to establish authenticity.

"Problems like tears and punctures rate worse than staining, but there is no rating chart per se," says Jennifer Vorbach, former head of prints at Christie's. "How much it affects the value will depend on the scarcity and popularity of the print in the first place."

The other big issue is how easily the damage can be repaired, if at all. "A conservator can repair damage such as fresh creasing, fresh tears, losses in nonessential areas, and modest discoloration from paper aging," says print curator Marjorie Cohn of Harvard University's Fogg Museum. "The problem

is when a print requires treatment that would damage whatever was left of the original qualities of the print."

Try to avoid buying damaged prints. Fine art restoration can be expensive, and too much restoration can be as big a problem as poor condition.

Forming a Collection

Collecting—as opposed to casual buying—is very personal. The best collections are idiosyncratic and reflect the tastes of their owner. You should always collect whatever excites you. That said, you'll want to be careful about quality. Try to buy the best prints you can afford, in the best condition. Avoid the temptation to "fill in" your collection with lower-cost pieces that have something wrong with them. You'll be happier in the long run.

The best thing you can do when you're getting started is to develop relationships with good dealers. Even if they don't have what you want in inventory, dealers see huge numbers of prints and can often locate specific pieces for you, or even alert you if they find something they think you'll like. They can also recommend books and exhibitions to help you learn more.

Best of all, they understand what it feels like to be addicted to prints. Why do you think most of them became dealers?

Checklist for Buying Prints

How many copies were made? Is there more than one edition of this print? The greater the number of copies, the less collectors have to compete to own it. Comparable works with fewer copies will cost more.

If it's a fine art print, was it made or supervised by the artist? Many posthumous prints are on the market. Even if the artist's estate has approved or commissioned posthumous prints, connoisseurs don't consider them to be "by" the artist. These prints are not as valuable as those made by the artist in person.

If it's a print from a rare book, do you know for sure which edition it's from? The difference can mean thousands of dollars.

Is this work in a catalogue raisonné? If so, does the print you're looking at match what's in the catalogue raisonné in size, signature, watermark, and so on?

Have you checked a price guide or database to see what a fair price is? Remember, though, that dealers often charge a markup over auction house prices, and for good reason. They offer you more security than an auction purchase.

Have you taken the print out of its frame and examined it for condition problems, such as tears, fading, stains, and improper trimming?

Are you buying from a reputable source, such as a
 member of the International Fine Print Dealers
 Association?
Do you love it?

ADVICE FROM A MASTER PRINT DEALER

DAVID TUNICK
*David Tunick, a member of the Art Dealers Association of
America and the International Fine Print Dealers Associa-
tion, is a New York dealer specializing in fine works on paper.
His clients include major museums and private collectors
around the world.*

▸ *Can you explain why certain prints are considered better
or more valuable than other prints of the same image?*
 The short answer to your question is impression
quality. With prints, you have to compare impressions side
by side, because none of us can retain every subtlety in
our mind's eye. After forty-five years, I can tell right away
what's an early or a late impression. I can tell what's a
$2 million impression and what's a $20,000 impression
from the same plate. But I won't necessarily remember
the subtleties and details of a print in a certain museum
or private collection that make it better than another
print that's just become available.

▸ *The difference between $2 million and $20,000 is pretty
large! What accounts for that?*

I usually run through a series of criteria before I acquire a print. Here's what I appraise:

1. Who the artist is.
2. Is it real? We see lots of things that purport to be real but aren't.
3. The subject. Some subjects are more valuable than others. Religious subjects (even though we have lots of them by Old Masters) are not as easy to sell.
4. Size also has something to do with it. If a piece has what museum people call "wall power"—if it's a large image that looks very striking and pictorial hanging in a gallery—it will have more value than a tiny little print by the same artist.
5. Impression quality. This means not only how well it was printed but *when* it was printed. Was it printed by Rembrandt or Dürer himself? Or was it a posthumous printing using the artist's plates?
6. Condition. As you go back in time, there's more and more that we allow for in the way of defects. After all, these are pieces of paper we're talking about. Impressions that were kept in folios and libraries—not on the wall—may be in quite good condition. You must also check for restoration, which impacts enormously on value.
7. Provenance. What really matters is the art, but if a print has been in a great collection, that adds glamour and makes it easier to sell.

Those are the primary things I consider.

▶ *How much difference does it make whether an artist printed a piece himself, or whether a printer did it?*

It's night and day! If an artist didn't print it himself, I don't consider it his work. Much of what's for sale at auction houses—or at Las Vegas and Rodeo Drive–type galleries*—isn't done by the artist. Salvador Dalís sold on cruise ships aren't done by the artist.

As soon as Rembrandt died, a *huge* industry sprang up using his old plates. Those prints show up all the time. I suspect there may even be an original Rembrandt plate or two in Paris that someone is still printing from.

To be fair, the top auction houses' catalogs will say that something is a "later impression" (that's their code word for one of these prints). But they don't use the words "posthumous" or "printed off the worn-out plates," which they should do in the interests of full disclosure.

▶ *How widespread is the problem?*

If people go to the top sources, there's no problem. The difficulty is when people shop for bargains, or get carried away on vacation at tourist art gallery venues or at church and temple sales.

Somebody once tried to sell me a Picasso that he'd paid $65,000 for at a gallery on Rodeo Drive—one of

Author's note: Huckster dealers like to set up shop in areas with tourists and upscale shoppers, so Las Vegas and Beverly Hills' Rodeo Drive are prime real estate. This does not mean, however, that all dealers there are bad. For example, the Pace-Wildenstein Gallery has a presence in Las Vegas, and it's one of the most prestigious names in the art world. You have to judge by the gallery, not the address.

those places that come with gilt-edged certificates of authenticity. The picture was real—it wasn't a fake—but he'd been taken to the cleaners! I showed him in the sales records that other examples of the print had sold for $12,000 to $18,000 over the past ten years. He ended up selling it for $8,000 because he needed money right away.

▶ *How do you suggest would-be collectors educate themselves? Do you recommend specializing in one particular area?*

Everyone thinks they have to specialize. Gosh, no!

Go to museums and look at the print and drawing galleries, just for fun. The big museums—like the Met, Boston, Philadelphia, Cleveland, Detroit, Chicago, the National Gallery, etc.—almost always have prints on display. Sometimes it's major work; sometimes it's minor. The shows are usually revolving.

If you do decide you want to specialize, call your local museum and ask if you can come in and look at material in the print room, where they store their prints. Tell them you want to look at the Toulouse-Lautrecs or the Picassos or the Della Bellas—whatever it is you're interested in.

▶ *Really? You can just call them up?*

Some places will ask you if you're a graduate student or a scholar. Just say no, that you're a collector and you're just getting started. They're usually very welcoming to people who are interested in collecting. Among the major museums, Chicago, Philadelphia, the National Gallery, and the New York Public Library are especially friendly.

▸*And how about the top galleries? You say that collectors should go to top dealers, but aren't most people too intimidated to go to a gallery like yours, which sells Rembrandts to major museums?*

I think most people probably are intimidated, but they shouldn't be. We have an inventory of two thousand to three thousand items, many of which sell for only a few thousand dollars. We don't advertise it, but we also have a box of prints that are about $50 each. We call it our "Student Box," but actually the curators comb through it hoping we've made a mistake!

We do have a reputation for being absolutely high-end—that's our clientele. But we also try to be welcoming to collectors with modest budgets and to students, because I remember when I was young and had no money and felt unwelcome in galleries. I try never to do that in my own gallery.

5

Vintage Posters

If you're one of those skeptics who question whether posters are Real Art, spend about five minutes in a good vintage poster gallery. You'll want to start collecting them yourself. Posters have "wall power"—the ability to grab and hold your attention. For more than a century, top artists have turned their talents to this art form. You can find an enormous range of styles and subjects, from elaborate Belle Époque masterpieces to streamlined Art Deco ads to funky psychedelic rock posters.

A "vintage poster" is, by definition, an advertisement. No matter how beautiful or decorative it is in its own right, a vintage poster was made to advertise something—whether that something was a nightclub, a war bond subscription, a horror

movie, or shoe polish. Alphonse Mucha's landmark 1894 poster of Sarah Bernhardt, for example, may have launched the Art Nouveau movement, but it was commissioned to advertise a play. Vintage posters weren't art for art's sake.

Even so, they have long appealed to collectors. Posters have already had two major collecting "crazes"—one in the 1890s and another that began in the late 1970s and is still going on.

Compared with other art forms, vintage posters are quite affordable. Many vintage posters sell for a few hundred to a few thousand dollars. If you have deeper pockets, you can still find many of the most desirable posters ever made. They're not all in museums—yet.

The best part about collecting posters is that it's easy to do. Fakes are relatively rare, and condition is graded according to uniform standards, so you can compare the price of a poster against previous sales of the same piece. As long as you buy from a reputable dealer—such as a member of the International Vintage Poster Dealers Association—you really can't go far wrong.

What Makes a Vintage Poster Valuable?

Why do some vintage posters sell for a few hundred dollars while others cost thousands? According to Jim Lapides, owner of the International Poster Gallery, the value of vintage posters is based on several factors:

1. *The quality of the image.* Nothing beats a great design. And if it is beautifully printed, all the better.

2. *Subject matter.* "Some subjects are more popular than others," says Lapides. "For example, things that go fast (cars, trains, and planes) are particularly popular with men."

3. *The artist.* Leading artists like Cheret, Toulouse-Lautrec, Steinlen, Cassandre, Dudovich, Loupot, Hohlwein, Cappiello, and Klutsis are very collectible.

4. *Rarity.* Posters obey the laws of supply and demand. The harder an image is to find, the more valuable it usually is.

5. *Condition.* It's logical that a poster in mint condition will generally be more valuable. But a rare poster even in fair condition might still be quite collectible.

"You have to weigh all the factors and use common sense," says Lapides. "The bottom line is that you should always assess value, but not get overly concerned with investment potential. You'll always do better buying what you love."

You have a lot of choices to fall in love with.

Belle Époque Posters

Some of the most sought-after posters were created in the 1890s in Paris. Artists such as Jules Cheret, Alphonse Mucha, and Henri de Toulouse-Lautrec made astonishingly beautiful

advertisements that elevated the poster to the status of fine art. Their designs launched a poster craze in Paris, with artists competing to create ever more sumptuous works. (For more on Belle Époque posters, see my interview with Jim Lapides at the end of the chapter.)

Some people might tell you that it's "too late" to start buying Belle Époque posters. Not true. Although prices have multiplied (you don't want to know how little they sold for in the 1970s), you can still find some examples for a few thousand dollars.

For smaller-scale budgets, there are also smaller-scale posters. During the first collecting craze, at the turn of the 20th century, artist Jules Cheret published a series of portfolios called "Masters of the Poster." It featured small-scale lithographs of the most appealing posters of his day, by all the top artists. These miniature posters are roughly 11-by-16 inches and are highly collectible. With prices starting at just a few hundred dollars apiece, they're a good option if your taste exceeds your budget.

Judging Authenticity

Deliberate fakes aren't a major problem in the Belle Époque poster market, with one notorious exception: Toulouse-Lautrec is widely forged. No one knows how many of "his" posters on the market are forgeries, but fakes turn up all the time. If you're interested in Toulouse-Lautrec, buying from a reputable dealer isn't just good advice—it's a necessity.

Don't be tempted by supposed bargains at auction. Many small auction houses don't vet their art; it's strictly caveat emptor. Even established auctioneers might not offer guarantees if you're buying in one of their lower-end sales. Always check the catalog. Unvetted auctions are a dumping ground for fakes. If you see a particularly tempting Toulouse-Lautrec poster at auction, call for backup. For a commission, many reputable dealers will evaluate the work and even bid on it for you if it passes muster.

The more common problem with Belle Époque posters is that they are widely copied. Commercial reproductions—the kind you can buy at your local frame store for $25—are everywhere. I've rarely been to a flea market where I didn't see one of them described as a "real vintage poster." Here's how to tell the difference:

* *Authentic paper*
 Belle Époque posters were typically printed on thin, inexpensive paper that was easy to plaster on walls. By now, most have been mounted on linen to help preserve them. (Others, unfortunately, have been dry-mounted on a hard surface, which reduces their life span.) If you see an unmounted "Belle Époque" poster printed on thick, shiny paper—the kind that modern posters are typically printed on—it's a reproduction.

* *Printing process*
 From 1890 through the 1930s, the most ambitious color posters were made with a printing process called stone

lithography, or chromolithography. Modern reproductions are made using a different (though similar-sounding) technique called *offset* lithography.

Look at the poster through a magnifying glass. If it's a machine-printed offset reproduction, you'll see a grid pattern of evenly spaced blue, yellow, magenta, and black dots—just like what you see if you look at the cover of a magazine through a magnifying glass.

★ *Size*

Vintage posters from the 1890s are often very large. If you find one that fits perfectly in a standard-size poster frame from Ikea, be cautious. You can usually look up a poster's original size in a reference book or on the Internet. A good gallery will have references on hand for you to check.

★ *The "too good to be true" test*

The most famous posters are the ones most widely copied. If you see a Steinlen *Chat Noir* or another well-known piece on eBay for a bargain price, the odds are very much against its being real.

Art Deco Posters

In the 1920s and '30s, artists throughout Europe adopted an elegant, streamlined "Art Deco" style. It's the same aesthetic you see in the Empire State Building and on the sets of old Fred Astaire movies. These posters—advertising everything

from steamships to absinthe—are extremely popular. Collectors pay a premium for well-known artists such as A. M. Cassandre, whose bold, innovative graphics helped define Art Deco style. But if you can't afford his work, don't worry. You can find attractive Art Deco posters by secondary and anonymous artists too.

Many Art Deco collectors buy posters according to theme. This drives up the prices for the most popular and prestigious subjects. All else being equal, a travel poster for the French Riviera will cost more than a poster for laundry detergent. If you have quirky or broad taste, you can find bargains.

Whatever your preference, it is important to determine that the poster is genuinely vintage. Hundreds of inexpensive Art Deco reproductions are for sale on the Internet, misleadingly advertised as "vintage posters." What the sellers really ought to say is that they're posters *of* vintage posters.

A misattribution (innocent or otherwise) can often be detected by following the guidelines for spotting a reproduction Belle Époque poster. Until the late 1930s, Art Deco posters were usually printed using the same chromolithography process.

Propaganda Posters

Some vintage posters weren't advertising cars or ocean liners; they were advertising patriotism. During both World Wars, governments on both sides used posters as propaganda tools. These posters delivered strong visceral messages, whether they

were vilifying the enemy, sentimentalizing the home front, or urging citizens to enlist or buy war bonds.

Propaganda posters were typically printed in large numbers, so prices are relatively low. You can still find good examples for a few hundred dollars, though the most popular images now go for thousands.

Design enthusiasts especially covet Soviet posters from the 1920s and early '30s. Influenced by the avant-garde Constructivist movement in art, these posters have strong, bold graphics and innovative photomontages. Although their purpose was to exhort Soviet workers to create a strong communist state, they are now starting to sell for *very* capitalist prices. If you find you like Constructivist posters, don't wait too long to start buying!

As recently as ten or twenty years ago, you could find vintage propaganda posters at yard sales, small-town flea markets, and other out-of-the-way places. Today, many of the best posters have been absorbed by museums and private collectors, and the supply is starting to dry up. A dealer or auction house is your best resource.

Some entrepreneurs are now reproducing the most popular propaganda posters for decorative purposes. You can usually tell a reproduction by its paper. Original propaganda posters were typically printed on thin, cheap paper. The point was to get the message out, not to create high-quality collectibles. With a war effort on, paper (like everything else) was in short supply. Today, nobody prints commercial posters on flimsy paper stock like that—customers would balk. Instead, reproductions are usually printed on heavy or glossy paper.

Movie Posters

Movie posters walk a fine line between art and memorabilia. Although some collectors buy them for their artistry, most people buy because they like the film or the genre—or because the star is, well, a star. Rare posters of classic movies can cost over $100,000 at auction, but you can find plenty of good posters with prices starting at a few hundred dollars. From sci-fi to surfer movies, there's something for every taste and budget.

Older posters, from before World War II, are quite rare—and expensive. At the time they were made, few people thought about collecting them as art. Movie studios required theater owners to return the posters so they could be used elsewhere. Then, when the movie's run was over, the studio simply discarded them. Early posters survived only if someone at the studio or theater decided to tuck them away as souvenirs.

For certain classic films of the 1930s, only a handful of original posters survive. That's why an original poster from the 1932 Boris Karloff flick *The Mummy* set the all-time auction record for a poster, at over $450,000. Sure, it had great art and a popular subject, but rarity was what sent the price into the stratosphere. Most of the other highest-priced movie posters are classics from the same era: *King Kong, Frankenstein,* and Fritz Lang's *Metropolis* have all fetched six figures at auction.

That doesn't mean you're out of luck if you like old movies. Many popular films were re-released decades later, and new posters were made to advertise them. Re-release posters cost much less the originals, because they aren't as rare. If *Gone*

with the Wind is your passion, a re-release is your chance to get an authentic poster of the movie without applying for a mortgage. You can often distinguish a re-release by a copyright date in the fine print.

You can also find posters for American movies from an unlikely source: Europe. "Until about fifteen years ago, collectors wanted American posters for American films. Now they want the most interesting artwork," says Robert Chisholm, co-proprietor of Manhattan's Chisholm Larsson Gallery.

"In the United States, movie studios controlled the look of the poster. It could be in a star's contract that his head had to take up a certain percent of the poster. In Europe, designers had more artistic freedom, since they weren't being dictated to by the studios. We think that Italian and Russian movie posters are a great opportunity for collectors—they're often more visually interesting, and rarer."

Posters for new movies are printed in large quantities and are less likely to become valuable—even if the movie is hugely popular. Chisholm advises collectors to look for unusual sizes: "We have just acquired some very large posters for *Batman Begins* that were made to go in the subways and bus stops. You have to have a connection to get these, since this format was never meant to be sold in a shop. Because they're rarer and unusual, they're more likely to increase in value."

"Movie posters are an enormous field," says Chisholm. Although rare posters can sell for tens of thousands of dollars, "a beginning collector can find a good movie poster for $100, with some good detective work."

Size and Condition of Movie Posters

Understanding the size of movie posters can be confusing. Many dealers don't give dimensions in their inventory lists. They'll call something a "three sheet" and expect you to know what that means. In the United States, the standard small poster—called a "one sheet" or "single sheet"—is roughly 27 inches by 41 inches or else 25 by 40. "Two-sheet," "three-sheet," and "four-sheet" posters are, respectively, approximately double, triple, and quadruple the size of a single sheet.

Until the 1980s, these posters were usually delivered to theaters folded, rather than rolled. It's fine for a vintage movie poster to show the original fold marks; that's not considered a condition flaw. Also, because vintage movie posters were actually used in theaters, some collectors make allowances for pushpin holes and tape marks, as long as they're not excessive and don't detract from the look of the poster.

Psychedelic and Rock Posters

Posters experienced a renaissance in the 1960s. Inspired by the counterculture, artists embraced the poster as a "nonbourgeois" art form that everybody could own. Milton Glaser's depiction of Bob Dylan with flowing, multicolored hair became an icon. In San Francisco, artists such as Rick Griffin, Stanley Mouse, and Alton Kelley created a new "psychedelic" style. Today, posters from this nonmaterialist era can sell for hundreds, even thousands, of dollars.

Because many original printing negatives still exist, you have to be very careful about buying "original" rock posters. Some of the most popular pieces have been reprinted in response to collector demand. These newer versions aren't as valuable as the originals. Honest reprints—second printings (or third printings, etc.)—typically have some indication that they were made later. Look at the fine print. It can mean the difference between a poster worth $500 and a poster worth $50.

Rarity is important in determining the price of a rock poster. You can make a rough guess about how rare a piece is by what it was used for. Posters that advertised individual concerts were usually printed in small quantities, because they were only used locally. Posters that promoted popular record albums may have been printed en masse and distributed to many different areas.

Of course, authenticity is *the* major factor in determining value for any poster. In the rock poster market, fakes are plentiful—especially on the Internet. We're not talking about honest misattributions here. We're talking about deliberate forgeries meant to deceive. An average buyer can't tell the difference, because the fakes may be printed the same way, on the same type of paper. Only buy from a reputable dealer or auction house, or from the original creator of the poster.

Open-Edition Posters

If you start shopping for high-quality posters, sooner or later you'll run into one that seems to have everything going for it:

a great image, a well-known artist, a popular subject, and mint condition. The seller can prove that it's absolutely authentic. Yet it's very inexpensive. Before you buy up the seller's entire supply as an investment, look back at Jim Lapides's list of what makes a vintage poster valuable. Something is missing: rarity.

Many established artists have made "open-edition posters." The phrase *open edition* means that the printer produced so many copies—usually thousands—that nobody kept an exact count. Because there are plenty to go around, prices stay relatively low, no matter how great the poster itself is.

Here's a good example: The organizers of the 1972 Olympics commissioned a group of international artists—including such notables as David Hockney and Oskar Kokoschka—to create promotional posters for the 1972 Munich Games. These posters are literally museum quality—they're on display right now in the Victoria & Albert Museum—and they advertise one of the most historically important Olympic Games. Knowing that Olympic posters are extremely popular with collectors, how much would you expect to pay for something like that?

Take a zero off your estimate. You can buy one of these posters for about $250 at a reputable gallery. The Munich organizers printed thousands, so you can usually find several for sale at any given time.

If you don't mind that other people have them too, open-edition posters offer you the chance to buy great art for an affordable price.

Judging Condition

As with any multiple, condition is key to determining value. If an individual poster isn't up to snuff, collectors can simply buy a different copy of the same image. That's why you'll often see wildly different prices for the "same" poster.

In a typical vintage poster gallery, condition is graded from A to F. Dealers use standard ratings so that they—and you—can legitimately compare a Cappiello "green devil" poster in one gallery with the same poster somewhere else. A poster in "A" condition is pristine; one in "B" condition might have minor folds or tears or some minor restoration; one in "C" condition has problems, such as fading, that detract from the overall look; a "D" condition piece has a lot of damage. Few dealers actually use an "F" designation, because they don't handle posters that are that far gone.

Other dealers may grade their posters by descriptive terms instead: "mint," "near-mint," "fine," "very fine," and so on. This is often the case with movie and rock posters. Always ask what the terms mean, because the hierarchy of terms can vary. In many instances, "good" condition may actually mean that the poster is in terrible shape!

When you're trying to judge condition for yourself, you have to weigh a variety of factors. Rips, creases, stains, and fading can be minor or major, depending on how much they detract from the overall look of the poster.

When you don't know what the poster originally looked like, it can be hard to tell how serious the problems are. If a poster is very faded but you still think it's attractive, ask the

dealer if you can see a picture of what the poster looks like in mint condition. (Galleries usually have reference books on hand. You could also look it up in the library, if the poster is well known.) When you see what you're missing, you may not want to settle for a faded piece after all. Or you might decide that, for the right price, the fading won't bother you that much. With some of the more sought-after artists, a poster that has something wrong with it may be all you can afford.

Be careful, though, if a poster looks *too* perfect. It may have been overrestored. The issue of overrestoration is hard for many new collectors to understand. You might think that if a conservator can make a poster look as good as new, why not do it? The answer is that if a conservator recolors the entire piece or makes other substantial changes, something of the original is lost; it's less authentic. Not everyone agrees with this aesthetic viewpoint, and you don't have to either. Just understand that a heavily restored poster is not as valuable as a pristine, untouched version.

Finally, you have to be concerned with *future* condition. Never dry-mount a poster. Doing so reduces its life span. A vintage poster needs to be framed with the same archival-quality materials you'd use to frame an antique print. That can get expensive, since many vintage posters are five feet high. Be prepared to spend several hundred dollars correctly framing a large poster (more, if you insist on an expensive frame). It's a necessary part of preserving your investment.

If you can't get your poster framed right away, ask the

dealer whether it should be stored flat or rolled. Then keep it someplace dry and climate controlled until you can get to the framer.

Finding a Reputable Seller

Here's the easy part: If you're looking for a reputable gallery, simply check the website of the International Vintage Poster Dealers Association (www.ivpda.com) to find one near you. If you're looking for a specific poster, you can e-mail the association, and they will forward your request to member dealers. Anyone who has what you're looking for will contact you. If your local dealer isn't in IVPDA or another vetted dealer's association, see Chapter 10, "Dealing with Dealers," for information on references and background checks.

And don't forget to look at auction houses. Most of the top houses have experts who specialize in vintage posters. You can sign up to receive e-mail alerts whenever a poster sale is about to take place. Or, for a fee, you can subscribe to the sales catalogs.

As long as you buy from a reputable source, your only real difficulty is deciding which posters you like best.

Checklist for Buying Posters

If the poster was supposedly printed in the 1930s or earlier, have you determined that it's not an offset reproduction? (See the Belle Époque section at the beginning of this chapter for how to tell.)

Is the paper appropriate? Many vintage posters were originally printed on cheap lightweight paper, not on the heavy, glossy stock publishers use for reproductions.

Does the size seem appropriate? If the poster fits conveniently in a commercially produced frame, it might be a reproduction. A dealer usually has reference books that tell what a poster's original size was. You can also look this information up on the Internet or at the library.

Is this the original version of this poster? Look for clues that a poster is a later print. Telltale signs include copyright symbols with later years or, in the case of movie posters, the letter "R" followed by a year.

How rare is the poster? Movie posters printed before 1940 are rare, but new ones are relatively common. With Belle Époque and Art Deco posters, rarity varies. Check Artnet.com or a price-guide book for a ballpark idea of what you should pay, or look online to see what other galleries are charging for the same poster. Propaganda posters usually had

large print runs. Open-edition posters had *huge*
print runs.

Are you buying from a dealer who's a member of the
International Vintage Poster Dealers Association or
some other reputable dealer organization? If not,
call one of these organizations and ask if they know
anything about the dealer. The world of vintage
posters is small. People tend to know who's good
and who's not.

Do you love it?

COLLECTING VINTAGE POSTERS

JIM LAPIDES
*Jim Lapides, owner of International Poster Gallery in Boston,
is one of the leading poster dealers in the United States.*

▸*Poster collecting started very suddenly in the 1890s. Why
is that?*

By 1890, Jules Cheret had perfected his "four stone"
printing process that could be used to inexpensively cre-
ate full-color posters as vibrant as paintings. The arrival
of color advertising changed the way the city looked. The
explosion of color turned the boulevards of Paris into an
art gallery. Suddenly posters became a huge craze.

Cheret was not only a great artist but a great mar-
keter. The girls in his posters selling bicycles, gas lamps,
and cabaret performances were so pretty that everyone

couldn't wait for the arrival of the next "Cherette." People were pulling them down with fresh glue still on them! Soon posters began to be sold in art galleries.

▶ *How expensive were they originally?*

The typical poster cost 2 to 5 francs at the time—not very much. What changed that was Toulouse-Lautrec's 1891 poster for the Moulin Rouge. It was immediately recognized as something special and sold for 25 francs— equivalent to the price of a fine men's suit.

Overnight, the artistry of *Moulin Rouge* turned posters into Art with a capital "A." Lautrec made one masterpiece after another, and many artists of the first rank—Bonnard, Villon, and others—were also commissioned to create posters. The artistic potential of posters was further revealed in Alphonse Mucha's [Sarah Bernhardt] poster in 1894, which ushered in the Art Nouveau movement. The poster craze quickly spread to major cities around the world.

The 1890s are thus called the "golden age" of the poster, but by around 1900, Lautrec was dead, Cheret had stopped making posters, and Mucha had emigrated. The movement lost much of its creative energy, and the craze died down early in the new century.

▶ *When did posters start becoming popular again?*

Beautiful posters continued to be made throughout the 20th century and were always collected, yet we didn't really see the development of a modern poster market until the late 1970s. But since then we've seen a doubling in value every five years. I keep thinking it will stop, but it doesn't.

people get involved in the field, because they're inexpensive and the image quality is often outstanding. We've seen price increases there too. The famous poster of Uncle Sam saying "I want you" cost about $1,000 in "A" condition ten years ago; now it's about ten times that, even though many thousands of them were printed. It just is much harder to find today, and the demand is greater than ever for the best images.

▶ *What other collecting areas are popular?*

The poster-collecting world has broadened enormously. We see interest in posters from every country and time period, while twenty-five years ago the focus was on the Belle Époque in France. We see strong interest in the posters of Italy, Switzerland, the Soviet Union, and the United States, to name a few. Art Nouveau and Art Deco, as well as avant-garde styles, all are popular today.

A lot of people collect by subject: food and beverage, travel, music, sports, etc. There is a poster for virtually every interest. Travel is an area that has exploded. The big collecting area used to be the great ocean liners, but ski posters have also become blue chip. That's because baby boomers around the globe now have ski homes and want something special to decorate them with. Skiing is very big.

Ten years ago, little after World War II was interesting to customers, but today that's changed. Now I see customers who can't afford the early masters but who relate to the 1950s and '60s for nostalgic reasons. In the same way, collectors who can't afford Cappiello can find equally clever images by post–World War II artists such as Herbert

▶ *Vintage posters are so popular now that there are many reproductions. Is there a problem with collectors mistaking copies for the real thing?*

Typically, fakes and reproductions are not a huge problem, at least for a dealer, because most of them are done badly. This will get a lot tougher for everyone as printing technologies improve in the coming years.

My biggest concern today is restoration. Restoration of tears, paper losses, and fading has improved enormously, so it's harder to tell whether a piece is really in mint condition or if it has been restored. Color is very critical for me. If you have to restore color, you're really repainting whole surfaces. In the Internet era, it is more important than ever to work with dealers you trust.

▶ *How much does condition affect price? What would be the difference between, say, a Toulouse-Lautrec poster in "A" condition and the same poster in "B" condition?*

This can be a substantial difference, especially with Lautrec. It might be worth two or more times as much, depending on the poster.

In general, though, people are becoming more relaxed about condition because they have to be. After all, these pieces are up to one hundred years old and getting harder to find in pristine shape. I should also note that in Europe, condition has always seemed to be less important than in the United States.

▶ *You also handle propaganda and military posters from the World Wars. How popular are they with collectors?*

War and propaganda posters are very often the way

Leupin and Raymond Savignac, at much lower cost, that speak to them.

Posters are very reflective of the collector's personality. We don't have many interior designers coming into our gallery, because it's hard for a decorator to know what someone's going to respond to. It's very personal. One of the most exciting things for me as a dealer is when I visit my customers' homes and see the posters they've bought over the years all together. They tell a story—their story. It never fails to knock me out.

6

Native American Art

Anthropologists began collecting tribal art in the early 20th century because they were afraid that traditions were dying out. In the case of Native American art, they may have been wrong. Today, hundreds of Indian artists continue to work in traditional forms or to expand on their traditions to create new, individualistic work. More Native American art is probably being made today than at any other time.

For a novice collector, contemporary Native American art is a good place to start. Not only is it beautiful—it's easy to collect. Although older tribal pieces have a special spiritual integrity, some collectors don't want the legal headaches that come with them. If you stick to contemporary work, you can buy pottery without worrying whether it was stolen from an

archaeological site, and you can buy feather work without fretting that it's made from the feathers of an illegal-to-own endangered species.

That doesn't mean anything goes. For contemporary art to be considered "authentic," it must have been made by an acknowledged member of a tribe. The U.S. government has stringent laws specifying who is allowed to call himself or herself a Native American artist. Anyone who fudges the truth faces fines and jail time. As an additional protection for collectors, the U.S. Department of the Interior issues a sticker marked "Indian Arts and Crafts Board," which certifies that the art was made by a Native American. Not all authentic art has the sticker, but when you see it, you can buy with confidence.

A major difference between antique and contemporary Native American art is the importance of the individual artist. For most older pieces, the artist is unknown, and no one minds. With newer art, however, the artist's reputation—including his or her prizes and museum exhibitions—determines the monetary value of the art. Ask to see background information on the artist, as you would in any contemporary art gallery.

Contemporary Inuit Art

Inuit art—sometimes called "Eskimo art"—has a thriving contemporary market, particularly in Canada. Many Inuit artists still carve traditional stone figures that depict life in the Arctic Circle. Others make prints with traditional imagery. Both types

of art are highly collectible. As with other 20th-century art, the price is largely determined by the reputation of the artist, his or her popularity with collectors, and recent auction prices.

Be aware, though, that not all contemporary "Inuit art" is genuine. Every souvenir store in Canada has piles of inexpensive knockoffs, and brazen sellers sometimes try to pass them off as the real thing. It's easy to tell real from fake if you know what to look for. Real Inuit art is one of a kind. If the seller has multiple identical figurines, you can be sure they're copies. Also, many reproductions are made from molded synthetic, not from genuine stone. Real stone feels cool to the touch. The synthetic material feels plastic-like.

In Canada, genuine Inuit art has an "Igloo" sticker from the Canadian government. It's a picture of an igloo with the words "Eskimo Art Esquimeau" underneath. When you see that sticker, you know you're getting the real thing.

Vintage Native American Art

Collectors seek out older Native American art because of its special combination of history and artistry. Pieces that are a hundred years old or older are usually quite rare and expensive, but work from the mid 20th century is still available and often within the means of an average collector. Not every vintage piece or "antique" is really antique, though. Modern fakes are plentiful—and very convincing at first glance.

"A lot of people fall into the 'it looks like' trap," says

Scottsdale, Arizona, dealer Steve Begner. "It looks like something they've seen in a book, so they think it must be real. That's not so. The fine details are very important."

Here are some guidelines for the most popular types of antique or vintage pieces.

Navajo Weavings

A Navajo blanket holds the record for the most expensive treasure ever uncovered on *Antiques Roadshow,* receiving an estimate of a half million dollars. Flat-woven Navajo rugs and blankets are among the most sought-after items of Native American art, but you don't have to sell your house to be able to afford one. Some 20th-century rugs are still available for a few thousand dollars. Be careful, though. Many of the "Navajo" rugs you see for sale are really fakes made in Mexico.

Here's how to tell the difference: Ordinary Mexican fakes aren't made using the Navajos' unique weaving techniques. In Navajo weaving, the warp—the base thread—is one continuous string, up to a half mile long, that loops back and forth. Because the Navajo warp doesn't have any "ends," a typical Navajo rug doesn't have fringes. (A few do, but fringes are rare.) The majority of Mexican fakes have fringes. Sometimes those fringes are tucked under and sewn with a hemstitch to look more authentic, but all you need to do is turn the rug over and look.

Fringes are also the telltale sign of Navajo-style rugs sold at home furnishing stores. These commercial rugs are made in large quantities in places such as India, Pakistan, and Ukraine.

They're not intended to deceive and usually are sold inexpensively, but someone might try to pass one off as the real thing on the Internet or at an out-of-the-way sale.

Recently, dealers in Native American art have noticed another type of fake coming onto the market, possibly from eastern Europe.

"In the past year I've seen seven or eight fakes with designs that come straight out of books," says Steve Begner. "I'm not talking about general patterns. One of them had a pattern with 1920s vintage cars in each corner. When you see that, clearly they're meant to deceive."

If you don't happen to have all the scholarly literature on Navajo rugs at your fingertips, you can identify these new fakes by their wool. The wool in early Navajo rugs is soft. Later, as different types of sheep were introduced to the West, the rugs became stiffer, more canvas-like. The new fakes, however, have scratchy wool—"almost like steel wool," says Begner. "When you run your hand over the fakes, it's almost painful." Real Navajo rugs never feel like that.

The simplest way to spot a fake is the too-good-to-be-true test. Are you buying something for a fraction of what it would cost at a top gallery or auction house? Why are you getting such a good deal? If you see an antique Navajo rug in pristine condition, ask yourself, "What are the chances of its having stayed in this condition?" Sometimes it happens, but not often.

If you can't afford to buy an antique Navajo rug at a reputable gallery, don't waste your money looking for a bargain. Just buy a new rug. "As many Navajo rugs are being made

today as at any time in the past," Begner says. "Many Navajos are still working in the traditional way, doing fantastic work."

Kachina Dolls

Kachina dolls are among the most popular of all Native American art forms. Traditionally, they were carved by members of the Kachina cult, a male secret society in the Hopi and Zuni cultures. Since women couldn't take part, the men carved Kachina dolls for the young girls in their family, to teach them about the different spirits. Antique Kachinas (from the early 20th century or before) are rare and highly prized by collectors. Not every old Kachina, however, was made by Native Americans.

"Kachinas became popular as folk art and were carved by a lot of people," says Arizona dealer John Hill. "There is a pamphlet called *How to Carve a Kachina*. Boy Scout troops used to make them. There's also a whole class of 'Route 66 Kachinas' that were sold to tourists for as little as fifty cents or a dollar. They're lathe-turned and cut on simple angles. You can see they were cut with a hand saw."

About thirty years ago, deliberate fakes of old Kachinas started entering the market, as Kachinas started becoming valuable. Experts can often unmask the fakes because the forgers mixed elements that don't traditionally go together.

"I've seen my share of fakes," says Delia Sullivan, an expert on Native American art for Christie's auction house. "I can usually tell by the photo. I was offered a fake last year. It was very gussied up, with a lot of necklaces and shells, and hair on

the forehead. It was just too much. Kachinas were made to give to children—they're not ostentatious. I couldn't believe that a Native American had carved this to give to a little girl."

Sullivan also pays close attention to the form of the doll—especially the feet, legs, and arms. "I want to see semicircular feet and slightly bent or straight legs. The arms should be carved shallowly—not apart from the body—unless it's a Zuni Kachina." In the Zuni tradition, arms are carved separately and attached to the body with some type of pin.

Other things to look for include natural pigments (as opposed to commercial paint), wear patterns consistent with the doll's having been used, and size. Most older Kachinas are small—typically about eight inches high.

Native Americans still make Kachinas—usually as artwork to be sold in galleries, rather than as dolls to instruct children. The older Kachinas were relatively simple. Newer Kachinas can be highly detailed and realistic, sometimes depicting the dancers in motion. The older Kachinas are more valuable because of their rarity and historical importance, but new Kachinas can be valuable in their own right.

Pottery

Old pottery may be beautiful, but whether it is legal to own depends on what it is and where it was found. If it came from a grave site, for example, you could have a problem. The U.S. government has passed laws against the sale of any artifacts excavated on public lands, as well as any ceremonial ob-

jects that are considered to belong to the entire tribe. (See my interview with Bruce Shackelford at the end of the chapter for more details.) Buy old pottery only from a reputable dealer or auction house. You want a seller who will give you a written, money-back guarantee that the work came from lawful sources.

With any type of Native American art, if the seller isn't a member of a major dealers association, such as the Antique Tribal Art Dealers Association (ATADA) or San Francisco Tribal (see the Resources section), make some phone calls to people who are. A fellow dealer may not come right out and say someone's a crook (the art world is far too polite), but if you hear hemming or hawing, something's wrong. If you insist on buying anyway, don't pay any more than you would for a new reproduction. That may be exactly what you're buying.

Northwest Coast Carvings

The tribes of the Northwest Coast are famous for their totem poles and imaginative masks. Fakes are not a major issue, but most of the best pieces have already been absorbed by museums and important private collections. When top pieces do become available, they're often very expensive. That doesn't mean that an average collector is priced out of the field altogether. You just have to be selective.

"We always recommend buying at the higher end of the quality scale," says Ontario dealer Donald Ellis. "A collector who has a few thousand dollars to spend shouldn't look at

masks or shamans' rattles. A quality [antique] mask is going to be six figures."

Instead of buying poor-quality work, Ellis recommends that these collectors look for carved ladles and wooden bowls, which were used ritually by Northwest Coast tribes and often have the same imaginative carving style as the major masks and statues. The very finest ladles are about $10,000, so someone with a few thousand dollars can still buy a good-quality piece.

"Buying the best you can afford today is almost always the best move," says Ellis. "I wouldn't recommend that anyone buy for purely investment reasons, but quality pieces are the easiest to market down the road if you need to."

Ellis also recommends buying from top sources, even if you have a modest budget. "Don't make bargain hunting your priority. You can only identify a bargain with experience. Whenever I buy something outside of my own field, I buy from top dealers."

Where to Buy

If you live in the Southwest, the question of where to buy Native American art is almost laughable. It's like asking where to find a bagel in New York. Scottsdale, Santa Fe, and several other southwestern cities are wall-to-wall galleries. You can even find contemporary Native American art being sold on the side of the road in tourist areas.

The Indian Arts and Crafts Association (www.iaca.com) holds two major exhibitions of contemporary tribal art every year, in different southwestern cities. All vendors at these shows are legitimate tribal artists or dealers dedicated to selling only authentic work, so you can buy with confidence.

The biggest, most prestigious Native American art show is the Santa Fe Indian Market, which draws 100,000 visitors every August. A panel of experts selects the contemporary artists, and competition is rigorous—it's like getting into Harvard. Merely being included in the Santa Fe Indian Market makes an artist's work more desirable to collectors. If the artist also wins a grant or a prize from the show, then prices can zoom up. You'll pay more at Indian Market than you might elsewhere, but you're making a relatively sound investment.

If you're among the six billion people who don't happen to live in the American Southwest, don't worry. You can find reputable dealers in many regions—particularly in the Pacific Northwest (for Northwest Coast art), the Dakotas, and major cities such as San Francisco, Toronto, and New York. To find a dealer near you, check the websites of the major dealers associations. In addition, the major auction houses, such as Christie's and Sotheby's, hold sales of important antique Native American art. *American Indian Art Magazine* is a good resource to find out about upcoming art shows and auctions.

Checklist for Buying Native American Art

Who is the seller? You want to buy from a good dealer who is a member of a major dealers association, or who has good references from people who are, or from a reputable auction house. Beware of too-good-to-be-true "bargains."

Is it legal to own? With antiques, you need to be sure the piece wasn't stolen from a grave site, found on federal land, or made with parts of an endangered species. A dealer should give you *written* assurances on all of these counts, with a money-back guarantee if there's a problem later.

If you're buying a Navajo rug, is it made of wool (not synthetic)? Is it woven in the traditional manner, with no fringes? Check to see that fringes haven't been tucked under and sewn to the bottom of the rug—that's a sign of a reproduction.

If you're buying an older piece of Native American art, does it show appropriate signs of wear? Sometimes older pieces are found in pristine condition, but they're often very expensive. If you see a bargain "antique" piece that looks "just like new," it actually might *be* new.

If you're buying contemporary art, is the artist an acknowledged member of a tribe? Proof of authenticity may include membership in the Indian Arts and Crafts Association or a Department of the

Interior sticker on the art. Ideally, you want the artist to belong to the tribe that created the art form (i.e., you want a Navajo artist for a Navajo weaving). If you're buying at a vetted art fair, such as the Santa Fe Indian Market or an IACA show, the organizers have already done the checking for you.
Do you love it?

THE TREASURE HUNT FOR NATIVE AMERICAN ART

BRUCE SHACKELFORD

Bruce Shackelford, an independent consultant on Native American art, is a regular appraiser on the television series Antiques Roadshow.

▸ *You've been on* Antiques Roadshow *for how long?*

Since the beginning, nine years ago. We're starting our tenth season. We're about to pass Seinfeld.

▸ *What kinds of "hidden treasure" have you found in that time?*

The most exciting times are when we find something very early—prior to the Civil War, or even before 1800. Sometimes people bring in a wooden piece, and they aren't sure what it is. They don't even realize it's Native American because there isn't much to compare it with. I've seen bowls mistaken for early American that were actually 18th-century *Native* American. When that happens,

it's very exciting, because it's rare. It's something we don't have a lot of.

The other finds are generally pottery and textiles. People may have things their grandparents bought on a vacation out West in the 1930s that turn out to be important. They thought the pieces were just souvenirs.

But I've also seen people buy weavings they thought were valuable just to be disappointed. "Navajo" weavings sell from $20 to $200,000. With the older pieces, it's hard to tell the age just by looking—it's not just a matter of pattern and color. We need do a spectrographic analysis and sometimes a twist analysis of the yarn. It turns into science. The analysis can make a difference of tens of thousands of dollars in the appraisal.

▸ *How can people be sure they're getting the real thing?*

If you're buying from a reputable person, it's not going to be a problem. A reputable dealer will give you a receipt and a money-back guarantee that you can return the piece if it doesn't check out. Someone selling fakes doesn't want it back.

▸ *How convincing are the fakes on the market?*

Oh, people do such incredible fakes! There are very skilled artisans out there. They're not all intending to deceive. Some of these artisans advertise in *American Indian Art,* and dealers take orders for their reproductions. But later, down the road, other people try to pass their work off as the real thing.

I once had "fakes" made for a museum exhibit I was curating about the Comanche tribe. The real thing would

have been too expensive, and we wanted stuff kids could touch, so we had everything made specially. We gave the artisans the specifications and the scale, and what they did looked just like the real thing. The beads were what you'd have found in 1860. The drums were made of authentic hides. The only nonauthentic thing was a goose feather painted to look like an eagle feather (because eagles are an endangered species). Some Comanches saw the exhibit and wanted to know where we'd gotten the stuff!

The top dealers have a standing order to get photos of everything these reproduction guys make. They don't want you to know that, but that's how good the reproductions are.

▶ *What about the legal issues of collecting? I understand that's complicated.*

It's a can of worms. Different agencies disagree about whether tribes can come after private collectors to reclaim stuff. Regulations about grave artifacts differ from state to state. In some states, it's county by county. At one time, *all* religious objects were taboo, including church rattles, which you could buy at gas stations in Oklahoma.

As of right now, there are certain things you can't buy. Prehistoric pottery recovered on federal lands is illegal. I won't fool with anything that's been dug up. If I'm buying pottery, I want to know where it comes from. And I want a receipt that says where, with the seller's name, so if the Feds ask me about it later, I can go back to the seller. That's the only way I buy.

It's also illegal to buy animals or birds on the

endangered species list. Anything with eagle feathers is a problem. I won't buy any sacred medicine, or anything with feathers, unless I know for sure what they are. You're on your own if you buy antique eagle or hawk feathers, or any protected songbird or animal species. There's a possibility you'll end up in court.

Also, some objects are considered to be owned by the tribe. For instance, if you have an altarpiece, that's owned by the tribe. Only the tribe can sell it.

The Zunis used to make these wooden figures that they would put in caves up in a cliff, and they'd leave them there to disintegrate. If you have one of these figures, it's obviously not disintegrated, so you know somebody must have taken it. Because these figures are owned by the tribe as a whole, it's stolen property.

▸ *Yikes. What can you buy without worrying about legal problems?*

Baskets. Rugs. Plains Indian beadwork is hardly ever a problem because the pieces were owned by individuals, hardly ever by clans or groups. (I do have a friend who was a member of a Prairie tribe and inherited the right to wear a magnificent beaded grizzly-bear-claw headdress. But he never even considered selling it. He would have lost his place in the tribe if he had.)

▸ *What about Kachinas? I've heard that they're okay to buy because they were created for private use, to teach children about the Hopi gods.*

Some larger Kachinas are considered "altar Kachinas" by the Hopi and Zuni people and might be a target

for being reclaimed, but most Kachinas are not a problem at all.

Again, if you're buying from a reputable dealer, it's not going to be a problem. The same is true if you're buying at the big auction houses—not the little country places that may be out of business tomorrow, but the big ones like Sotheby's, Skinner, Christie's, and Wes Cowan's Historic Americana auctions.

▶ *Can people still find good things in out-of-the-way places?*

You could go to the flea market and find a treasure, but it's even more possible that you'd get burned. The people who make money buying at fairs know a lot, and even they've been burned.

Years ago, I bought a beaded pipe bag at a fair thinking I could triple my money. A friend of mine wanted to buy it based on a photograph I'd sent him. (This was in the days before the Internet.) So I mailed it to him, but no check came. After a couple of weeks, he said there was something wrong with the piece. He said some of the beads on top had been made recently in Germany! It might just have been a repair, but I gave him back his money. Then I put the pipe bag away and forgot about it. Later I was looking at the portfolio of a reproduction artist and saw the exact same piece. I told him how I had ended up with it. He was surprised, and he said, "But my name was on the inside neck of it in indelible ink." And I said, "No, it wasn't." Someone had obviously taken an electronic erasing tool to it.

I also saw pieces at a Texas antique show recently, from a good dealer, and I happen to know these pieces were made fifteen years ago in England. At the price, it

wasn't a big deal—they weren't expensive. They looked great. But they weren't old.

That's why you need to buy from dealers who will give you your money back if they're wrong. Bargain hunting is very iffy.

▶ *What's the hardest part about collecting Native American art?*

How different the tribes are. I could study every day and still not know everything. Some people just assume the tribes are alike, but that's like saying a Viking and an Italian fisherman are alike. They're both in boats, but that's about it.

7

African Art

African art has boomed in the last few decades. Originally col-
lected as ethnographic curios, African masks and statues are
now recognized as sophisticated art. Even so, prices are lower
than for many other types of art. Big sales are still measured in
thousands, not millions, of dollars.

You may have a mental idea of what "African art" looks
like, but it's actually incredibly diverse. Traditional African
artists carved wooden masks and statues in dozens of dis-
tinct visual styles. Some tribes also produced bronzes, ivory
carvings, rock paintings, stone sculptures, or goldwork. And
that's not even counting decorative arts, such as pottery and
textiles.

While the aesthetic is different from Western sculpture,

many collectors feel a natural affinity for African art. After all, it inspired scores of modern artists (including Picasso, Gauguin, and Matisse) in the way African music influenced jazz and rock and roll. And it's never been more popular.

Tribal Versus Tourist Art

Here's the major thing you need to know about buying African art: Collectors make a *huge* distinction between "tribal art," which was made for a tribe's own use, and "tourist art," which was made for the commercial art market. As you can probably tell from the names, tribal art is more valuable.

Most of the African art you'll find in flea markets, on the Internet, and in home décor stores is tourist art. Connoisseurs consider these often-crude works to be reproductions, regardless of whether the original tribe made them. Even if you find a beautiful or well-executed tourist piece, a tribal piece of the same type will always be worth more.

That may seem like an odd prejudice. After all, Western contemporary art is made with the idea that someone will want to buy it. Part of the problem is that the market for traditional African art—unlike that for Native American art—doesn't emphasize the individual artist or reward innovation. Most carvers work anonymously, and their creativity is constrained by market demands. As a result, tourist art seldom has the power and presence of an authentic tribal piece.

Some casual collectors don't appreciate the distinction be-

tween tourist and tribal art. In their view, if the piece looks great, who cares whether it was used by the tribe in a ritual or not? Well, the art market cares. Tribal art—in addition to having special aesthetic qualities—can be a sound investment, whereas tourist art is unlikely to appreciate.

That doesn't mean that tourist art is inherently "bad." If you aren't concerned with investment value and are simply decorating your house, then it's fine to buy tourist pieces. You have a huge selection to choose from, with prices starting around $100.

The main thing is to avoid confusing tourist art for the more expensive tribal art. That's how people lose money—sometimes lots of it.

Tribal Art

Here's a little irony in the art market: While dealers have a hard time selling religious Western art, collectors clamor for religious African art. The most desirable tribal objects tend to be those that were used in rituals, such as masks, statues, and fetishes (also known as "power objects"), which were believed to possess magical properties.

Although these are highly sought-after pieces, they might not be the best things for a novice to start with. If you buy a fake, you're out of a lot of money. For a smaller investment—often just a few hundred dollars—you could start by collecting decorative arts. Utilitarian objects—such as textiles, wooden

spoons, combs, and simple furniture—are all good choices for novices or for collectors on a budget. You're less likely to encounter deliberate fakes at this price level, and you can develop your relationships with dealers. By starting small, you also give yourself more time to learn.

If you're thinking of collecting seriously, find a good dealer and consider specializing. Africa is a big continent. You are no more likely to become an expert on all African art than you are on all European art. In a reasonable amount of time, though, you could learn a lot about an individual tribe: what type of wood or metal the artists worked with, what type of tools they used, and what their rituals were. (As a practical matter, most of the figurative art available is made of wood or common metals. Older pieces made from valuable materials, such as ivory or gold, tend to be in museums or extremely expensive.) A good dealer can guide you toward books and exhibits that will teach you what you need to know.

Don't be put off by the prices at a reputable gallery. The "bargains" you see elsewhere probably aren't bargains at all. Besides, the premium you pay when buying from a good dealer is not only an insurance policy against fakes; it's also "tuition" for the education you'll get in African art.

What Makes Tribal Art Valuable?

The first criterion, of course, is that it's a great work of art. Ideally, it should be well crafted and have a certain emotional power or elegance. Here are some other things to look for:

★ *Age*

Tribal art has three different price categories: pre-1900, 1900 to World War II, and postwar. Many connoisseurs prefer pre-1900 pieces, which are deemed more authentically African than later pieces, which were influenced by contact with colonial Europeans. If you share this prejudice, you'd better have a lot of money. Pre-1900 pieces are scarce, so they often sell for six-figure prices, though age alone doesn't make something extremely valuable—it also has to be a fine piece.

Art from 1900 to World War II is the next most desirable category, for reasons that have as much to do with authenticity as with aesthetics. About forty years ago, many African tribes started to sell their tribal art through middlemen—called "runners"—who took things to Europe and America to sell to dealers. Over the years, the market became very lucrative. At the same time, real pieces became harder to get. Fakes and tourist art started showing up in some runners' shipments. As a result, collectors who worry about fakes feel safer buying a piece that was in someone's collection long ago.

Postwar art is the least expensive category. That doesn't mean you won't find a great piece. One dealer confided to me that because of the demand for prewar pieces, "that's what sellers often say they have—even if it's something that was really made later. To me, if a piece is beautiful and authentic—if it was used ritually by the tribe—I don't care if it was made in the '40s or '50s."

Again, the key is that the piece was made for the tribe's own use. Only a fraction of contemporary pieces qualify as authentically tribal.

★ *Condition*

Many authentic tribal pieces were kept out in the open, so they may have damage, breakage, and (in the case of wooden pieces) even termites. Pristine pieces are worth more, but erosion doesn't significantly reduce the value unless the look of the piece is diminished.

When a piece has been broken, the value depends on the extent of the restoration. For example, let's say a statue has an arm broken off. If someone glues the arm back on, that's a minor restoration. But if a restorer creates a *new* arm, that lessens the value of the piece significantly because now part of the piece isn't authentic.

★ *Provenance*

Because authenticity is such a major concern with tribal art, ownership history becomes especially important. If something has been in a documented collection for a long time, buyers feel more confident that it's real. As a result, the price is higher than it would be for the same piece with no provenance.

★ *Rarity*

If an artwork is rare, collectors have to compete to buy it, so prices go up. All else being equal, an older piece will cost more than a new one, because there simply aren't as many

old pieces. Similarly, if a tribe produces very little art, its work may be more expensive than the art of a more prolific tribe.

★ *Market factors*

Certain types of art—such as masks and fetish statues—tend to draw higher prices than utilitarian pieces, even if they're from the same tribe. In addition, certain tribes can become "hot" with collectors if they're included in an important museum exhibit. For example, if the Metropolitan were to mount a major exhibition of Dogon art (from Mali), that might boost Dogon prices—at least for a while.

You can get a ballpark idea of what African art should cost by looking at auction records of comparable sales (see the Resources section for how to do this). The low and high estimates at the top auction houses set the market. This is only a rough guideline, however.

"Sometimes a good piece is $5,000. A piece that's just a little bit better is $50,000," says California tribal art dealer Joshua Dimondstein. Many new buyers mistakenly think they're getting bargains when they see that a similar piece sold for a huge price at auction, without considering that the expensive piece might have been in an important collection or might have art historical significance. That's why the help of a good dealer is important, especially when you're just starting to buy.

Spotting Deliberate Fakes

A little knowledge is a dangerous thing. If you've seen African art in museums, you probably remember only its most pronounced characteristics: bulging eyes, flattened faces, upraised arms, and so forth. At a museum, you can't take the masks or statues out of the case and feel how heavy they are. You can't tell whether the backs and undersides are rough or smooth. You can only see how they look behind glass.

That's why so many smart, educated people get fooled by fakes. A fake will always have the same major characteristics as the real thing. Experts can dismiss a deliberate fake if the artist used the wrong materials or combined elements of cultures that have nothing to do with each other, but the evidence is often in the subtle details, which the average museum-goer may not see. That's why it's important to go to galleries and auctions where you can examine authentic works close up.

"The more desirable a piece is, the more fakes there will be," says dealer Joshua Dimondstein. "And the higher the price point, the *better* the fakes will be. At the $50,000 range, the fakes are great looking!" Some of the most common fakes right now are Chiware, Baule, and Fang pieces. Apparently it's such big business that some fakes are even being made outside of Africa.

That's why—let's say it again—you need to buy from reputable sources. If you find a potential treasure in an out-of-the-way sale and need to evaluate the art yourself, the following guidelines should help you eliminate the most obvious fakes.

Characteristics of Genuine Tribal Art

1. It should be used. When you see a supposedly old piece, ask yourself whether it seems to have been used or is even usable. For example, if it's a mask, put it on your head. Can you see? Can you breathe? Is there a way to attach it to your head, or evidence that there once was? If the inside is rough and hurts your face, or if it's unrealistically heavy to wear, it may not have been made to be worn.

Sometimes the interior of a genuine mask shows signs of its original owner. The forehead area might be discolored by perspiration. If the wearer had to bite down to keep the mask on, the mouth area might show teeth marks or saliva stains.

With a fetish statue, ask the seller how it was supposed to be used. Certain areas should be more worn than others. An all-over polished surface on a fetish is a sign that it may not be old, or may have been heavily restored.

2. It should be handmade. Look carefully at the surface of the art. Does it seem perfectly smooth, as if it were made with an electric carving tool? That's a sign that it might be tourist art. Real tribal art is made by hand. You can usually see some evidence of a handheld chisel.

Many masks have tiny holes where strands of raffia were threaded and tied onto the mask. Traditional carvers often made these holes in several steps. If the holes are perfectly round and smooth inside, that's a sign of a modern drill.

Keep in mind, though, that labor costs in Africa are cheap. A deliberate forgery may be carved using traditional methods. You can rule out a piece of tourist art by looking at technique, but you can't prove for sure that a piece is genuine.

3. It should be as old as it's supposed to be. Older tribal art should have signs of age. You'll often see cracks in a carving that's really old, for example, because wood expands as it ages. Wood also tends to dry out and darken as it ages, whereas new wood is light and fresh.

Again, this guideline can help you eliminate fakes, but you can't prove that a piece is genuinely old. Forgers know that Western collectors prefer older pieces, so they often use old wood (which passes any scientific dating test) and simulate an antique patina. They may even leave the carving outside for termites to infest, because insect holes make African art seem authentic.

4. It should have a provenance. If a piece is genuinely old, it must have been somewhere all these years. A piece with no past is a problem—and not just in terms of authenticity. Many African museums, lacking money for proper security, have been looted. Where do you suppose the stolen art ends up?

The more African art you see, the better you will be able to judge quality. To develop your eye, go to good auction houses or galleries, where you can pick things up and examine them from all sides. Over time, you'll start to internalize the characteristics of a genuine piece.

Telling Tourist from Tribal

An average collector isn't likely to encounter elaborate fakes intended to deceive experts. More commonly, you'll find tourist art reproductions in antique shops or at fairs, where the seller mistakenly (or perhaps deliberately) presents it as a valuable piece of African art. How do you tell the difference? The easiest way to learn to recognize reproductions is to buy some! Museums routinely stock fakes and reproductions for curators to study. There's no reason why you shouldn't do the same.

Buy a couple of inexpensive tourist pieces, and put them over your desk where you can see them every day. Get to know what they feel like. Are they heavy or light? Is the surface powdery or sticky? Then go see the real tribal pieces in museums, auction houses, and galleries. You'll notice the differences in patina, carving, and design.

You may also notice that your reproduction art is bigger than the originals. Copyists like to make big, showy pieces because they get more money that way. The carver doesn't have to worry that a headdress is too large and heavy for anyone to actually wear.

Before long, you'll start being able to tell whether your friends' African art is tourist art. Most commercial reproductions have a certain "sameness." Artists make the same thing over and over again. Once you become familiar with a reproduction Ashanti doll, for example, you'll start to see its twins everywhere, and you'll never be fooled into paying a high price for one.

Buying African Art on Vacation

Africa has a lively trade in tourist art. Any city frequented by tourists has a market where you can take your pick. You're not always limited to local styles. In South Africa, for instance, you can find scores of pieces from West Africa.

Your chances of finding authentic, old tribal pieces, however, are small. Collectors have been buying African art for decades, and the supply of antique tribal art has largely dried up. If you want to buy older tribal art on vacation, Europe is actually a better bet than Africa. Countries that have long colonial ties, such as Belgium and France, have thriving markets in antique African art, as well as some of the world's top dealers.

You need to be careful, though, when buying antique African art overseas. Certain categories of African art are illegal to bring home. Most wooden carvings are fine, but other types of art can be iffy. Whenever you're planning a trip abroad, it's always a good idea to print out a copy of the customs regulations before leaving. Put it in your bag so you have it to refer to when you encounter that once-in-a-lifetime chance to buy an ivory carving (illegal) or a terra cotta antiquity (ditto). See Resources for more information on import regulations.

On the other hand, if you're shopping for new African art, go ahead and buy all you want. Your only difficulty is your airline's weight limit.

CHECKLIST FOR BUYING AFRICAN ART

Does it show signs of genuine age? (Keep in mind that "age" can be faked.)

Is it the right size? Reproductions may be bigger than tribal pieces.

Are you buying from a reputable dealer: someone who has a track record and will give you a money-back guarantee? If the dealer is not a member of a major tribal art dealers association, have you called people who are to ask for references?

Does the art have a documented provenance? A tribal piece without documentation may be genuine, but you really want to be buying from a reputable source. Art without paperwork may be hard to resell.

If it's an important tribal piece, are you sure it isn't stolen? Will the dealer or auction house warrant that it has clear title? In some states, this is automatic by law.

If it's a newer "tourist" piece, are you comfortable buying something that has minimal investment value? If you are, buy whatever you like. After all, a collection is supposed to be for your own enjoyment.

Do you love it?

INSIDE THE AFRICAN ART TRADE

CHRISTOPHER STEINER

Anthropologist Christopher Steiner is an authority on the African art trade and the author of African Art in Transit *(1994). He teaches art history and museum studies at Connecticut College.*

▸ *Most collectors consider the newer African art to be essentially tourist art. How do Africans artisans feel about their work?*

A lot of artists are making it for a specific market. They refer to it as "copies." They're copying the classic forms that people want to buy. Although it gives income to a struggling group of Africans, the market also imprisons them in a certain aesthetic. Collectors expect a mask to look a certain way. If the artist deviates too much, he won't be able to sell it.

▸ *What about newer pieces that are made to be used ritually? Would those be considered authentic tribal art even though they're newer?*

Authenticity in African art is a hard question. I think most collectors would agree that something made to be used by the tribe is authentic. A lot of serious collectors would add that it should be pre-1910 or pre-1920, before colonialism started influencing the art. I don't necessarily agree with that.

▸ *I hear that a lot of authentic tribal art has been stolen from African museums. Do those stolen items get sold to tourists, or exported, or what?*

Museum thefts tend to go to high-end collectors, not to tourists. There's a myth that the runners [African middlemen] don't know what they have. Having worked with them for years, I can say that they have a much better sense of what they have than most people. If it's a really good piece, they don't want to waste it on a tourist. They want to sell it to somebody who knows what it's worth. A known collector is more likely to be shown the good stuff.

▶ *And this is mostly done privately?*

Major auction houses would much rather sell something with a pedigree to avoid issues of theft. Also, there's a kind of snobbery—an attitude that after 1920 or 1930, nothing good was left in Africa.

The major masks and statues were gone perhaps, but in the 1960s and 1970s, people expanded their view of African art and started collecting things like furniture and textiles. Those were still available. Also in the '60s and '70s, missionaries converted many Africans to Christianity, so some Africans started to sell their religious art then.

▶ *What about now? Is any really good art left?*

I think there's still some. There are still pockets of good pieces that were collected by urban elites inside Africa. Some of that art is coming out now because of political unrest. In Ivory Coast, the urban elites who had collected art are fleeing the country.

▶ *How much of the newer art that's imported into this country falls in the category of tourist art?*

I've heard different estimates. My guess is about 80 percent tourist art, unless you're looking at things like

pots and textiles. Those are more likely to be authentic, though fakes are starting there too. I saw a fake chair recently, which is kind of amazing.

▸*What do you advise beginners who are interested in collecting newer African art?*

When people ask me that, I tell them to buy whatever appeals to them aesthetically. But don't think you're making an investment. In all likelihood, you're not.

8

Oriental Rugs

When you're thinking of collecting art, don't think only about what goes on your walls. Think about your floor too! Oriental rugs have been a highly prized art form for centuries. Their styles are so varied that you can undoubtedly find one you like—whether you prefer luxurious Persian carpets or the rugged tribal weavings made by nomads.

Although prices can hit six figures for museum-quality pieces, you can still buy a good rug for a few thousand dollars. If you are buying rugs as art, or for investment purposes, don't skimp on quality. On a limited budget, it's always better to settle for a good small rug than a large mediocre one.

Not every oriental rug is valuable, no matter what a salesperson might tell you. Sometimes a rug is in bad condition (it's

the only art form that people trample on with muddy boots). Sometimes a rug wasn't that good to begin with. Sometimes it's even a fake. How do you tell whether you're making a wise investment, or overpaying for something that will never be worth more than a few hundred bucks on eBay?

Understanding Different Types of Rugs

Oriental rugs are typically associated with Turkey (Anatolia) or Iran (Persia), which produced many of the finest museum-quality pieces. But fine rugs have been made in many parts of the world. The Caucasus region of Russia has long produced exquisite geometric rugs, and Central Asia is famous for distinctive red carpets with repeating designs. India and China, which now produce many of the commercial reproductions on the market, also have their own indigenous rug-making history.

When you're choosing an oriental rug, don't be swayed by which style of rug sells for the biggest bucks at auction. Even though some types are more expensive than others, that doesn't mean that Persian rugs are inherently "better" than Caucasian rugs, or that Turkish rugs are superior to Central Asian pieces, or vice versa. You can build a fine collection in any of these categories.

What does make a difference is how authentic the particular rug is. It should be made by the people whose heritage the rug belongs to. And if it's supposed to be an "antique," it must

be genuinely old. Regardless of where a rug comes from, authenticity is key to having something that will hold its value.

Antique Rugs

Like antique furniture collectors, many rug connoisseurs only want things one hundred years old or older. This may seem like mere eccentricity. After all, things being made today will be one hundred years old eventually.

But older rugs are special. For starters, there aren't many of them. The colors have usually mellowed to create a beautiful, glowing patina that no new rug can truly duplicate. And finally, many of them are wonderful art—whether they were created in master workshops in Persia or woven by a nomad woman working in the only form of creative expression available to her.

The most expensive carpets—the ones that get published on the cover of auction house catalogs—usually combine great artistry, rarity, and condition.

Because real antiques are limited in quantity, some rug makers will obligingly "antique" a new rug for you. They take a modern rug and bleach it or mistreat it by scraping it, burying it, or putting it in a road for animals to trample over. Sometimes they burn holes in a rug and then mend the holes to give it a look of authenticity. One dealer recounted to me that he'd even seen weavers using a belt-sander on a new rug.

Some "aged" rugs get passed off as real antiques. Others are honestly sold for what they are.

Many reputable dealers sell bleached carpets—which they

call "golden washed" or "antique washed"—with no intent to deceive. Customers scoop up these pale rugs by the bushel because the neutral colors are easy to incorporate into home décor. As long as you understand that these bleached rugs aren't real antiques and are unlikely to become investment pieces, there's no harm in buying one. They become a problem only if some huckster convinces you that they came from a 19th-century Persian palace and are worth tens of thousands of dollars.

Note that although *antique* usually means that something is at least one hundred years old, some rug experts use that term only with rugs from before 1850. You might also hear "semi antique" bandied about. Technically, a semi-antique rug is about fifty years old, but some slick salespeople use this term to describe any rug that wasn't woven last Thursday.

Tribal Rugs

A "tribal rug" is a rug that was woven by nomads for their own use. It can be antique or modern.

Real tribal rugs are usually small, because nomads carry their looms with them as they move from camp to camp. Many tribal rugs are made entirely of wool—both the base and the pile—because that's the material most readily available. (Nomads don't grow cotton; they herd sheep.) For similar reasons, tribal rugs are usually woven in a limited range of colors. The designs are typically geometric. A room-size carpet with twenty different colors and lots of curvy lines is very unlikely to be "tribal," no matter what the salesperson says.

For many years, tribal rugs were underappreciated. Western buyers preferred plush, floral Persian carpets. Today tribal rugs are highly sought after—especially since the nomadic way of life is dying out and true tribal rugs are harder to come by.

Modern and "Westernized" Rugs

Authentic oriental rugs are still being made. Some are very fine; others are junk. With new production, you have to look at where a rug is from, how well it was made, and whether it's artistically successful. Don't believe anyone who says that all new rugs are bad or, conversely, that they're all destined to become valuable antiques.

Sometimes a rug is less valuable if it strays too far from tradition to cater to Western taste. Westerners have been collecting oriental rugs for centuries (think how often you see Turkish carpets in old Dutch Master paintings), and weavers in nearly every rug-making region have, at times, altered their designs or color palette to appeal to the Western market. Today you can get oriental rugs to go with almost any color scheme—from soft pastels to sherbet-y Palm Beach colors. This is great for interior designers, less so for rug purists.

Many of the motifs and color schemes in traditional rugs have symbolic meaning. If you change the colors to make the rug "prettier," the rug loses its integrity. It's sort of like commissioning someone to make you an American flag in mauve and peach. The catering to Western taste may explain why you sometimes see rugs in colors so hideously garish that you can't imagine how anyone purposely chose them. I suspect the

weaver didn't like them either. After turning out rug after rug in color schemes that made no sense to her, she probably just figured, "Yeah, it's revolting, but that's what those crazy Westerners want."

One logistical problem with buying rugs in fashionable colors is that fashion changes. What once looked elegant may suddenly look hopelessly dated. Just ask anyone with avocado-green kitchen appliances.

On the other hand, who's to say that some of these color schemes won't remain appealing? A century ago, Persian weavers created a type of Westernized rug known as an American Sarouk—or "an abomination," depending on whom you ask. These rugs are hot pink, almost magenta. I personally love them, and so do lots of other people. Abomination or not, they seem to hold their value.

In general, though, rugs woven in traditional designs and colors are the best long-term bet.

Reproductions

Not every handmade rug is a work of art. In China, India, Pakistan, and certain other countries, weavers churn out acres of look-alike carpets to meet the huge Western demand for oriental rugs. Although these countries have their own indigenous rug traditions, reproductions of designs that originated elsewhere make up the bulk of their exports. India typically makes Persian-style rugs, China makes "French" Aubussons (floral rugs), and Pakistan makes zillions of Central Asian

Bokharas—those ubiquitous red rugs with repeating "elephant foot" patterns. Although these rugs are handmade, serious collectors shun them.

"When reproductions are made primarily to provide the end user with an inexpensive alternative to an older, original example, I tend to view these items as 'floor coverings' rather than rugs," says dealer Mark Topalian.

What's confusing to novices is that these rugs are indeed "real" handmade rugs, using traditional knotting, following traditional patterns (though traditional colors are sometimes another matter). What reduces them to "reproduction" status is that they're not in the tradition of the people actually weaving them. The weavers aren't expressing themselves artistically. They're following a pattern their foreman gave them and trying to make their quota.

Novice collectors are often drawn to these rugs because they look "perfect." They are usually very finely knotted, have perfectly squared corners, and lie perfectly flat on the floor. You may well wonder why such a rug is considered less valuable than an old tribal rug that's crooked, or has "mistakes" in the pattern, or abruptly switches from one color to another because the weaver ran out of the original colored wool. Connoisseurs consider such "problems" to be a charming indication that the rug was made by a real human being.

It's an aesthetic you either get or you don't. Some people don't like old things and never will. If that describes you, then stick to new rugs and concentrate on finding the best *original* ones you can afford.

ORIENTAL RUGS AS WORKS OF ART

MARK TOPALIAN
Mark Topalian is an oriental rug dealer, as well as a consultant to the Doyle New York auction house.

▸*Why do connoisseurs consider some rugs to be works of art, and not others?*

I would refer to any old rug that has individual characteristics as a work of art. Of course, that is completely subjective—beauty is in the eye of the beholder.

Rug enthusiasts are always looking for attributes in a given rug to tell them that the rug is a fine or unusual example. Older rugs have a certain individuality.

Products woven for Western tastes, such as the commercial-grade Sarouks and Nichols Art-Deco Chinese rugs of the 1920s, are frowned upon solely because they are examples of mass-produced items. These are technically very good rugs, in that they are very durable and there is a level of quality in the materials used to make them. However, they lack any distinguishing characteristics that would differentiate them from other examples of that production.

▸*Why are older rugs usually more valuable than newer ones?*

Condition and age are the two main characteristics that ultimately determine value. A late-19th-century rug in good condition is, in itself, a rarity. It may have been part of a large production when it was woven, but today 95 percent of that production either is in poor condition or no longer exists.

All things being equal, if you were to compare two rugs that are similar in size, design, quality, and condi-

tion, and the only difference was the age, the older example would always be more valuable.

The one characteristic that has yet to be duplicated in newer rugs is the patina of an old rug, which is brought about by natural aging. A trained eye can always tell the difference.

▸ *What about tribal rugs? Are they still being made in the traditional way, or are most nomads settling down?*

There are relatively few nomads still weaving in the traditional way. Most have settled down into cottage-industry-type situations, where you will have a mix of the traditional designs and colors with more modern interpretations. Cottage-industry products are the result of weavers working in their homes, under the direction of a contractor who supplies them with materials and designs. These weavings will often possess some, if not all, of the characteristics that are in line with Western tastes.

▸ *And what about the Indo-Persians or the Pakistani Bokhara rugs? They seem to be everywhere.*

Indo-Persians and Paki-Bokharas were intended to be less expensive alternatives to the original rugs that they copied. They mostly used the poorest qualities of wools and dyes, even though they often had very fine knot quality. A purist will always frown on reproductions such as these, and these rugs have little longevity when it comes to normal usage on the floor.

However, it should be mentioned that to the average customer, these reproductions are viewed as aesthetically pleasing. After all, someone had to purchase all those yellow and green Paki-Bokharas back in the '60s and '70s.

What You (Really) Need
to Know About Rugs

At the connoisseur level, evaluating rugs gets very complicated.

For starters, merely knowing what kind of rug you're look-ing at can be tricky. Different rug-weaving groups often share the same design elements, so identification may depend on tiny details, such as whether the knots are symmetrical or asym-metrical, what color the base thread is, or even whether the wool was spun in a clockwise or counterclockwise direction.

No wonder some people just buy beige wall-to-wall.

Becoming a real connoisseur takes years, but fortunately, learning how to recognize a *bad* rug is relatively easy. By the time you finish this chapter, you should understand what makes a rug valuable, know how to spot obvious fakes, and be able to steer clear of the most notorious sales gimmicks.

What an Oriental Rug Is, and Isn't

Almost any throw rug with a pattern is casually referred to as an oriental rug. A true oriental rug is handmade, usually in Asia. Every single tuft of pile was created by a labor-intensive hand-knotting process.

The easiest way to tell if a rug is handmade is to flip it over. The back of the rug should have the same design as the front. If you see some kind of plastic coating or white mesh on the back, the rug was made by machine. (The exception that proves the rule is a Karastan carpet. Karastan isn't the name of

a nomadic tribe; it's a trademark for high-quality machine-made carpets. The mechanical looms produce rugs that have the same design on the back as on the front.) Look at the base of the pile through a magnifying glass. The rug is handmade if the tuft is knotted at the base.

Fortunately, you're unlikely to see machine-made rugs misrepresented as being handmade, unless you're at a garage sale where the seller doesn't know the difference. With so many inexpensive handmade rugs available, why would anyone bother?

Developing Your Eye

Rug experts develop their eye for quality by examining hundreds, or even thousands, of different rugs. You, however, will probably want to take some shortcuts!

Looking at high- and lower-quality rugs side by side is one of the easiest ways to develop connoisseurship, but very few people actually do it. Buyers typically look only within their price range and then narrow down their choice to two or three similar-looking pieces and pick one.

For the same amount of effort, ask to see both an antique rug and a modern rug of the same style. Or compare a top-quality new rug with an inexpensive piece from the same region. When you're looking at these rugs side by side, you'll see right away what the difference is. (Don't worry that you're pestering the dealer. He or she will be happy to haul out the better pieces because you'll be tempted to buy them!)

Auction viewings are another great place to educate

yourself. All of the top auction houses have condition reports for each piece in their sale. You can get these free just by asking. But don't look at them right away. Examine a rug for yourself first, using the checklist at the end of this chapter. Try to see if the rug has been repaired or has any major condition problems. Then look at what the experts found. How did your own assessment match up?

If there were condition problems that you missed, ask the expert to show them to you. That's how students in fancy connoisseurship training programs learn. Why shouldn't you do the same?

A third shortcut to connoisseurship is to specialize. You're not curating a museum of carpets; you're buying rugs for your own house. That means (cover your ears, experts!) that you don't have to know anything about rugs you don't actually like.

Go to a rug store or auction, or simply flip through a picture book of rugs, and make notes about which ones you do like. What country are they from? Are they curvilinear or geometric? Delicate silk pieces or rough nomadic ones? This exercise can help you define your taste. (But try to ignore color when you're doing this. Deciding that you like *red* rugs doesn't narrow things down very much.)

Of course, sometimes you have a great opportunity to buy a rug before you've done any homework at all. What should you look for if you're a complete novice?

Evaluating an Oriental Rug

Several factors determine the value of an oriental rug. You need to look not only at how beautiful the rug is, but at how well it's made and how long it's likely to last. If you're concerned with investment and resale value, you'll also want to consider how other collectors feel about the type of rug you're buying. Here are the major factors to consider.

Artistry

First of all, how beautiful is the design? Does it have individual elements that make it special? See my interview with Mark Topalian for more about how collectors judge the aesthetics of oriental rugs.

Second, how well executed is the design? How fine is the weaving? Some collectors are obsessed with knot count (how many knots per square inch a rug has). Others say that judging a rug by its knot count is like judging a painting by the number of brushstrokes. Who's right?

Well, both.

A rug with many tiny knots can have an intricate, highly detailed design, whereas a rug with fewer, big knots has to settle for a simpler pattern. The finest Persian carpets—the type you see in museums—often have an amazingly high number of knots per inch, which enabled the weavers to create exquisitely delicate designs. Their technical and artistic virtuosity makes these rugs better than the many lower-knot-count rugs

whose makers attempted to imitate their fine designs but couldn't duplicate their intricacy.

On the other hand, tribal rugs have relatively low knot counts, and nobody minds. Tribal rugs typically use bold geometric patterns that are perfectly suited for their coarser level of weaving. They are often great works of art. To shun them because of their low knot count would indeed be like dismissing Van Gogh for using thick brushstrokes.

Another reason not to rely exclusively on knot counts is that reproduction rugs from places like India and China often have high knot counts, even though their quality may be lacking in other areas.

A good rule of thumb is that if you're comparing two rugs *of the same type,* the one with higher knot count may be a finer rug, if all other factors are equal. That's why at auction house viewings, you'll see collectors flipping rugs over to count the number of knots on the back.

How do you do this yourself? Lay your tape measure on the back of the rug and count the number of knots in a one-inch horizontal row; then count the number in a one-inch vertical row. Multiply the two numbers to get the knots per square inch. You can often go just by your eye. When you're comparing two rugs side by side, you'll see right away if one is drastically finer or coarser than the other.

What you don't want to see in any rug is a "muddy" or blurry design. This means the rug doesn't have enough knots to "draw" the pattern successfully. When the pattern looks as if it's been half erased, it doesn't matter how many knots the rug actually has—it doesn't have enough.

Age and Rarity

Old rugs have a special beauty that can't be duplicated. They are also valued because of their rarity.

Experts can often dismiss a fake antique out of hand because they know that a certain pattern or color wasn't used until later. They can also distinguish the patina of a true antique just by looking. Until you reach this level of connoisseurship yourself, you'll have to rely on the forensic evidence:

★ *Wear patterns*

When a rug is walked on for many years, the knots on the back become flattened and smooth. If you flip the rug over and feel distinct "ridges" or "ripples," that's a sign that it might not be old.

If the pile of a rug is worn down in certain spots, ask yourself whether the wear is where you would expect it to be. A large rug that was used in a dining room, for example, will probably have wear around the edges, where chairs scraped against it, but be pristine in the middle. Faked wear is often in small, inconspicuous places that don't detract at all from the main design.

★ *Evidence of bleach*

If a rug has faded naturally over decades, the front of the rug will be lighter than the back, which hasn't been exposed to light. If you flip the rug over and see that the back is just as subdued as the front, that's an indication of bleach.

With rugs from the 1980s or earlier, you can even

smell the bleach, according to rug expert Mark Topalian: "Chemically washed rugs often have a pungent odor similar to Clorox or ammonia." Brilliantly white cotton fringes are another sign of a bleached rug.

You can also learn to recognize the artificial color that results from the bleaching process. Ask dealers to show you their "antique washed" rugs, which have been bleached with no intent to deceive. Compare them with genuine antiques. The difference will be obvious.

What *won't* reliably indicate age:

★ *Repairs*
The presence of repairs does not mean a rug is old. As noted above, merchants who cater to the prejudice for old carpets may obligingly scrape holes in new rugs and then "repair" them.

★ *Poor condition*
A new rug that's been mistreated may actually look older than an antique that's been well cared for.

Materials

As in cooking, the quality of the ingredients has a lot to do with the quality of the finished product.

★ *Wool*

The quality of the wool is especially important. Poor-quality wool doesn't wear well, and your rug won't last nearly as long. The best wool is rich in lanolin and feels "springy" under your fingers. The worst comes from dead sheep and feels dry and brittle. Make a point of not only *looking* at rugs but also touching them. Examine good rugs (even if you can't afford them) and bad ones (even if you can't stand them). You'll learn to tell the difference in wool quality.

★ *Silk versus art silk*

Some very delicate—and very expensive—rugs are woven entirely in silk. A material you *don't* want to see is "art silk," which isn't really silk at all. *Art silk* is a slick marketing term for mercerized cotton. Rugs made with art silk are usually low-quality commercial or bazaar rugs. Don't waste your money on them.

★ *Vegetal versus synthetic dyes*

Before synthetic dyes were invented, nomads and village weavers brewed dyes from plants, bugs, and other organic material. These natural dyes produce a subtle depth of color that connoisseurs prize. In fact, some collectors are downright snobs about it. Why?

In places where vegetal dyes are still used, wool is typically dyed by hand. This produces subtle and beautiful variations in color. Machine-dyed wool, by contrast, looks flat and uninteresting. It's sort of like hair color: If a

woman has naturally blonde hair, her hair is actually several different shades that give one harmonious look. A bleached blonde has one-tone hair that looks flat and fake.

But these days you can't always tell by looking.

"Hand-spun wool and vegetal dye are buzzwords to attract customers," says Virginia rug dealer Mark Kambourian. "Most people can't tell the difference because there are now techniques to make machine processes look like vegetal dyes and hand-spun wool. The first is sort of like tie-dying. People tie bands around the wool before dying it, and these bound areas resist the dye, which gives a variation in color. Another technique is to overspin the wool, which creates clumps that don't absorb the dye as well. Customers see a variegated texture and think it's hand-spun."

Whether the dye is vegetal or not, hand-spun or not, experts say the most important thing is that the rug be pleasing to look at. That's easy enough to tell.

Condition

Condition is a major factor determining how valuable a rug is. A pristine carpet is always worth more than a comparable piece with damage.

You could be forgiven for assuming that the opposite is true. Faded antique rugs sell for thousands of dollars at auction. Rugs in historic houses are often worn down to the knots. Very early pieces in museums or art books may even

have whole chunks missing. This misleads many new buyers into thinking that worn rugs are inherently more valuable. But it doesn't work that way.

Connoisseurs *tolerate* a certain amount of wear in an old carpet because they have to—there simply aren't many old rugs in perfect condition. But they don't actually *like* moth holes or patches. You always want your rug to be in the best condition possible.

Here are the most common problems you'll encounter:

★ *Pile loss*

Any carpet that has been used on the floor will show wear after a while. If the wear is even, and if all the pile still remains, it's not a problem. If the rug has been worn all the way down to the knots but the foundation isn't yet exposed, then the age of the carpet determines how serious the condition is. It's more acceptable in an older rug than in a newer one.

A rug's value becomes compromised when the rug has bald spots, holes, rips, or exposed foundation threads. These problems may or may not be repairable. Sometimes the repair would cost more than the rug is worth.

Beware that some rug sellers try to conceal a bald spot by tinting it or painting a design over it. This drastically reduces the value of a rug (though if the piece is extremely old and rare, collectors may make some allowances). Until you can spot this type of "repair" by eye, always run your hand over an old rug to determine whether

the design is made of wool or paint. A rug that has been heavily painted is no longer really an oriental rug; it's a painting on canvas.

★ *Repairs*

Repairs can reduce the value of a rug. How much depends on whether the repair was done skillfully or crudely. Some are so well concealed that you don't notice them when you're looking at a rug on the floor. Before you buy a rug, hold it up to a strong light. You'll see the stitching or different weaving pattern of repairs more easily.

★ *Dry rot*

When a rug is exposed to moisture or dampness over a long period of time, mold and mildew rot the foundation threads, and they crack when exposed to minimal stress. (Often you can feel the brittleness of the base threads or even notice them cracking when you examine the rug.) Rot is a very serious and irreversible problem. If you use a rug with dry rot on the floor, it will soon fall apart.

★ *Unstable dye*

If you've ever washed a red shirt with white clothes and found that your laundry was suddenly pink, you know what unstable dye is. New rugs can have this problem if the wool wasn't dyed carefully. Sometimes you'll see a dark color "bleeding" into a lighter part of the rug. To test whether dyes might be unsafe in the future, wipe a slightly

damp white handkerchief over a rug and see if dye comes off on it. If it does, that's a red flag.

★ *Missing sections*

The fringes and sides are usually the first parts of a rug to wear away. Missing fringe and replaced side cords are not an issue. If part of the outer border has worn away, however, that reduces a rug's value (though, again, collectors are more tolerant of damage in antiques than in newer pieces).

Sometimes a "rug" is really a fragment from another, larger piece. One way to tell is by the borders. The borders on an oriental rug go all the way around. If there aren't any borders at all, or if you have them only on one or two sides, part of the rug is missing.

Certain types of fragments may be collector's items, and others are honestly sold as "cutters" for making pillows. But in general, if you're buying a rug, you want the whole rug!

Market Considerations

Tastes change. Sometimes certain styles—or even certain sizes—of rugs lose their popularity. Right now, for example, long, thin "runners" made for hallways are often bargains; contemporary floor plans have fewer long hallways, so demand has dropped. You can't predict the future. All you can do is make sure you've bought the best rug you can, because quality tends to keep its value.

How Not to Buy a Rug

In any field of art, there are good dealers who can educate you and help you build your collection, and there are fly-by-night hucksters who will gleefully try to sell you overpriced junk. Here are a few things to watch out for when shopping for oriental rugs.

Bazaar Rugs

Many tourists think they'll get bargains on rugs when they're on vacation in Turkey, Morocco, or some other rug-producing country. They're often disappointed. Although Turkey has produced some of the finest carpets in existence, the ones you find in the tourist markets are often shoddily made. They may look great in their colorful souk surroundings, but they will fall apart soon after you get them home.

You might also end up paying just as much for a rug on vacation as you would at home. In parts of the world where bargaining is a way of life, you need to know the real value of a piece *and* have good negotiating skills to be able to get a fair price. Until you feel confident both in your knowledge of rugs and in your ability to make a deal, buy your rugs closer to home—where you can return them if there's a problem.

Going-Out-of-Business Sales

A modus operandi particular to the oriental rug market is the notorious going-out-of-business sale. Customers are lured inside by promises of deep discounts. The salesperson tells some hard-luck story about having to liquidate everything at cost or below cost. The list prices on the rugs are so inflated that even at "80% Below Retail!" you're still paying too much.

Later, you might find out that the rug has a problem, but you'll have no place to return it.

You can recognize a bad dealer when you hear a hard sell about how the rug is worth many times the sales price. If someone offers you a rug for $5,000 but says it's worth $50,000, how come you're getting such a good deal? If you start to hear that a bargain rug is "museum quality," ask, "So why aren't you selling it to a museum?" The question after that should be, "Where's the exit?"

Hotel Auctions

Another common huckster technique is to hold an auction in a rented hotel ballroom. Unless you really know what you're doing, it's a bad idea to buy from sellers who won't be there tomorrow. For more details, see Chapter 11, "Buying at Auction," as well as my interview with Mark Kambourian at the end of this chapter.

For tips on avoiding Internet rug scams, see Chapter 13, "Buying Art Online."

CHECKLIST FOR BUYING ORIENTAL RUGS

A New Rug

Where is the rug from? If it comes from China, India, or Pakistan, it may be a reproduction. These rugs are fine to buy for decorative purposes but are unlikely to become valuable.

Is the rug made of good-quality wool or silk? If the wool feels scratchy and brittle, it isn't good quality. If the rug is made of "art silk," it's not silk at all and is not a valuable rug.

Do some colors bleed into other colors? If you wipe a damp white handkerchief over the rug, do the dyes come off? If so, the dyes are unstable. Pass on the rug.

Are the colors of the rug traditional or popular Western shades (soft pastels, etc.)? Traditional colors are a better long-term bet for investment purposes.

Is the design well drawn? If you put the rug next to a higher-quality piece of the same type, does it suddenly look "sketched" or "incomplete"?

Is the rug finely knotted? The number of knots per inch should be enough to fulfill the ambitions of the design. If a rug looks blurry, it's not knotted finely enough.

An Antique Rug

Does the rug have visible condition problems, such as holes, rips, or bald spots? If so, do they detract from the overall look of the rug, or are they minor?

Are the foundation threads brittle or moldy (a sign of irreversible dry rot)? If so, pass on the rug. It will fall apart if you try to use it.

Is it in traditional colors? If it's in currently popular shades, it may be new, no matter how old it looks.

Are the knots on the back flat from having been walked on for decades?

Is the back darker than the front? It should be, because the front would naturally have been more exposed to light.

Is it painted? Sometimes when a design has worn away in a section of a rug, a merchant paints in the design. This reduces, or even negates, a rug's value, depending on the extent of the "repair."

Is it all there? Do the borders go all the way around? If sections have worn away, the value of the rug is reduced.

Has it been repaired? If so, is the repair subtle and well done or crude?

A New *or* an Antique Rug

Are you buying from a reputable dealer or auction
house? Don't buy at a going-out-of-business sale or
a hotel auction unless you're an expert.
Can you bring the rug back for a refund if there's a
problem later? Do you have that in writing?
Do you love it?

STEERING CLEAR OF FRAUDS

MARK KAMBOURIAN
*Rug dealer Mark Kambourian is President of the Oriental
Rug Retailers of America (ORRA).*

▸ *ORRA is adamant that people not buy rugs at going-out-
of-business sales. Can you explain why?*

ORRA doesn't recommend you buy rugs from people
who won't be there later. Unless you have an intimate
knowledge of rugs, you should never buy at going-out-
of-business sales, or at auctions held in hotel rooms and
other rented venues. The dealers won't be there next
week, and you have no way of getting your money back
if there's a problem.

▸ *What are the most common problems customers encounter
at these types of sales?*

Rugs are often misrepresented. Sometimes the rugs

are tinted [color enhanced], and the buyers don't realize it. But the main issue is that people pay too much.

People will buy a rug because the dealer offers them a certificate of appraisal and authenticity. These certificates are "faulted" at the very least. I saw one instance where people paid $18,000 for rugs they thought were worth $90,000. These rugs were really worth about $5,000. The certificate misstated the age and where the rugs were from.

There's also an enormous number of Iranian rugs on the market in the USA that are worth, wholesale, about $3 a foot. They're bottom-of-the-barrel rugs—they're garbage—but because they're from Iran they can be sold as "genuine" Persian rugs. A 9-foot by 12-foot rug like this is $324 wholesale. They're sold for $1,500 or $2,000, and customers think they're getting a good deal.

In general, dealers don't have prepared certificates of authenticity and appraisal *before* they sell the rug. That's a red flag. (If you ask me to give you a written appraisal after I've already sold you a rug, I'm happy to do so, but that's different.) The firms that advertise their certificates of authenticity and appraisals are traditionally the ones to look out for.

▶ *Aren't customers suspicious when they hear they can buy $90,000 worth of rugs for $18,000?*

These going-out-of-business dealers use all kinds of different lines: "I split with my partner and need to liquidate." Or, "I took over this merchandise from another dealer who went bankrupt, at pennies on the dollar." People get tempted by what they think is a good deal. By the time the customer realizes there's a problem, the dealer is gone.

▸*A reputable dealer will still be around, and also give you back your money if there's a mistake, right?*

Of course. I once had a new rug in my store that I didn't have time to examine for a couple of weeks. When I did look, I saw it had color transfer [bleeding]. Now, if someone had come into my store five days earlier, I might have sold this rug without realizing there was a problem. In that case, I would willingly have given the money back and hoped the person accepted my sincere apology. You work so hard to make a good name in this business!

▸*Aside from dealing only with reputable dealers, what other advice would you give a new collector?*

If you're buying a very expensive rug and you're not sure about it, get a second opinion. ORRA has a list of qualified appraisers who can help you. If you're going to spend $20,000 on an oriental rug, why not spend $125 for an appraiser?

9

Antiquities

A noted art historian has good advice for how to buy antiquities: "Don't buy antiquities."

The lure of the ancient world is strong. Many art enthusiasts—including me—are captivated by the idea of owning art from ancient Greece, dynastic China, or the Mayan empire. Unfortunately, this is not a field for amateur collectors. If you love Greek statues or Ming vases, go see them at museums. You're very unlikely to find authentic antiquities at bargain prices—at least, not legally.

Fakes are everywhere—particularly for popular items like pre-Columbian pottery—and some are impossible to unmask without sophisticated laboratory tests or scholarly expertise.

Nearly every major museum has been embarrassed to learn that a significant antiquity in its collection was a fake. If curators can get burned, imagine what happens to nonexpert collectors.

Buying a fake isn't even the worst-case scenario. If you buy a fake, all you lose is money. If you buy an object that's been looted from an archaeological site, something even more valuable has been lost: the country's cultural heritage. When looters dig up artifacts or steal them from ancient temples, they destroy the historical context of the art. Archaeologists never get a chance to study and understand it.

The problem is so bad that some archaeologists now hire armed guards at their digs. China—one of the countries most harmed by illegal antiquities exports—has even imposed the *death penalty* for archaeological thefts. Nothing helps. As long as collectors are willing to buy antiquities without proper documentation, impoverished "diggers" will literally risk their lives to find ancient art for collectors.

If altruistic arguments don't sway you, consider this: Your collection could be confiscated. A New York collector recently had to surrender an antiquity he'd paid over a million dollars for.

Governments around the world are working to curb cultural looting and have passed rigorous laws against exporting important cultural artifacts (see my interview with Patty Gerstenblith at the end of this chapter). The Archaeological Institute of America advises collectors to "refrain from buying any antiquities that are not identified as belonging to

public or private collections prior to December 30, 1970, a date established by the UNESCO Convention on Cultural Property."

None of this stops newly looted antiquities from flowing across borders anyway. Recently, some top American museums (I won't name names) had to return antiquities that turned out to have been illegally exported. In addition, some high-end dealers, and even the antiquities curator of a major California museum, found themselves in legal trouble—whether deservedly or not.

Always insist on a clear provenance—ownership history—for antiquities, and don't settle for obvious fronts. Sometimes it seems as if half the ancient world belongs to "a private collector in Switzerland."

Beleaguered dealers complain that it's unrealistic to expect excavation records and provenance for every single item, and they're right. A large portion of antiquities on the market—maybe even the majority—have no documentation at all. Opportunists have been digging up grave sites and looting abandoned temples for centuries, and until recently, nobody cared much about paperwork.

Today, the pieces that do have documented histories and clear title tend to be extremely expensive because they're the only ones that are truly safe to own. Unless you're willing to pay a premium to buy documented antiquities from the most reputable sources, you're better off collecting something else.

Checklist for Responsibly Collecting Antiquities

What evidence do you have that the work is truly authentic? Are there excavation records from an archaeologist? Has the work ever been exhibited in a museum or been part of a museum collection? Have experts with no financial stake in this item authenticated it?

Has the antiquity been accounted for since 1970? What is its provenance? The seller needs to give you the provenance before you buy. Don't accept promises that you can see it *after* you buy.

Is it legal to export the item out of its home country?

Who is selling the antiquity? You want a *very* reputable seller. The antiquities market is too full of stolen goods and fakes to take a chance buying any other way. Unfortunately, some of the world's top dealers aren't available at the moment. They're on trial.

ANTIQUITIES AND THE LAW

PATTY GERSTENBLITH
Patty Gerstenblith, a law professor at DePaul University, is President of the Lawyers' Committee for Cultural Heritage Preservation and cochair of the International Cultural Property Committee of the American Bar Association.

▸ *It seems that every time I open the newspaper, a museum or collector is having legal problems about antiquities. Has enforcement of cultural property laws become more stringent in the past decade or two?*

Enforcement of cultural property laws has become more stringent because U.S. law recognizes a foreign country's ownership of antiquities. Although this doctrine was first used in a decision in 1977, the federal appellate court in New York reaffirmed the doctrine in the 2002 conviction of a prominent New York antiquities dealer. This doctrine is also used as the basis for recovery of stolen artifacts by the country of origin and is the principle underlying the claims of Italy to the antiquities in the collections of the Getty, the Met, and several other U.S. museums.

In addition, increasing acceptance of the 1970 UNESCO Convention, particularly by [art] market nations such as Switzerland and the U.K., has led to greater recognition of the rights of the country of origin.

Finally, I think there is greater public recognition, in part the result of the media attention given to the looting of museums and sites in Iraq, of the losses caused to the historical and cultural record when archaeological sites are looted. This recognition helps to increase government resources that are devoted to these issues, such as the creation of the FBI's Art Crime Team in January 2005.

▸ *If someone wants to buy an antiquity in the United States, what kinds of laws apply?*

Only the laws of the United States apply to the buying and selling of antiquities in the United States. The United States has passed legislation implementing our ratification of the 1970 UNESCO Convention on the Means of

Preventing and Prohibiting the Illicit Import, Export and Transfer of Ownership of Cultural Property. This U.S. law allows the President to impose restrictions on the import into the United States of designated categories of archaeological materials from other countries that are also party to the 1970 UNESCO Convention.

If there are such restrictions in place, then the artifact can only be imported into the United States if it has an export license from the country of origin, or if the artifact was exported before the U.S. restrictions went into effect. For a list of the countries whose archaeological materials are subject to import restriction in the United States, you can check the website exchanges.state.gov/culprop.

The laws of another country also become relevant if that country has a national ownership law that vests ownership of newly discovered archaeological artifacts in the nation. If an object that is subject to national ownership is dug up and exported without permission, it is considered stolen property under U.S. law. In that case, someone dealing with such an object in the United States may be violating the U.S. National Stolen Property Act, the Customs statute, and state laws against handling of stolen property.

▶ *If a friend of yours were thinking about buying an antiquity, what advice would you give?*

My advice would be that anyone considering purchasing antiquities should first consider the moral and ethical questions of whether his or her purchase is likely to be contributing to the contemporary looting of archaeological sites, a phenomenon that causes serious loss to our ability to reconstruct and understand the past.

From a legal perspective, any potential buyer must be very careful. A buyer should demand full documentation as to provenance [ownership history] of an antiquity, keeping in mind that such documentation is often falsified. Both dealers and archaeologists estimate that 85 to 90 percent of the antiquities on the market do not have adequate documentation to establish that the antiquity has a legitimate history. Of these, many are likely to be forgeries; the rest are likely to be the product of recent site looting.

A buyer should not take the risk of buying without a paper trail that includes the list of prior owners with specific names (not statements such as "property of a Swiss gentleman") and that goes back to at least 1970. The buyer should then verify that the antiquity was part of these earlier collections. The buyer must read the fine print because what appears in auction and dealer catalogs to be provenance information is often a listing of similar antiquities and does not refer specifically to the antiquity that is being sold.

▸ *Wow. That's scary. What else?*

The buyer should also ask for the antiquity's import documentations so as to be sure that the antiquity was properly imported into the United States. Even with such documentation, the buyer should obtain an express warranty of title, a warranty of authenticity, and the dealer's promise to indemnify the purchaser if any sort of claim is made. The dealer should also agree to allow the warranties of title and of authenticity and the indemnification agreement to last until the buyer resells the artifact.

Part

TWO

How to Buy It

10

Dealing with Dealers

If you're a new collector, you probably haven't given much thought to what you want in an art dealer. When you go to a gallery, you focus on the art. The dealer just happens to come along with the package. From now on, try to evaluate the two separately.

You've heard a million times (including from me) that the way to avoid trouble is to buy only from reputable dealers. That's good advice. Unfortunately, it's not especially *helpful* advice. Nobody ever intentionally buys from disreputable dealers, yet new collectors fall prey to them all the time. How do you know who's who?

In general, art dealers fall into four recognizable categories.

From best to worst, they are the Good Dealer, the Honest Nonspecialist, the Huckster, and the Fraud.

The Good Dealer

Good dealers offer you more than works of art. They also offer their years of expertise. They can teach you about connoisseurship and advise you on how to build a collection. If you become a serious collector, they can often find specific pieces for you or even bid for you at auction. And they stand behind what they sell, so you can buy with confidence.

You have to pay extra for this expertise, but it's worth it. A bad art purchase—whether fake or overpriced—costs more than just money. It hurts your pride, ruins your enjoyment of your art, and may even turn you off collecting altogether.

Good dealers aren't cagey when you ask for documentation about their claims. Nor do they give you a hard sell. If they inadvertently sell a piece that's "wrong" (an art world euphemism for a fake), they'll buy it back and take the loss rather than have bad things said about them.

How can you tell if you've found someone good? Look for the characteristics you'd want in any other professional: expert knowledge, a good reputation, a well-established business, and a manner that makes you feel at ease. A spot-check for evaluating a dealer's competence and trustworthiness is to ask yourself, "If this person had gone to medical school instead of becoming an art dealer, would I want to be this per-

son's patient?" (For a discussion of how good dealers operate, see my interview with Richard Solomon at the end of the chapter.)

Dealers Associations, and Why They're Important

Good dealers don't like frauds and hucksters any more than you do. They often band together to form dealers associations, whose members promise to adhere to ethical practices or are vetted by a committee.

The top organizations, such as the Art Dealers Association of America and the International Fine Prints Dealers Association, are highly selective. If you're dealing with a member of the ADAA or IFPDA, you can buy with complete confidence. For a list of other reputable dealers associations, see the Resources section.

If a dealer is an "associate" or "affiliated" member, call the organization to find out what that means. Sometimes this category is reserved for newer dealers or for nondealer specialists, such as auction house experts. That's fine. However, some nonprofit groups aren't allowed to exclude people, because of how they set up their tax-exempt status. When such groups are forced to take a dealer they don't necessarily stand behind, they may make that person an associate or affiliate member. That's why you need to call. The art world is genteel, so you may have to read between the lines. The president of an association once tried to steer me away from a particular dealer by saying, "He's an associate member. Do you understand what I'm telling you?"

SIGNS OF A GOOD DEALER

- ► Displays knowledge about, and sincere interest in, the art
- ► Has a good reputation among others in the art world (We'll discuss how you can tell later in this chapter.)
- ► Works in an established business or has previous experience at an established gallery
- ► Is a member of a reputable dealers association
- ► Does not use hard-sell techniques
- ► Has proper documentation for the work he or she sells
- ► Will give a money-back guarantee and will take a piece back if it was accidentally misrepresented

The Honest Nonspecialist

Nonspecialist 1: The Antiques Dealer

Not everybody who sells art is an expert. Antiques dealers who specialize in furniture may have prints or paintings in their shop without knowing too much about them. If you ask, you might get a vague comment like, "I think it's Currier and Ives," or "It looks to be about mid-1800s." An honest nonspecialist admits when he or she doesn't really know about a piece.

The problem with that kind of honesty is that if the dealer says, "I don't know," you're not getting a guarantee of authenticity. You're taking a chance. The price ought to be low as a result.

Just as often, though, a nonexpert dealer might, through wishful thinking, be convinced that a reproduction print is actually an original Audubon, or that an amateur painting is by an important artist. In that case, the price might be way too high. You need to play the skeptic here. Merely because an honest dealer *thinks* something is real doesn't mean it actually is.

If you're interested in the piece, you should do your own examination, but be sure to ask the price before you take out your magnifying glass. If you appear to be an expert and you want the piece, the dealer may assume the work is valuable and price it accordingly!

It's human nature to want a potential treasure to be real. Most of us tend to focus on the ways in which a piece is similar to the real thing, and to overlook the problems. The nonexpert dealer—with no nefarious intent—may egg you on in this fantasy. One way to stay focused is to pretend you're an art detective out to prove that this piece is not authentic. Look for every possible problem. Trick yourself into thinking that you actually want to discover that the work is just a copy.

And if you still think you've found a treasure? Try to negotiate as much leeway as you can with the dealer. Ask if you can have a trial period with the art, so you can evaluate it further or have it appraised. Also ask if you can get your money

back if the piece turns out to be something less than what you thought. And, as always, get it in writing.

Nonspecialist 2: The Something-for-Everyone Dealer

Some commercial contemporary galleries have a little bit of everything: abstract paintings, Impressionistic pastels, sports photography, paintings of children with big eyes . . . You name it. These galleries feel sort of like department stores, and that's no coincidence. They're mostly for people who are furnishing their homes, not building art collections. The dealer seldom has an emotional investment in the art—it's just a business.

That doesn't mean you won't find an artist you like in one of these galleries, but it does mean the dealer probably isn't doing much to further the artist's overall career. You need to consider resale value—or lack thereof—before buying from this type of dealer.

Nonspecialist 3: The Artist-Dealer

"Cooperative" galleries (sometimes called *un*-cooperative galleries by people involved with them) are run by artists who want to promote their work themselves. Prices may be unrealistically high because they're based on how much the artist values the work, not on how much comparable pieces sell for. The artist-dealer may sound offended if you try to bargain or ask about resale value. The gallery may even have a manifesto about the evils of the art market. This is not your typical retail experience!

When you're dealing with artists, you can't point out that similar art sells elsewhere for half the price. You have to be tactful. These artists quite naturally believe their work is unique. (For tips on buying directly from artists, see Chapter 12, "Off the Beaten Path.")

SIGNS OF AN HONEST NONEXPERT

- Lacks extensive knowledge, but admits it
- May specialize in something other than art
- May be a new dealer without much experience
- May not have any particular aesthetic vision—it's just a business
- May be an artist promoting his or her own work

The Huckster

Huckster dealers don't care about art. They care about money. And they make plenty of it by selling overpriced works to gullible collectors.

Hucksters sell authentic art but use hard-sell techniques that make exaggerated claims about its value. At a huckster gallery, every contemporary artist is "world famous," even if you've never heard the name before. Every second-rate piece by an artist you actually *have* heard of is "museum quality." The sales pitch here is that you have a rare opportunity to buy something that's going to become valuable later.

Fortunately, this emphasis on money is what helps you spot a huckster.

For example, hucksters often brag that a contemporary artist's price doubled recently, though that may simply mean that the gallery doubled its asking price. Before you get too excited about what huge profits you're going to make, check the Internet or a buying guide to see what the art really sells for outside the gallery (see the Resources section for more information). You may find it has no resale value at all.

If a gallery is giving you a hard sell about how "hot" their contemporary art is, you can be sure it isn't. At the truly hot contemporary galleries, collectors often have to beg the dealer to get even a place on the waiting list. Macabre promises about how the prices will skyrocket when the artist dies are another dead giveaway.

Huckster galleries are sort of like tourist traps and, not surprisingly, are often located near tourist hotels and souvenir shops. Hucksters also like to be near legitimate galleries, to poach potential customers and to look as though they're part of the art scene.

Because hucksters rely heavily on walk-in customers, you are most likely to find them in street-level galleries in busy, upscale pedestrian areas where tourists and shoppers have money to spend. Conversely, you're *less* likely to be dealing with a huckster if the gallery is on a hard-to-find side street, or on an upper-level floor, or in a neighborhood where struggling artists have yet to be replaced by investment bankers.

Recognizing the Huckster's Hard Sell

As soon as you walk into one of these sell-sell-sell galleries, the salespeople will cozy up to you, complimenting you on your excellent taste. Whichever picture you happen to look at first will invariably be the "best one in the gallery," and aren't you smart for having picked it out all by yourself? The point of this flattery is to link your self-esteem to ownership of the artwork. Hucksters also try to draw you into small talk about your occupation or where you live, in a sneaky attempt to figure out how much you can afford.

Before you know it, a salesperson is taking a picture off the wall and scooting you into a private "viewing room." An assistant offers you wine or Perrier. Another salesperson may pop in to reaffirm what a good choice you made. If you've ever been to snooty galleries where you felt unwelcome, such attention may be flattering and fun. At this point, it's very hard for most people to get out of the viewing room without buying.

If the artwork is part of a numbered series, a huckster might tell you that the series is almost sold out or that you are looking at the very last copy. Better get it now! If it's a one-of-a-kind piece, you may be told that another collector wants it, but if you buy right now—today—it's yours.

Never go into a viewing room unless you have already decided you want to buy the art and have the stamina to hold out for a fair price. If you find that you've been transported to the viewing room seemingly against your will, make an excuse and leave. Or leave without an excuse.

Remember: If a dealer's main sales pitch is that you'll make

money, what he really means is that you'll make money for *him*. (To learn about the special practices of huckster oriental rug dealers, see Chapter 8, "Oriental Rugs.")

TELLTALE SIGNS OF A HUCKSTER

- ▸ Is more interested in profits than in art
- ▸ Uses hard-sell tactics
- ▸ Resorts to excessive flattery
- ▸ Usually has easy-to-like, very commercial art
- ▸ Often is located in a tourist area

The Fraud

You might assume that art fraud would take place in some hole-in-the-wall showroom that looks . . . well, criminal. But the opposite is true. Fraudulent galleries have all the trappings of fancy establishments. They're frequently on ritzy streets, next to luxury-goods stores where shoppers might drop thousands of dollars on a handbag or diamond watch. Think about it: If you wanted customers willing to spend big money on an impulse purchase, that's exactly where you'd set up shop.

Fraudulent dealers typically specialize in famous artists: Chagall, Matisse, Picasso, Dalí, or other big names you remember from art history class. Frauds don't want to waste time pitching a lesser-known artist. They want to sell you something they already know you want: prestige.

A fraud uses the same smarmy sales techniques as a huckster: flattery and the fantasy of owning "museum-quality" art that will zoom up in value. The sales pitch can be very enticing. After all, who wouldn't want to have an authentic Picasso? Especially since it's such a good investment . . .

The only problem is, it's not a real Picasso. (Or Renoir, or Modigliani, or whoever.) Some frauds sell machine-made posters of famous paintings and pass them off as original lithographs for thousands of dollars. For even higher prices, they may sell hand-painted copies of actual paintings, or totally new fakes painted in the style of a well-known artist.

One way to thwart a fraud is to insist on seeing the piece in the artist's catalogue raisonné—a scholarly list of every known work by an artist. The new fakes won't be there, and you can often unmask the copies because they don't match the catalogue raisonné description in every detail. A fraud might try to brush off your inquiries by offering you the gallery's own "Guarantee of Authenticity" instead. Imagine what that's worth—the "word" of someone who knowingly sells fakes!

You should also ask for the work's ownership history. But keep in mind that documents "proving" provenance can be faked easily.

In an interesting twist on the usual art scam, a New York gallery was recently busted for selling fake art with *real* documents. First, the dealer bought expensive (but not famous) paintings at auction, with proper provenance and proof of authenticity. Then he allegedly sent the paintings out to be copied by a forger and later sold both the real ones and the copies. He got caught by pure chance, when he was trying to

auction an original painting at Sotheby's at the same time the unsuspecting owners of the fake version were trying to resell theirs at Christie's. The auction house experts quickly realized something was up. That's why you always need to check a gallery's reputation too. Apparently, this particular dealer had already raised some eyebrows in the art world.

The best way to guard against frauds, though, is to beware of your own greed, because that's the emotion they appeal to. When you start daydreaming about how jealous your neighbors will be when they see a signed Picasso over your couch, or about how big a profit you'll make on it, that's when you're most vulnerable to a fraud.

TELLTALE SIGNS OF AN OUTRIGHT FRAUD

- Uses hard-sell tactics (same as a huckster's)
- Usually sells only famous-name works
- Appeals to greed, not aesthetics
- Provides no documentation other than the gallery's own guarantee
- Has a bad reputation in the art world

Checking References

Unless you're buying new contemporary art for pleasure, you should always do a background check on the gallery. The most prestigious galleries belong to major dealers associations, which

vet their members carefully and confer a seal of approval (see Resources to find reputable dealers associations). To find out about less lofty galleries, experts usually recommend that you ask other art world professionals—dealers, artists, art history professors, or museum curators. Find out how long the gallery has been in business and what other pros think about its sales practices and the art it sells.

Don't worry if you don't know anyone in the art world to ask. You can call experts, cold, and they'll usually try to help you. Really. Start with local dealers and curators, or get a membership list from an appropriate dealers association. Look for people in the same field or geographic area. Tell them you're a new collector unfamiliar with the market and you're wondering if they can tell you anything about the dealer—or can recommend someone else.

If a dealer is good, other dealers will be generous with praise. But don't expect anyone to tell you outright that someone's a crook, especially in today's litigious climate. "The art world is very small, and what you say comes back to you," says one art world insider. "It's sort of like being asked about your cousin. You might say, 'Well, we don't see him very much,' instead of saying, 'He's a big jerk and we can't stand him.' " In other words, a comment that might seem innocuous—such as, "I think I heard there might have been a problem once with something he sold"—is actually a bad reference.

You may find that other dealers have never heard of the gallery. That can be telling too. No one can keep track of all the galleries for contemporary art, but if you're buying in a highly specialized area—such as vintage photographs or Inuit

art—the legitimate dealers tend to know each other. They see each other at auctions and shows, and they read about each other in the trade press. Someone really *ought* to know your dealer. Similarly, any dealer who promises you "museum-quality" art ought to be known by his or her peers. If all you get are blank stares, be careful.

Don't let the dealer sway you with glowing references from other customers. References from customers are useful only if they're *bad* references. People who fall for smooth-talking frauds are often delighted with their purchases.

Building a Relationship

Being a good client can be as important as finding a good dealer. When you're a valued customer, dealers spend more time educating you about art. They keep an eye out for pieces you might like, and they may give you discounts on art that's just beyond your price range. What's more, many galleries sell their best pieces to established clients before an exhibit even opens.

How do you get on a dealer's good side?

1. *Don't insult the art.* If you do, you're insulting the dealer's taste. You're also breaking the art world's genteel code of conduct. The worst thing I've ever heard dealers say *publicly* about art they hated was, "It's not my taste." When a piece is a hideous, obvious fraud, they merely say it's "not right."

(Another reason not to insult the art is that the artist

may be standing right behind you. An artist friend of mine actually had this experience when a customer was trying to get a lower price on one of his pictures from the dealer. Later, at a gallery party, this same collector tried to befriend him and say how much he loved his work! Given the small, gossipy nature of the art world, the story spread; now people the collector has never met already think he's a jerk.)

2. *Make an effort to learn.* Dealers are a great source of knowledge, but don't expect them to give you tutorials. Ask them to recommend books or magazines about art; then *read them.* When you go back to the dealer next time, mention that you followed his or her advice. You'll mark yourself as a serious collector.

3. *Don't complain that some other gallery has better prices.* The only possible response to that is, "Okay, so go buy your art there instead." If you notice a large price discrepancy between this gallery and others, ask diplomatically why these artworks are more expensive. There may be a good answer. For example, the pricier work may be by a well-established artist, while the painters down the street are unknowns. If the prices are high for no discernible reason, don't buy there, but don't make a scene.

4. *Don't treat the dealer disrespectfully.* The art world is small. An imperious, customer-is-king attitude can get you a bad reputation fast.

5. *Pay retail.* If you've found a fabulous dealer you'd like to work with in the future, pay the asking price, at least for now. Doing so will pay off later.

Guarantees of Authenticity

Both good dealers and bad dealers will offer you a guarantee of authenticity. How can you tell which certificates and assurances actually mean something?

The best way to evaluate a guarantee is to put yourself in the dealer's shoes. If you were going to give your solemn word that something was authentic, what kind of proof would you want to have before you made that claim? You'd want to know where the work has been since it was created. The paper trail would include original sales receipts, auction catalogs, or other documents that prove the ownership history. If something has no verifiable past, it may be a copy.

If you didn't have original documentation, you'd want an expert opinion from someone who has no financial stake in the sale, such as the artist's authentication board, an art historian, or a curator. For a piece by a major artist, you'd want to see the work listed in the artist's catalogue raisonné.

Good dealers are perfectly willing to show you the documents that convince *them* a work is real. Don't be afraid to ask for proof. That's part of what you're buying.

How and When to Bargain

Unfortunately, there's no universal rule about bargaining. Bargaining for oriental rugs, for example, is expected because it's part of the culture where these rugs are made. In other fields, such as blue-chip contemporary art, you're lucky if you get a piece at full retail.

In general, the more desirable the art is, the less you can negotiate a discount. Your success at bargaining depends on how easily the dealer thinks he can sell it to someone else. If you're buying in a recession or collecting an underappreciated type of art, you'll have more leverage than if you're looking at highly sought-after work in a boom economy.

It never hurts to ask for discounts. Dealers bargain all the time for their inventory. For some dealers, haggling is almost a reflex. They won't be offended.

Many people, though, are mortified by the idea of bargaining. Money is so tied to their self-esteem that they cringe at the thought of admitting they can't afford something (interestingly, extremely rich people don't seem to have this problem). Instead, they try to disparage the art in hopes of convincing the dealer that it isn't really as valuable as he or she thought it was. This strategy doesn't work.

What does work is giving a *solid reason* why the work is overpriced—assuming it is. If you happen to know that there's a glut of the artist's work on the market right now (because an estate or a major collector decided to unload inventory, for example), that's a good bargaining tool.

But suppose you don't have this type of knowledge. What

also works—believe it or not—is simply saying, "It's out of my range. Can you do any better on the price?" Dealers will often knock 10 to 15 percent off. If you're embarrassed to say you can't afford something, try asking, "Can you do any better on the price if I pay in cash?" That works too, because the dealer saves paying a fee to your credit card company. (Some dealers may also "forget" to include cash transactions in their tax returns.)

There are several reasons why a dealer might give you a discount:

1. *You're a good client.* Dealers have to work harder to sell to first-timers than to repeat customers, so they appreciate their "regulars." This is true in other industries as well, which is why companies give you "special introductory offers," frequent-flier miles, and myriad "club" memberships. If you're a regular buyer, or seem as if you might become one, the dealer may offer a discounted price, "for you."

2. *The piece has been in inventory a long time.* If something has been in the gallery a long time, the dealer might be anxious to make space for new work. Casually asking, "How long have you had this?" is a good way to find out. Sometimes, though, dealers sell art on consignment (meaning that the owner has asked the gallery to sell something in exchange for a commission). Consignment pieces are essentially free inventory, so the dealer may not be in a hurry to bargain.

3. *You're buying more than one piece.* When you're buying more than one piece, many dealers will automatically knock something off the price. If you ask, "How much for both?" it's understood that you're not simply asking the dealer to add the two price tags for you.

4. *You're buying a multiple.* When a dealer has multiple copies of a limited-edition print or photograph, you may have more flexibility to bargain. Some dealers charge less to early buyers, to build interest in the piece; then they even out the cost by charging later buyers more. Without a fixed price, there's room to bargain.

5. *The gallery needs cash right now to cover overhead.* In smaller galleries, the end of the month might be a good time to bargain, because a round of bills is coming due.

6. *The asking price was inflated.* This is especially true of oriental rugs.

7. *There's something wrong with the art.* Take a close look at condition.

There are several reasons why a dealer might not give you a discount:

1. *The art is already fairly priced.* Huckster galleries have wildly inflated prices that they "discount" to entice you to

buy, but legitimate galleries don't play that game. If they don't know you and don't need a quick sale, they may hold out for their sticker price.

2. *Someone else will pay more.* If the work is especially collectible, the dealer may prefer to hold out for someone who will pay the asking price.

3. *You look as though you throw money around.* Leave the diamond watch and designer labels at home when you go to galleries. Sure, you want to look as if your check will clear, but if your outfit costs more than the art, a dealer will naturally assume you can pay full price.

I once helped organize an exhibition of prints that had been donated to a museum by a very successful doctor. He was adamant that his profession not be mentioned in any of the promotional materials. He'd concealed his lucrative occupation from his dealers for decades, and he was worried they would start charging him more if they knew he was rich!

Another problem with wearing showy labels is that hucksters will target you as someone who's insecure and spends money for status. They're very, very good at manipulating people's insecurities. They do it for a living.

4. *They don't like you.* Rudeness can cost you money. No matter how accustomed you might be to bossing people around in your professional life, mind your manners in a gallery. Save the big-shot routine for Donald Trump.

Negotiating Techniques That Work

While many dealers will give you some type of discount if you simply ask, getting your ideal price may take some negotiation:

1. *Start the negotiation below what you're willing to pay.* Some experienced bargainers—the type who actually *enjoy* haggling— will advise you to make an unrealistically low first offer. Most of us, however, aren't comfortable doing that. For one thing, it seems rude to offer an absurdly low price. For another, it would be embarrassing. What if the dealer laughs at you?

There's an easy way to get around this problem. Instead of offering $400 for an item marked $1,000 and risking ridicule, simply say, "I really like this, but I had only budgeted about $400. I could probably stretch, though, if there's any flexibility in the price."

What you've actually done is start the "negotiation" at the lowball number, but in a way that no dealer can take umbrage at. You've admitted that $400 is too low, and because you didn't expect the seller to accept a lowball offer, you haven't hurt your negotiating position by offering to pay more. In fact, you've made yourself look both realistic and sincere. (You've also kept the option to "stretch" your budget up to the asking price if the dealer won't budge and you simply have to have the artwork.)

2. *Go up in small increments.* If the dealer is willing to negotiate, go up in small increments. If you've offered $2,000 and

the dealer counters with $3,000, don't hurry to split the difference at $2,500. Offer $2,200 and see if the dealer comes down closer to your price. The worst that can happen is you spend a couple of extra minutes negotiating.

3. *Take your time*. Some people rush to make a deal because they're uncomfortable with negotiating. Take your time. In many parts of the world, bargaining involves hours of talking over innumerable cups of tea. The more time the dealer spends with you, the more he or she has invested in making the sale.

4. *Change the subject*. If negotiations bog down, change the subject. Ask if the gallery will do a layaway. Many galleries will let you pay in installments and take the work home when you've paid in full. By asking for layaway, you show that you're serious about needing a better price. Questions about framing and delivery are also good for awkward spots. Sometimes a dealer who won't come down on price will throw in delivery or another perk to seal the deal.

5. *Be polite*. Even though bargaining is an inherently adversarial activity, always be polite. If you're pleasant to deal with, people are usually willing to work with you. If you're a pill, a dealer may prefer to lose a sale than have to talk to you another second.

Negotiating Techniques That Backfire

★ *Good cop/bad cop*
Some buyers swear they get better deals by shopping with a "bad cop." The "good cop" buyer expresses interest in a work of art, and the "bad cop" tries to talk the buyer out of the purchase, claiming that the art is overpriced or second-rate. Supposedly, this strategy makes the dealer realize that a sale is likely but not at top price. The problem is that good cop/bad cop can turn the conversation into a discussion about why the piece is good—that is, why you should pay full price—rather than a negotiation.

★ *Bargaining when you're not serious about buying*
If a dealer meets your price, you're expected to take out your wallet. Some people, for reasons unfathomable, bargain on things they don't actually intend to buy. This practice not only wastes the dealer's time but gets you a bad reputation—and deservedly so.

★ *Bluffing*
Pretending to know a lot about art and how much it's worth will always backfire. Remember: The dealer does this for a living!

Checklist for Dealing with Dealers

Does the dealer have a good reputation? Some promising signs are memberships in major dealer associations (see Resources), good word of mouth from people in the art community, a long business track record, and a clean record with the Better Business Bureau or some other relevant consumer organization.

Does the dealer seem knowledgeable about the career of the artist you're interested in, as well as how that artist's work fits into work of the period?

If the dealer isn't an expert in the art you're looking at, will he or she offer you a trial period and be willing to take the art back for a refund if it turns out to be something other than what he or she thought it was?

Have you checked resale values for the artist (whether in a price guide or over the Internet)? Do these values correspond with what the dealer says? Remember that a dealer may charge a markup over auction prices. That's normal.

Is the dealer willing to hold the artwork while you do research and think about it? A hard-sell dealer who wants you to buy this instant is usually a huckster.

Does your gut feeling tell you the dealer is trustworthy? Some red flags that might indicate otherwise are:

* excessive flattery about what good taste you have
* questions that sneakily try to figure out how much money you have
* hard-sell tactics about how this work is going up, up, up in value
* insistence that you buy today—tomorrow it will be gone
* talking too much about monetary values, not enough about art

HOW THE TOP DEALERS WORK

RICHARD SOLOMON

Richard Solomon is President of Pace Prints—a premier contemporary art gallery—as well as President of the Art Dealers Association of America (ADAA). He is a past president of the International Fine Print Dealers Association.

▶ *You've said that the general public doesn't always understand the full range of what art dealers actually do. Could you explain?*

The dealer's role as an educator is underappreciated by the collector—and frequently by the dealer himself! A good dealer educates the potential collector about how a particular piece fits within an artist's body of work, and within art of the period.

To do our job well, we need to be able to find out how much knowledge a collector has. How much can the

collector absorb? Most people go into a gallery with trepidation that their ignorance is going to show.

▶ *Well, some galleries seem to encourage that feeling. Some of them seem to be intimidating on purpose.*

Part of the problem there is circumstantial: Galleries try to create an environment where nothing interferes with viewing the art, so their environment is, by its nature, minimalist. That has a tendency to be austere and off-putting. A reception desk may be behind a wall, for instance, to help you view the art without distraction, but that makes you feel unwelcome. It's not intentional.

But I suppose certain aspects of elitism creep into any high-end, luxury-goods operation. Some dealers may think it enhances their prestige to be elitist. I'm not sure that isn't counterproductive. Too many of my colleagues make it a treasure hunt to find out about the artist and the prices. In my opinion, galleries should have good signage. It should be easy to get a price list.

The warmth of reception is important to make collectors feel at ease. Real dialog can happen only when the collector is at ease.

▶ *Isn't there a reason for collectors to be on guard, in that you're trying to sell them something?*

A contemporary dealer's first obligation is to his or her artist—to sell the work—but the art sells only if the buyer understands the context of the work. We dealers aren't just selling art—we're also selling confidence that the collector can rely on us.

▶ *What responsibility does the buyer have in this transaction?*

A collector has to spend enough time and energy to become informed. It's not enough to look at a picture and say, "Well, I like it."

You have to evaluate a work in the context of the artist's career, and in terms of comparable work by other artists. An exhibition will usually have enough works for you to get a sense of the artist, but sometimes a gallery may have only one piece by each artist. In that case, the dealer should be able to give you information to help put the work in context. The Internet is also a great tool for finding out more about artists and their work.

Art fairs, by the way, are a great place to become educated. They're less formal than a gallery, less intimidating, and you can talk to dealers on neutral ground. A few years ago I went to an art fair with some people who were sneering at everything they saw. They thought the art was a joke—you know, "My kid could do that." And I said, "Let me take you around and tell you about the art, and if you still feel the same way afterwards, fine." So we went around the fair together, and so far, I've sold about fifty works of art to these now-avid collectors. They've become very knowledgeable about contemporary art, and sometimes I think they know my inventory better than I do.

▶ *You're president of the ADAA, whose members are the cream of the art world. Collectors know when they walk in the door that they can rely on you. But what about other galleries that aren't members—newer galleries, for example, or smaller galleries outside major cities? How can a collector know whether it's safe to rely on them?*

▼

The first characteristic of a good gallery is the repu-
tation of the dealer in the community. ADAA membership
is by nomination, and galleries are vetted based on the
reputation of their artists and the quality of the works
they show, their programs and publications, their rela-
tionships with colleagues and curators, and their finan-
cial standing.

But you can get a good sense, just on your own, of
whether someone's trying to pawn something off or is
giving you a fair and legitimate price. A bad dealer thinks
he's just a salesman—like an auto dealer who tries to
sell you a car without first finding out what your driving
needs are. A good dealer imparts knowledge. If it's a new
artist, does the gallery give you sufficient information and
backup materials? Are they positioning the art? Those are
the kinds of things to look for.

▸ *What if you're still not sure if the art is for you?*

Many dealers are perfectly willing to allow you to
take a work home—with certain safeguards, of course—
to make sure it looks as good at home as it did in the
gallery. There's no reason why you can't ask a dealer to
see if this arrangement is possible. Or reserve the piece
if you can, and come back another day to look at it with
fresh eyes.

The key to collecting is doing one's homework. It
takes time, education, and looking. The first work of art
you buy may be an accident. The second time, you're a
collector!

11

Buying at Auction

Auctions are the most exciting way to buy art—or anything else. A bidding war between two buyers, each determined to win, has all the thrill of a sporting event, whether you're participating or just watching. Sometimes when a sale is particularly dramatic, the audience will break into spontaneous applause at the end. You never see *that* at a store, do you?

Auctions are also one of the easiest ways to buy art, since you don't have to fend off the hard sell from dealers working on commission, and you don't have to haggle over price. So why is the thought of bidding at auction so terrifying to many new buyers? Blame Hollywood. We've all seen movies where, for comic effect, the hero stumbles into an auction house,

scratches his ear, and suddenly finds that his gesture has oblig-
ated him to buy a million-dollar painting.

Real auctions don't work like that. You can scratch as much
as you like (or as much as the person sitting next to you will
tolerate) without the auctioneer ever looking your way and
barking, "Sold!" The real danger in buying at auction is being
unprepared. Fortunately, this problem—unlike a sudden itch—
is something you can control.

Finding the Right Auction for You

Auctions have been around since ancient times, and today
they're a multi-billion-dollar business. Nearly every kind of
art is sold at auction, from Titian to tramp art. Whatever your
price range and taste, you should be able to find an auction
that's right for you—and also find bargains. An art dealer can
hold out for the asking price, but an auction price is set only
by the people bidding against you. Getting a good deal is often
just a matter of doing your homework and being in the right
place. You have lots of options to choose from these days—
more than ever before:

The Major Auction Houses

The major auction houses—such as Sotheby's, Christie's,
and Phillips—can be intimidating to a novice because they
tend to conjure up images of men in tuxedos and dowagers

with mink coats and little dogs. Although these places are famous for their multi-million-dollar sales, you don't need the art budget of the Metropolitan Museum to buy there. In fact, the major houses have made great efforts in the past decades to bring in new buyers with sub-Rockefeller incomes. Both Sotheby's and Christie's, for example, auction prints, posters, and photographs with estimates under $5,000. They also hold lecture series you can attend for a small fee, as well as classes in connoisseurship. Why? They're trying to develop new collectors.

Don't feel that you have to be a serious buyer before you can set foot in one of these places. Nearly all auctions are free and open to the public (only the most rarefied evening sales require tickets). So are the viewing sessions, when the art for sale is displayed in the galleries for you to examine. If you live in a major city, try to go to viewings as often as you can. I once lived next door to Sotheby's in New York, and every week I'd stroll through the galleries to see what they were offering and eavesdrop on art world gossip—even when the paintings for sale cost more than my entire net worth.

There are several benefits to hanging around auction houses. First of all, you might see something in your price range that you want. That's why the auction houses are happy to have you there. Second, you'll see a lot of art. The major houses hold auctions every few days. The more you train your eye by looking at high-quality art—whether you can afford it or not—the easier it becomes to recognize the phony or the second-rate.

Art experts often say that they can spot a fake simply because it doesn't "feel" right.

Finally, the more time you spend in the environment, the more comfortable you're going to feel. After a while you'll start to be a "regular," and that will help you keep a calm head when you're bidding.

ADVANTAGES: A wide range of expertise and items for sale; extensive customer service

DISADVANTAGES: Locations only in major cities; lots of bidding competition

Regional Auction Houses

Art auctions aren't limited to the big, international establishments. Hundreds of regional auction houses cater to local clienteles, and they're not only in big cities. You can also find auctioneers in resort towns, affluent suburbs, and rural areas. Check newspaper ads or search the Internet to find out if any are located near you. Many operate like the major houses, though on a smaller scale and with fewer zeros on their sale prices. Others are mom-and-pop businesses that hold auctions infrequently, whenever they have enough items accumulated.

The experts at small auction houses are often extraordinarily knowledgeable. They have to be, because they probably handle everything from jewelry to Chippendale single-handedly. But they don't necessarily have the depth of scholarship you'll find at the major houses, where staff members have the luxury

of specializing in one field. Always assume that the item you're interested in may represent a gap in the expert's knowledge, and be prepared to do your own homework.

Some regional auction houses make no claims to vetting the art. In their view, they're simply providing a service, and you're solely responsible for whether the art is authentic or not. Never buy at auctions like this unless you're an expert. They're a dumping ground for fakes. If you're unsure of what the house policy is, ask!

Outside major cities, the best finds tend to be works by local artists or, conversely, things that local people aren't interested in. Big-city dealers of hip 1950s furniture, for example, often look for inventory in towns where locals are getting rid of "old-fashioned" boomerang tables and the like. (I've heard that some dealers even drive around on trash night, trawling for castoffs.)

In the good old days, you wouldn't have had much competition at these smaller auctions. If you took the trouble to show up in bad weather, you usually had your pick of the lots. But the situation is changing. Nowadays, an auction house in a town you've never heard of may have a presence on the Internet through eBay or some other host site.

ADVANTAGES: Limited competition (for now);
 possibility of finding an underappreciated treasure
DISADVANTAGES: Limited supply of art; possible gaps
 in staff expertise (and thus the chance that art is
 misattributed); unvetted fakes

Charity Auctions

If you're just starting to buy art, you might be tempted to start small, with a charity auction in your community. Charity auctions are usually held during fund-raising events for hospitals, universities, arts organizations, and other nonprofits. Unfortunately, they may be the most stressful auction experience of all. Their purpose is to raise money for a worthy cause (that's why the word *charity* comes before the word *auction*), so items often sell for above-retail prices. Even when you're willing to pay a premium for charity, well-meaning auctioneers try to cajole you into bidding more than you intended by reminding you what a good cause you're supporting. This appeal makes it hard to drop out of the bidding and risk looking like a cheapskate to your friends. Fortunately, many charities hold "silent auctions," in which you simply submit your bid in writing.

Even so, you still have to consider that these events are usually run by fund-raisers, not art historians, so purchases won't come with any expert evaluations. The organizers are often going on the word of the donor, who is getting a tax deduction for the value of the gift. You might find something great (especially when an artist contributes an original work to support his or her favorite charity), or you might find yourself unwittingly bidding on damaged, forged, or unsalable art that someone wants to dump.

Always make sure you have a chance to evaluate condition and to ask questions about authenticity and ownership history before you bid. If you feel uncomfortable asking for this at a

charity auction, bid on the "Trip for Two to Acapulco" and buy your art elsewhere.

> ADVANTAGES: Intrinsic reward of contributing to
> charity; possibility of buying something not often
> on the market
> DISADVANTAGES: Inflated prices; limited (or
> nonexistent) expertise of auction staff

Estate Auctions

Outside major urban areas, the type of auction you're most likely to encounter is an estate auction, at which the entire contents of someone's house are sold. You can usually find out about these in your local newspaper or by subscribing to one of the many publications devoted to art and antiques (see the Resources section).

Estate sales are hit-or-miss, depending on whether you share the taste of the previous owner. Sometimes, though, you can find treasures in unexpected places. I once attended an estate auction in upstate New York that had been advertised as having antique furniture and knickknacks. The "knickknacks" turned out to be a serious collection of African art. Most people were there to buy dining room chairs, so valuable African masks and statues went for almost nothing, often on the first bid, to two dealers who had taken the trouble to investigate the auction (and who tried very, very hard not to smile until the auction was over).

You, too, will need to do legwork to take full advantage of

estate sales. The auctioneers usually have a huge number of items to sell all at once, so sometimes their cataloging is not what it should be. In the rush to arrange a sale, reproductions may be mistaken for the real thing, and vice versa. Sometimes it's not even clear exactly what's being auctioned: You may see an estate sale ad that merely lists "old oil paintings." Are they Hudson River School originals or Elvis on velvet? You can certainly find treasures at estate sales, but you'll have to evaluate artworks for yourself and be willing to spend time sifting through junk.

ADVANTAGES: Limited competition; possibility of finding an underappreciated treasure

DISADVANTAGES: Difficulty in determining what will actually be auctioned; possible gaps in staff expertise

Cruise Ship Auctions

Cruise ships are getting in on the art boom by offering onboard auctions. Although these auctions can be a fun way to spend an evening, they have a bad reputation for selling art of dubious quality at high prices. People tend to spend money more freely on vacation than they do at home and are less careful about purchases.

Always do the same research onboard that you'd do if you were attending an auction back home, unless you're considering an inexpensive piece to buy as a souvenir. If you don't want to spend your sunbathing time on art research, take the

auctioneer's card and jot down the name of the artist who interests you. Chances are, you can have another chance to buy some of the artist's work when you get back home. Don't invest thousands of dollars on spur-of-the-moment purchases.

For Internet auctions, see Chapter 13, "Buying Art Online."

Auctions to Beware Of

Many years ago, I went to an auction for oriental rugs that was held in a hotel ballroom on a very snowy night. There were only about thirty people there, plus some three hundred rolled-up carpets. A good chance to find a bargain, right? Wrong. This setup, I later learned, is a notorious auction practice, particularly for oriental rugs. Here's what happened: The auction kept getting "postponed" while we waited for more people to show up. Then the auctioneer made an announcement that he couldn't let all of these rugs go for pennies and was canceling the auction, but if we were interested in any particular rugs, we could speak to the owner and try to make a deal. All of this is classic bunk. I didn't stay to see what happened next, but I now know enough to make a good guess.

At a phony auction, the estimates will be stratospheric, so you feel you're getting a great deal if you negotiate half of the estimate with the owner, who invariably will tell you he's making this deal only because he needs the money right now. You're probably paying more than you would in a store. As you walk out congratulating yourself on the "discount" you

negotiated, the merchant is rubbing his hands and laughing at you.

How can you tell if you're at a phony auction?

For starters, do the math. If they're offering a one-hour preview for three hundred items, they don't really expect anyone to do a very thorough investigation, do they? The viewing period should always be longer than the auction itself. Major auction houses usually offer two or more days of viewing for each sale. Smaller houses may allow a half day. And what happens when you divide the length of the auction by the number of items in the catalog? Would they have to sell something every ten seconds to finish on time? That's a sign that they are either terrible, terrible planners or have no intention of auctioning anything in the first place. As a benchmark comparison, Christie's auctions from sixty to one hundred lots per hour—and that's with expert auctioneers and a super-efficient infrastructure to scoot things along.

A hotel ballroom location is also a red flag (though it's perfectly fine for an art fair or an auction fund-raiser by an established, licensed charity). Auctioneers working out of a hotel room are literally fly-by-night. They're gone in the morning.

The Importance of the Viewing

All auction houses offer a viewing period when you can inspect the art that will go on the block. Don't shortchange yourself by skipping it. If you're short of time, you can usually forgo the auction itself by placing an absentee bid.

Viewings are a lot like museum exhibits, with one special advantage. You can touch the art or at least examine it very closely. You can see what the back of a painting looks like, feel the weight of a bronze statuette in your hand, and actually sit in a seventeenth-century chair. It's the kind of experience usually reserved for museum curators, and it's a great way to improve your connoisseurship.

But a viewing is more than just a hands-on shopping spree: It's also your only chance to examine the art closely before you buy it. As Yogi Berra said, "You can observe a lot by looking." When you see art in person, you notice problems that aren't apparent in photographs. The paint on a picture may seem about to "bubble up" and chip off. The edges of a print may be wavy from humidity. A bald spot on an oriental rug may have been painted to make the pattern look uniform. Any of these problems should influence how much you bid, or whether you bid at all.

If you're overwhelmed by the number of items to examine at a viewing, try this strategy: Make one tour through the gallery to decide which pieces interest you; then make a second pass to narrow down your choices and look carefully for scratches, repairs, and other problems. You should always take along a pen and paper for making notes, a calculator, a magnifying glass, and a tape measure. (If you're thinking of buying something very large, you need to be sure it will fit in your house and—don't laugh—through the door.)

Auction Catalogs, and What Their Terms Really Mean

Each auction will have a catalog listing the items for sale, along with descriptions, estimated prices, and auction house policies. It may be a glossy, full-color publication, or it may be stapled batch of photocopies. Either way, it should contain most of the information you need to prepare your bid. Here are some terms you'll need to know.

Attribution

Attribution simply means who the artist is, or (not so simply) who the experts *think* the artist is. Let's suppose you want to buy a Picasso, and four paintings are up for auction. One is marked "by Picasso," another is "attributed to Picasso," the third is "in the style of Picasso," and the fourth is "after Picasso." What's the difference?

"By Picasso" is straightforward enough. It means that the painting was done by the artist and the seller can prove it.

The phrase "attributed to Picasso" means that some people may think the painting is by Picasso, but the auction house is not betting its reputation. A work that is merely attributed to an artist will be less expensive than a piece whose authenticity is backed up. At the upper end of the art market, the difference between "by" and "attributed to" can be millions of dollars.

"In the style of" (or "school of") means that the painting was influenced by Picasso and is probably from the same era, but wasn't made by Picasso himself.

Finally, a painting marked "after Picasso" is a copy, probably painted by an art student.

If you are amazed to find something in your price range, double-check the attribution. It probably isn't what you thought it was.

Sometimes you may be tempted to take a risk on a mystery painting. After all, what if it turns out to be the real thing? Buying unattributed art is like playing the lottery. You read about major coups in the newspaper: Someone buys an old silver spoon for $50 that turns out to be an original Paul Revere; someone else finds a Rembrandt Peale painting at a garage sale because the sellers thought it was only a copy. You see folks on *Antiques Roadshow* find out that Aunt Tillie's old junk is actually worth six figures. But for every time this happens, there are untold numbers of buyers who thought they were getting something better than what they got. People who find "sleepers" in the big auctions are usually experts who know exactly what they're looking at. They're not guessing.

"Signed" and "Signed by"

Some auction houses have a tricky way of conveying attribution information. If they say that a painting is "signed *by* Picasso," they're claiming that the artist himself signed it. But if they say that the work is "signed Picasso," all they're saying is that *someone* signed Picasso's name to it, but they're not promising who.

Estimate

For every item the auction house plans to sell, an expert makes an educated guess—an estimate—about how much the work will fetch. Estimates are almost always given as a range (such as "$2,000 to $3,000") and are *not* the same as prices. An item may ultimately go for much less or much more than estimated. Sometimes an estimate may be intentionally low to encourage people to bid. Occasionally it may be high, if the sellers decide they won't let a picture be auctioned for less. The estimate is a useful benchmark, however, when you're deciding whether something's in your price range.

Reserve

A reserve is the lowest minimum price at which the owner will allow a work to be sold. If the bidding doesn't go that high, the artwork is "passed" and returned to the seller. You don't know in advance what the reserve price is, though by law it's less than the low estimate. To give you a ballpark idea, Sotheby's says that their reserves are about 80 percent of the low estimate. Wouldn't it be simpler if bidding always started at the reserve price? Yup.

Provenance

Provenance is a fancy word for "who the art belonged to before." Prior ownership can sometimes determine how much you'll pay—and whether you should buy at all.

If the previous owner was someone famous (or infamous), prices can skyrocket. Andy Warhol's cookie jars, for example, fetched thousands of dollars at auction and weren't even original art. Similarly, anything that belonged to Thomas Jefferson or the Duchess of Windsor is worth more than it would be if it belonged to their next-door neighbors. Prices also get bumped up if a painting once belonged to a respected collector or museum, because this type of ownership conveys a stamp of quality and authenticity.

Lot

The term *lot* refers to any item being auctioned. Sometimes a lot consists of two or more objects being sold together as a set. Each lot gets a number to identify it. When many similar items are up for sale, always double-check the lot number to be sure you're bidding on the correct lot.

Doing Your Homework

There are two basic types of art collectors: those who buy eclectically because something appeals to them, and those who calculate in advance what they want—often to fill a perceived gap in their collection—and then go seek it out. If you're not sure which type you are, think about how you buy clothes. Do you have a closet full of impulse purchases, or do you decide you need a blue sweater and then go buy one?

If you're the blue-sweater type, you've probably done most

of your homework before you even get to the viewing. If you're an impulse buyer, though, you need to do your research fast, between the viewing and the auction. Where do you start?

First, study the sale catalog to make sure you know exactly what you're bidding on, and what guarantees the auction house will provide for your purchase.

Guarantees of Authenticity

Established auctioneers usually guarantee that an item is what they say it is, with certain legitimate qualifications. For example, a guarantee may be good only for a limited number of years. The fine print may also say that evidence of authenticity is limited to the best scholarship currently available. This means that if, years from now, an art historian unearths documents proving that all of Rembrandt's later works were actually done by his assistant, Joe van Shmo, then their owners are out of luck. These are reasonable business practices to limit the institution's liability.

Here's where it gets complicated: Sometimes auction houses make exceptions to their guarantees for items they themselves have problems authenticating. A couple of major auction houses, for example, won't guarantee the authorship of art created before 1870. In addition, at some houses, the high-end sales have guarantees, but the lower-priced sales don't because, from a business standpoint, it's not worth the experts' time to vet items the same way.

No matter how many things you've bought at a particular auction house before, don't assume that you're getting the same promises as last time. Always check the catalog for each individual sale you intend to bid on. If anything seems unclear, don't be shy about asking questions. That's what the experts and the customer service staff are there for.

As we already noted, some smaller auctioneers may not offer any guarantees at all. As they see it, they're providing a service by making art available to you. The amount you're willing to risk on nonguaranteed art depends on your personality, your budget, and your level of expertise. When you're torn between wanting something and walking away, ask yourself these questions:

How confident am I that the art is authentic, based on my own evaluation?

If it isn't what the catalog claims, what else might it be? A work by a lesser artist? A modern copy? An outright forgery? To make your best guess, turn to the chapter in this book that covers the kind of art you're interested in; then follow the step-by-step checklist. Sometimes this exercise alone will help you eliminate a bad purchase.

Will I feel worse if I buy it and it's fake, or if I don't buy it and it's real?

Can I afford to be wrong?

Evaluating Art for Yourself

You may not have the years of training and experience that the experts have, but you can follow the same steps they do when examining art. Here's how.

* Evaluate the artwork using both your gut feeling and the checklist in the chapter that covers the type of art you're looking at. If something seems "wrong" at first glance, trust your instinct.

* Find out how much similar items have sold for recently. If the viewing is on a different day from the auction, you have time to consult the Internet to examine sales records. If the viewing is held the same day as the auction and you won't have Internet access, take along one of the price guide books that are published annually—*The Hislop's Official International Price Guide to Fine Art* is one of the most widely used—to give you a ballpark idea of what people are paying for similar pieces.

* Examine the condition of the item. A statue that's been chipped or a rug that's been repaired will usually go for less than a perfect example. Keep in mind, though, that an object with original peeling paint is often worth more than a similar piece that's been refinished; too much restoration can ruin an artwork even more than neglect. If you're not confident of your own abilities to find all the problems, ask the auction staff for a condition report.

★ With valuable, one-of-a-kind art, make sure the item has a clear provenance. The auction house experts should already have investigated this. If there's a gap in ownership, ask why. If you don't get a satisfactory answer, reconsider your bid.

★ Once you have a rough idea what the artwork is worth, you have to decide what it's worth to *you*. Is it something you'll be happy to live with for a long time? Or is there something else you'd rather have for the same money? Decide how much you can afford to spend; then note that figure in the catalog. Putting it in writing for yourself can help you stick to your budget later when you're bidding.

Calling for Backup

Some people are uncomfortable evaluating art on their own and prefer to work with a dealer. Actually, you can have the best of both worlds. For a 5 or 10 percent commission, many dealers will evaluate auction house art and even bid on it for you.

"Museums pay dealers to do this for them all the time," observes top dealer David Tunick, "so why shouldn't a novice collector?"

Surcharges and Other Little Extras

Before you can decide how much to bid, you need to know how many "extras" you'll have to pay for before you

can actually get your purchase out the door. It's often more than you'd think.

As a buyer, you'll have to pay a commission—usually between 10 and 20 percent of the sale price—for every item you win. Thus if you buy something for $1,000, and the commission is 20 percent, you'll have to pay the auction house $1,200. Then you need to add on sales tax. In New York, for example, this would be an additional 8.25 percent—and that's on both the purchase price *and* the commission. (See why I told you to take a calculator?)

Beware also of hidden costs. Can't fit the marble statue in the back of your car? Delivery is extra. Can't arrange delivery right away? The auction house might charge you for storage and insurance in the meantime. Believe it or not, you should even double-check whether a picture displayed in a frame actually comes with the frame.

Your "final" bid should always allow for extras. Never bid your entire budget!

The sale catalog ought to list all the information you need to calculate your real costs, but the text may be squished in the back in tiny print. If in doubt, ask. And, as with any contract, get it in writing.

The Bidding Process

Congratulations—you're ready to bid. Before the auction begins, you need to register with the auction staff. They will take your name, address, and credit information. Then they'll

give you a card or paddle (like a table-tennis paddle) with a bidder number on it. When you want to bid, you raise it so the auctioneer sees you. Simple, right? Not necessarily . . .

The funny thing about an auction paddle is that it has an almost magnetic desire to rise up. Sometimes simply touching one changes people's personalities. Even if you're normally level-headed, you may get a sudden adrenaline rush from being the center of attention while bidding. And if you find yourself in a bidding war, winning the item can inexplicably become as important to you as winning the Super Bowl. People in the art world call this "auction fever."

The most important thing you can take to an auction is discipline. Make sure you mark in your catalog which items you want, what your top bid will be, and how much you can spend overall at the auction. Then stick to that. Don't decide to bid on something "while you're at it"—particularly if you didn't examine it carefully at the viewing.

(For more tips on buying at auction, see my interview with Jennifer Vorbach at the end of this chapter.)

Absentee Bids

Most auctions allow you to bid without attending the actual sale. You can do this by submitting a bid in writing or over the Internet, depending on the rules of the individual auction house. Don't wait until the last minute, though. Many establishments have cutoff deadlines for absentee bids (such as twenty-four hours before the sale), and if they receive multiple bids for the same amount, the earliest bid wins.

One advantage to absentee bidding is that you never get caught up in the frenzy of the salesroom and bid more than you planned. If you're particularly nervous about how you would do at a live auction, consider placing an absentee bid and then watching the sale from the sidelines. (If you do this, though, make sure you don't also register for a paddle. You don't want to get auction fever and start bidding against yourself!)

Beating the Dealers

You may wonder if you can possibly get a good deal at auction when you'll be bidding against experienced art dealers. You can, but it depends on the circumstances.

When a dealer is bidding on an item for a client who definitely wants it, you have a formidable opponent. The dealer is much more skilled at bidding than you are, and a client who hires a dealer to bid is probably very serious about winning. Your only sure way of winning is to overpay. Not good.

On the other hand, when a dealer is buying inventory on speculation, you have a chance. Dealers have to pay for their overhead (rent, salary, insurance, etc.), so they need to charge a markup on everything they resell. If you buy an antique print in a gallery, you might be paying double what the dealer did. When you're sitting next to that dealer at the auction where she's getting her inventory, however, you may only have to bid 10 to 20 percent more before she feels her profit

margin is too small to make the purchase worthwhile and drops out.

(A wine-collector friend of mine swears that there's a pattern to auctions where you're up against dealers. Most of the best buys, he says, are made either at the beginning or the end of the sale. The dealers come in with lists of what they want, and sometimes they let a terrific lot go by early on to make sure they have enough funds for what they want to buy later. Toward the end of the auction, they're often out of money. My friend routinely gets spectacular buys by bidding early and late. Obviously, things aren't so simple when you're bidding on art to live with forever, rather than on a nice Sauterne to serve after dinner. But if you're attending a sale where many works are similar in nature or by the same artist, the same pattern might apply.)

Winning Through Intimidation

One way to get other bidders to drop out is to raise your paddle in the air and keep it there. Affect a very determined I-can-hold-this-up-all-day pose. This signals that you're out to beat everyone. Anyone who is only mildly interested will likely pull out. Be sure to take your paddle down if the price goes beyond your top bid, though!

After the Auction

Most auctioneers expect you to pay for your purchase immediately after the auction, whether by cash, credit card, wire transfer, or personal check (the catalog will tell you which payment methods are accepted). The big auction houses can bill you and give you a few days to pay. They're used to buyers who have to consolidate funds to pay for that multi-million-dollar Matisse.

Be aware that you may be responsible for the insurance on your new picture or sculpture even before you take it out the door. To be sure exactly when the responsibility crosses over from the auction house to you, always check the catalog or ask.

If you are arranging for professional delivery (the auctioneer can usually help you with this), be sure that the moving company has its own insurance. Even if an auction house recommends the moving company, the auctioneers are not responsible if something happens between their front door and yours. Make the movers fax you their insurance certificate before you hire them—it takes only a few minutes and saves a lot of grief. If you've bought an extremely valuable piece of art (lucky you!), you may have to arrange supplemental insurance, and you'll want to check the movers' references too.

Buyer's Remorse

Buyer's remorse can happen with any art purchase, but it's especially bad after an auction. You've bought something that, literally, no one else wanted for the price. That's why, for

your own peace of mind, you should always decide in advance what you'll bid on, and for how much. Remorse is inevitable if you've bought on a whim only to discover that you overpaid, or that the piece has damage you failed to notice at the viewing.

Even when you're vigilant, you can still make a mistake. Perhaps the painting doesn't look right in your home, or maybe you see something you like better the following week but you've spent your whole art budget.

If you really, really hate what you bought, you do have a few options. First, check to see exactly what the catalog text said. If the catalog misrepresented the artwork, you may have a case for getting your money back.

Second, you can try to make a private deal with the underbidder (the person you beat out for the item). To preserve your options, always try to introduce yourself to the underbidder and exchange contact information. At the very least, you've met someone with similar taste and interests; sometimes he or she is even a dealer you may want to work with. If you later make a private deal, you probably won't get all your money back. After all, the underbidder wasn't willing to pay what you did. If you have the nerve, though, ask for 10 to 20 percent over the underbidder's final bid, comparable to the take-home price he or she would have paid with the auction house commission.

If that fails, you can ask the auction house to resell the object for you in a future sale, or you can try to sell it yourself at a consignment shop, through a dealer, or over the Internet.

Planning for the Future

When you go home with your first art auction purchase, you probably think that all you need to do now is figure out where to display it. But you also need to do some record keeping. Make a file for all the documents related to your sale: the catalog description, receipt, condition report, and all of your notes. This information will come in handy if you ever need to file an insurance claim, or if you want to sell or bequeath the art.

While you're at it, you might want to start keeping files on the "ones that got away." Chances are, you'll be attracted to the same kinds of art in the future. If you keep notes on items that you liked but didn't buy—where you saw them and what they went for—you have ready-made research for next time. To increase your chances of finding similar art, you can subscribe to auction house catalogs in the fields that interest you, or you can sign up to receive e-mail alerts when an auction in your field is coming up. (See Resources for details.)

Happy bidding.

Checklist for Buying at Auction

Have you attended the viewing and examined the art? Is it in good condition? If you're not sure, ask the auction staff for a condition report. All the large auction houses can provide one.

Do you know what kind of authenticity guarantee the
auctioneer is offering, if any?

Have you researched prices for comparable work,
either online or in a price guide?

Do you know how much commissions, taxes, and
other extras will cost?

Have you determined your maximum bid and written
it down in your catalog? And do you trust yourself
not to exceed this amount in the heat of the
auction?

Do you love what you're buying?

INSIDE A TOP AUCTION HOUSE

JENNIFER VORBACH

*Jennifer Vorbach began her career at Christie's in New York
as head of the Print Department, later becoming the head of
Contemporary Painting and an auctioneer. She is currently
Christie's International Director for Postwar and Contempo-
rary Art, based in Geneva.*

▸When you were the head of Contemporary Painting, how
did you determine estimates? Prices in that field seem
like constantly moving targets.

It depends on what you mean by the contemporary
market. Even within postwar art, there are tiers of
"contemporary."

Established, blue-chip contemporary art is evaluated

much the same way that Impressionists and Modern masters are evaluated. First and foremost, experts consider comparable sales—both auction and private sales (if known)—when determining estimates, along with a qualitative judgment of the work being appraised, its condition, and so on.

When you are looking to assign value to very young art, then the gallery price is a greater factor, since there may be few resale records to use. The general rule of thumb was that the auction estimate should reflect a price somewhat lower than the "retail" price, to make the work enticing. And while the auction houses used to shy away from offering the work of young artists, they are now in the thick of participating in those fresh markets.

What's interesting to see is which very young art gets taken into auctions, and which is deemed unauctionable. There has to be the perception of a strong after-market for the work to be considered interesting for auction—in other words, there has to be pent-up demand for the work to be included successfully. The auction results can then exceed the "retail" pricing because of the pent-up demand.

▶ *Speaking of exceeding estimates, are there times when auction house estimates are intentionally low? I'm thinking of the Jackie Onassis sale at Sotheby's, for example, when the estimates were substantially lower than the final hammer prices. I heard they were low on purpose to encourage new bidders.*

The auction houses have found that printing a low estimate can be to the seller's advantage by enticing more

competition—and to the advantage of the auction house, which can then publicize how many lots sell for more than the estimates. So yes, there is a tendency to underestimate. But there are also pressures from sellers to keep estimates (and therefore reserves) at a level that the sellers are comfortable with, which can send the estimates off in the other direction.

You're right that estate sales often have low estimates because there is no living owner to push for higher estimates. The estate sales often do well because of their "celebrity status" when they have one, and also because of what seems to be a universal human trait, which is that people are generally happier to pay a high price to a dead owner than to their living co-collector.

▶*What advice would you give to a new collector who is planning to bid at auction for the first time?*

I would advise any unseasoned collector to do a "dry run." They should get a catalog, go to the viewing, identify several works which are of theoretical interest, talk to the expert in charge about the lots in question, do their own investigation of condition and scarcity, examine the pieces, and then follow the sale and examine the results of the sale without actually buying anything.

The beginning collector should also investigate the commission charged by the auction houses and factor that into his or her bidding strategy. For instance, a work sold for less than $100,000 now carries a 20 percent–plus commission at the major houses. Then there is sales tax to consider, and the shipping and insuring of the work once you have paid for it.

The collector would also be well advised to make friends in the dealer community and investigate what similar objects are available on the private market. While there can be bargains to be had at auction, there are just as many instances of works selling for more at auction than the asking price of a comparable object in a gallery. Caveat emptor.

And remember that the fall of the hammer represents the sealing of a contract between the buyer and the auction house, and that you don't get to try the work at home or change your mind once the lot has been hammered down.

Once collectors are prepared to go ahead and bid at auction, then they can repeat these steps. I would also suggest going with a friend who knows what the bid limit is and won't allow the bidder to go over that amount. Seasoned collectors, later in the process, may wish to amend their bidding strategy during the sale, but a beginning collector should guard against the enthusiasm generated by the auction process itself. Auction fever is real!

12

Off the Beaten Path

Although art is typically sold at galleries and auction houses, you could build a fine collection without ever setting foot in either. Art doesn't miraculously appear in Chelsea or Christie's. The dealers and experts have to seek it out—sometimes in unlikely places. You can too.

How far you want to stray off the beaten path depends on your personality. Some people (like me) love a treasure hunt. We'll happily comb through twenty dud flea markets to find one great piece. Other people (like my husband) get overwhelmed. They don't want to search for art under piles of Fiestaware and Barbie lunch boxes. They want a dealer to have preselected all the good pieces for them.

If you're just starting to collect and your connoisseurship is shaky, start with art fairs and vetted shows, where a certain amount of prescreening has already taken place. As you get more comfortable with your taste and expertise, you can look farther afield. (My own best discovery was a fragment of Northwest Coast Indian art *lying in the street* next to a major auction house. It had somehow become detached from a larger piece while being transported. I returned it, of course, but at least I got a good story.)

You never know what you'll find—or where you'll find it.

Art Fairs

Okay, art fairs aren't really off the beaten path, because you're still working with reputable dealers. Established galleries rent booths at these fairs to expose their artists to a wider public. Collectors feel safe buying here because they know in advance that the dealers are reliable, even the unfamiliar ones. At many fairs, the art has also been vetted, which means that a team of experts has determined that everything is authentic. When that's the case, you can buy with confidence.

Some of the art fairs are extremely high-end, with million-dollar price tags. It's still worth going, even if all you can afford is an admission ticket. In one place, you get to see a large section of the art market. You'd have to spend a lot of Saturdays going to galleries to see as much. It's also a great way to get to see work from other regions and countries.

Many collectors find art fairs less intimidating than fancy

galleries. The environment is more casual, and dealers seem more approachable than they do back home, where they're invariably on the phone, with another collector, or hidden behind a big white wall.

The biggest problem with art fairs is that they can be overwhelming. When you start out, you'll probably spend time in each booth, but after a while, you'll start zooming past the booths unless something happens to catch your eye. You can miss things that way. Make a plan before you set out. Decide in advance what type of art you want to look at. Or, if you really want to stroll and discover new things, take breaks so that you stay fresh and focused.

The Affordable Art Fairs

The Affordable Art Fair in New York has become very popular with new collectors. For a $12 admission fee, it offers a chance to see original art from more than one hundred dealers, without any of the trepidation that sometimes accompanies going to a gallery. "Our goal is to get people who are intimidated by going into the white cube galleries," says Helen Allen, director of the fair.

All art at the Affordable Art Fair has clearly marked prices, starting at as little as $100, with no artwork costing above $5,000. The pricing system takes away the fear that you'll ask a dealer how much something costs and it will be more than your house.

"Because of the price point, most of the fair's artists are younger to midcareer, though we've sometimes had prints by

Larry Rivers, Richard Serra, Christo, and other well-known artists," says Allen. "The galleries run the gamut from young, new places to ADAA members looking to promote their younger artists or trying to reach out to a new audience."

The Affordable Art Fair franchise began in 1999 when London dealer Will Ramsay decided he wanted to expose the broader public to galleries in his price range and to "help eliminate the intimidation factor associated with learning about and purchasing art." The first Affordable Art Fair was an instant success. There are now two fairs a year in London, one in Bristol (England), one in New York, two in Australia (in Sydney and Melbourne), and another scheduled for California. These four-day events now draw thousands of art enthusiasts.

They're not only a place to buy; they're also a place to learn. The New York Affordable Art Fair hosts lectures on a variety of topics related to collecting. It also features demonstrations of printmaking and photography techniques so that visitors can educate themselves and know more about what they're buying.

As the fair has grown, the audience has changed. "It used to be mostly newcomers," says Allen, "but now our audience is a pretty even split between experienced collectors and new buyers. Part of that is because our repeat visitors no longer consider themselves newcomers—they're now collectors."

Art Shows

The difference between an art *fair* and an art *show* is simple. Fairs have dealers; shows don't. At fairs, dealers rent booths. At shows, artists submit their work directly to the organizers.

If an art show is advertised as being "juried," that means that someone with (presumably) some level of expertise has weeded out the junk. Some juried shows, especially the well-known P.S. 1 show in New York, are prestigious, career-making opportunities for new artists. This is where top-notch dealers go to discover new talent.

The alternative to a juried show is an "open" show, where anybody can exhibit artwork. Don't assume that these shows are amateurish. Some are excellent. If you live in a major city, or in a resort or college town where artists congregate, don't turn up your nose at an open show.

You'll often have a chance to meet the artists and hear them talk about their own work and the work of their peers. Listen to what they say. Artists are usually good judges of which other artists have talent. Whenever you have a chance to talk to contemporary artists, always ask them who else they think is good. (Remember, out of courtesy, always to include the "else.") You may find that the same name or names keep coming up.

Antiques Shows and Fairs

Antiques shows aren't only for buying furniture. You can also find wonderful prints, posters, photos, rugs, and more.

Rule 1 about these sales is to get there early. And by that I mean *really* early. At the major shows—such as the huge ones in Brimfield, Massachusetts—serious collectors are up by dawn, on the prowl for treasures. (Apparently some treasure hunters even roam around with flashlights the night before, to get the jump on the morning's competition.) Whenever you go to a big fair like Brimfield, try to go on the first day— usually a weekday—when dealers are buying from each other. You'll often get better prices than you would on a "tourist" weekend day.

If you're not a morning person and can't take off work during the week, don't worry. You can also find bargains at the very end of a show. Sometimes a dealer doesn't want to schlep things back home, especially if they're heavy. Or perhaps the dealer didn't sell as much as he or she had hoped and wants to make the trip worthwhile.

Whether you buy early or late, the pricing at fairs can be confusing. Some dealers have price tags; others wait to size you up before settling on a price. Try not to look as if you throw money around. (No designer labels on the outside of your clothes, please!) Be aware that dealers may get bargaining fatigue after a while. If you come on the last day and ask, "Can you do any better on the price?" you may well get a snappish response: "Sure, I'll double it!" Don't take it personally.

Keep in mind also that a piece may be cheap because there's

something wrong with it, such as poor condition or a problem with authenticity. At the biggest fairs, experienced collectors are unlikely to have overlooked a true bargain. Look critically at anything that has been passed over, and always ask the dealer to tell you about it. Some new collectors think they'll pay less if they don't call the dealer's attention to the piece they're interested in; they want to buy fast, before the dealer realizes how desirable it is. That's a sure way to build a collection of reproductions and damaged art if you're not an expert. A good dealer is your ally, not your nemesis.

Artists' Studios

Dealers are lucky. They're inundated with slides from aspiring artists. You, alas, are not. You have to do some legwork to find the most promising new artists before they get priced out of your range. How do you get to see artists' studios if you're not an artist yourself? Go to open studios!

Local arts associations often host "open studio" days when the general public can go into studios, meet the artists, and see their new work. To find out about art associations in your area, try an Internet search for your town or region and the words "artist association" or "open studio."

Be forewarned that if you go to open studios in New York City—especially the ones hosted by the Lower Manhattan Cultural Council—lots of other collectors will have the same idea. Sharpen your elbows if you want to get the best art for yourself.

Buying from Artists

If an artist doesn't have a dealer, you can usually buy directly from the artist, but doing so is not as easy as it sounds.

If an artist has taken time out of the workday to show you his or her art, you may feel morally obligated to buy something even if you haven't sparked to the work. Another problem is that you can't bargain on price, the way you could with a dealer. An artist often has his or her ego (and perhaps next month's rent) tied up in the negotiation.

If you do want to buy, remember that you're more comfortable in your role as a customer than the artist may be in the role of a seller. Don't ask the price of every single piece. Ask only about the pieces you're truly interested in. (Better still, ask if the piece is for sale before asking how much it is.)

If you can't afford the work, avoid making the artist uncomfortable. Say that the piece is definitely worth the price but beyond your means. If you think the artist would be willing to show you additional work, ask if there's something similar but cheaper—perhaps a drawing or a print.

Sometimes your enthusiasm alone will be enough to get a discount on the price. Once when I visited an artist-friend's studio, I loved a particular one-of-a-kind monoprint but could afford only a smaller limited-edition print. When I unwrapped my package at home, I saw that he had given me the piece I really wanted (at the lower price) just because he knew I loved it.

Art Schools

Once upon a time, aspiring artists went to art school to learn technique. After graduation, they worked odd jobs, lived in bohemian poverty, and tried to develop an individual style. Those days are gone.

Today, the top MFA programs—especially Columbia, Yale, and Hunter College—are springboards into the New York art world. Their MFA graduation shows are no longer just for friends and family of students; they're for dealers and collectors who are literally buying art off the walls.

"Columbia is like a feeding frenzy," says private curator and dealer Renee Vara. "I feel bad for the artists because of the level of pressure. If you come out and don't have a curator or dealer, you're dead." (For more on "hot" art schools, see my interview with Jon Kessler at the end of this chapter.)

For many collectors, these MFA shows provide a great opportunity—possibly your last opportunity—to buy work by artists who will become stars. But you're not the only collector who has thought of this, so don't wait until the last day of the show.

Less frenetic MFA shows are a good place to learn more about contemporary art in general. Ask the students to tell you about their work, and also ask who else they think is good. (Again, remember that critical "else.") Art students typically have a good sense of what's new and innovative in the art world—and they're not yet bored with talking about it.

Museum Rentals

Have you ever visited a museum and wished you could take the art home? Actually, you can. In several major cities, museums are opening retail galleries where you can buy art—usually contemporary work—that's been vetted by experts.

What's more, museum members can even *rent* the art—for as little as $15 a month at some museums. Rental costs may be applied toward buying the work later. If you have a modest budget, or if you're still trying to figure out what type of art you like, museum rentals can be a great opportunity to try new art with little cash outlay and no buyer's remorse.

To find out if your own local museum has a sales and rental gallery, check its website, or give the museum a call. Don't be put off by the membership requirement. At most museums, you can buy an annual membership for about $50 to $100, some of which is tax deductible.

As an added benefit, many museums have a "Young Collectors" group you can join by becoming a museum member. (Don't confuse this with a "Junior Patron" program, which is how museums cozy up to future CEOs and heiresses who'll inherit Aunt Minnie's Renoir someday.) These "New Collector" groups are a great way to meet other people with similar interests and to get invited to special lectures, gallery tours, opening-night parties, and artist talks. You're instantly part of the art community.

Yard Sales

It can happen. People really do find treasures at yard sales, but the reason is always the same: The buyer knew more than the seller. If you don't have expertise, you're just guessing. When you're just guessing, the odds of making a major find are not in your favor. Big art discoveries get written up in the newspaper because they're *rare*.

If an item is inexpensive, go ahead and take a chance. It's fun, and you can learn a lot about connoisseurship by trying to figure out at home whether the piece is real. (You can always resell it at your own garage sale if it doesn't pan out.) Just be sure you don't buy so many potential "treasures" at yard sales that you waste the money you could have spent on something real at a gallery.

Let's say, though, that you *do* feel confident of your knowledge in a particular area. How do you find the best deals? Get a reliable alarm clock! The best material at yard sales goes early, often before you've had your first cup of coffee, to people called "pickers."

Pickers are a critical part of the art and antique market. They have a good eye and extensive knowledge that helps them find treasures at low-end sales and then resell items to dealers at a markup. Pickers always show up early, sometimes even before the sellers have set up their merchandise. (Have you ever seen yard sale ads that say "No early birds"? That's what they're talking about.) Pickers also pay cash. They carry wads of low-denomination bills, on the theory that it's easier

to bargain when the seller doesn't see a big bill in your hand. You should do the same.

Fortunately, pickers buy only what they know for sure they can resell. For all their knowledge, they don't make much money, so they don't waste their funds on anything eccentric or out of fashion. If that's what you collect, you're in luck.

Yard sales are great places to find what's known as "Outsider art" or "tramp art" (or *art brut,* if you want to get French about it). These one-of-a-kind pieces were made by self-trained artists, and they're often eccentric and amazing. Last summer I saw a fabulous "beaded curtain" made out of found objects and pieces of garden hose. (My husband hated it; I'm still brooding about not buying it.)

If yard sales are your passion, you might want to check out the annual Highway 127 Corridor Sale—a 450-mile-long yard sale that snakes through four southern states (Alabama, Tennessee, Kentucky, and a smidgeon of Georgia) over four days (for details, see the website www.127sale.com).

Estate Sales

The difference between an estate sale and a garage sale is that at an estate sale the entire contents of a house are being sold, not just "junk" the owner is tired of. That's great if you're looking for household goods, less so if you're looking for art. Why is that?

Usually, a professional appraiser is hired before an estate sale. So if there was any important fine art in the house, it's al-

ready been carted off to a dealer or auction house. And because the expert looked over everything else, you're unlikely to find undervalued treasures (though it sometimes happens—no expert is infallible). If you're willing to pay a fair-market price, you can often find midrange art—the pieces that aren't worth sending to Sotheby's but are still attractive. If you collect something that's currently out of fashion, you might actually get some bargains.

Beware if you're led to believe you will be able to buy investment-quality art at an estate sale. Sometimes a misrepresentation is an honest mistake. The heirs might sincerely believe that a fake painting is the real thing. Perhaps they even have Grandma's bogus "Guarantee of Authenticity" from a huckster gallery and are genuinely baffled as to why the auction house told them "no thanks."

A more serious (though fortunately rare) problem is fraud. Unscrupulous dealers may try to dump their inventory at an estate sale by pretending that the pieces belong to the estate. Be suspicious if more oriental rugs than would realistically fit in a house are offered for sale. If all the art is by big-name artists such as Picasso, Chagall, and Dalí, ask yourself whether heirs with truly valuable art would allow it to be sold to whoever happens to attend the estate sale. Use common sense.

Thrift and Consignment Shops

Consignment shops resell things for people in exchange for a commission. Thrift shops resell donated things that people

don't want anymore, and keep the profit. Either type of store, especially if it's located in a rich community or resort town, can be a good place to find affordable art.

Of course, dealers and decorators already know this. When I spent summers in Newport, Rhode Island, I often saw great things at low-rent thrift shops. But they always, always, always had little red stickers on them indicating that they were already sold. A few weeks later, I would see the same pieces in smart shops, with much higher price tags.

Crafty dealers know which days (and even which hours) new material is put out for sale at the best thrift and consignment shops. You can find out, too, by asking the staff. If you saunter in only when you're in the mood, you'll miss the best stuff.

Many upscale thrift shops sell their best pieces at special auctions or evening sales. Ask to get on the mailing list for these events. With a little legwork, you can avoid seeing those dreaded red stickers!

Flea Markets

Flea markets are the low-end cousin of antique shows. They're held anywhere from school gymnasiums to church basements to vacant lots. The biggest ones are like makeshift towns that go on for miles. Wherever you find them, flea markets are great fun.

The best flea markets for art enthusiasts are the established, weekly events where professional dealers sell their wares. You

can find out about them by checking the ads in your local newspaper or in specialized publications, such as *Antiques and the Arts Weekly*. These dealers are constantly replenishing their inventory and socializing with other dealers, so they know about a huge amount of things for sale. They also know all the gossip about who's reputable and who's not. If you specialize in a particular area, tell the dealers! Even if what you collect isn't their area of expertise, they might know about things that interest you. Give them your card, and ask them to call you if they find something. You'll save yourself a lot of legwork.

Another tip from the cognoscenti: If you collect a particular type of art and have no sense of personal shame, go to flea markets wearing a T-shirt that says, "I collect vintage posters," or whatever your particular passion is. Dealers will seek you out.

If you ever have a chance to go to the big Paris flea markets—*les puces*—you should. They can be just as educational as spending the day in a museum. The huge Saint-Ouen market on the outskirts of town draws twenty thousand visitors every weekend, including dealers and interior decorators trawling for treasures. You can find wonderful oriental rugs, Belle Époque posters, 19th-century paintings, tribal sculptures, and objets d'art that look as though they were pilfered from Versailles during one of France's various revolutions.

The downside to buying big-ticket items at a flea market is that you don't have much time to consider your purchase. If you hesitate, you may find something bought right out from under you. When you find a piece that's interesting, pick it up—or, if it's large, keep your hand on it—while you

make up your mind. That signals to other would-be buyers that it's "yours." If you want to look around some more before buying, ask the dealer to hold the piece for you. He or she is more likely to do this if you leave a small good-faith deposit.

Since you probably won't be able to do any research on the Internet, take along one of the art price-guide books. It's also a good idea to carry a copy of your own country's customs regulations about importing art and antiques.

Take plenty of cash with you to *les puces*. Many of the dealers—whether for reasons of tradition or tax evasion—don't take credit cards.

On Television

In Europe, some entrepreneurial art dealers have begun selling art on television. The shows are similar to home shopping programs that sell foot massagers and antiaging creams: The host makes a sales pitch for a work of art on camera, viewers call in with their credit card numbers, and the art shows up at their door a few days later.

It's only a matter of time before someone tries the same thing in America. Television is a natural medium for sales. The question is whether future art-buying shows will feature work from reputable galleries or junk targeted to unsophisticated buyers. My guess is the latter, but who knows?

When buying art through any electronic medium—whether television or the Internet—you want all the safe-

guards you'd have from a traditional gallery. You want to know how reputable the dealer is. You want documents that prove authenticity and title for the art. You want a chance to examine the art at home for condition. And, most important, you want a money-back guarantee.

Over the Phone

Caveat emptor. Some "art galleries" use telemarketing cold-call techniques to sell people art as an "investment." Their sales pitch is about how much the art will go up in value. Even well-educated people have fallen for this, buying prints by Dalí, Chagall, or some other big-name artist sight unseen. Unfortunately, the art often turns out to be fake or worthless. By the time buyers find out they've been duped—usually when they're trying to resell the art—the "gallery" they bought from is long gone.

Buying art from a telemarketer is a bad, bad, bad idea. If you get one of these sales calls, don't reach for your wallet. Instead, reach for the phone number of the Better Business Bureau.

Art on the Street (or Even Below It)

Don't assume that artists selling their work on the street are people who couldn't make it in the "real" art world. Maybe they just haven't made it *yet*.

When I first moved to New York, Jean-Michel Basquiat was selling his art on the street for pocket money; now it sells at auction for millions. Keith Haring drawings were plastered all over the subways; you could peel them off the walls and have an original Haring for free. Now these same pieces cost thousands. At the time, I thought that "real" art came from air-conditioned galleries on Fifty-seventh Street. Learn from my mistake.

Just because *most* street art is touristy doesn't mean you'll never find anything good. Wherever you see art—whether in a fancy gallery or in a subway station—try to tune out the surroundings. Look at the art itself. Is it special? Does it speak to you?

Good art isn't always in good places. Paintings that are now in gilded frames at the Metropolitan Museum began their lives in unheated garrets. A picture propped against the wall in a junk shop may once have hung in a mansion. You never know. And that's half the fun when you're shopping off the beaten path.

Shopping Tips:
What to Take with You

- ★ The usual toolkit: magnifying glass, tape measure, pen and paper.
- ★ A price-guide book, such as *Hislop's*. You probably won't have a chance to check the Internet before you decide on a purchase.

* Cash, preferably in small bills, if you're going to garage sales or flea markets.
* Your significant other, if he or she is persnickety about what goes in the house. Most off-the-beaten-path sales don't let you return things.
* Business cards with your name and address, if you want dealers to search out special pieces for you.
* This book.

CHECKLIST FOR BUYING ART OFF THE BEATEN PATH

What kind of guarantees do you have, if any? At art fairs, you have the same guarantees you'd get at a reputable gallery. Dealers at antiques shows and flea markets will often offer guarantees too, if you ask. (As always, get it in writing.) Elsewhere, you may get no guarantees at all.

At an estate sale, did a professional appraiser evaluate the art, or did the sellers simply set a price? If a licensed professional was involved, ask if you can get the written appraisal of the piece you're buying. It's not a guarantee of authenticity, but it helps establish value for insurance purposes.

Are you buying something "too good to be true"? No one *knowingly* sells museum-quality art at a garage or estate sale. If the sellers tell you you're getting

important original art for a fraction of its market value, ask yourself why. Beware of hardship stories about how someone has to liquidate for cash. Once you've forked over *your* cash, you could have your own sob story.

Are you buying something only because it sort of looks like something you saw in a museum and you think it might be valuable? The odds are against you. Only buy if the price is no higher than what you'd pay for an admitted reproduction, and if you like the piece enough to keep it even if it turns out to be not what you think.

At an art fair or show, are you buying simply because you feel that you have to buy something to make your excursion worthwhile?

Have you evaluated the art according to the checklist in the appropriate chapter of this book, as well as looking up pricing information in a price guide?

Do you love what you're buying?

FINDING TOMORROW'S STARS
AT STUDENT ART SHOWS

JON KESSLER
Jon Kessler is chair of the Visual Arts Division at Columbia University's School of the Arts—a premier MFA program. His sculptures are in the permanent collections of the Museum of Modern Art, the Whitney Museum of American Art, the Walker Art Center, the Museum of Contemporary Art, and other institutions.

▸ *The Columbia MFA program has become one of the "hot" places to discover new artists. Someone described the graduation show to me as a "feeding frenzy" of dealers and collectors. What's that like for the students?*

The thesis exhibition is the students' coming-out party. Since the program has gained so much notoriety, we get a large number of dealers looking for new artists to sign, as well as collectors who are actually buying things off the wall.

There's a surplus of galleries and collectors right now, which is unprecedented. There's so much opportunity. It's great for our students, but there are pitfalls. Students who are doing more challenging work might not necessarily find their audience right away. If they don't get signed by a gallery, we need to advise them on different kinds of career paths, about how to get grants and residencies to support their art.

▸ *Doesn't this system put a lot of pressure on artists to "make it" at a very young age?*

There is a lot of pressure on younger artists, but it doesn't start in MFA programs. I was showing at MoMA when I was twenty-five, and it was the same back then. At Columbia, we do everything we can in terms of pedagogy to keep the marketplace out of the studio. We've tried to build a firewall between the school and Chelsea [galleries].

But we also have a practical approach that this is a profession. We have a fourteen-week practicum that teaches students things like how to photograph their work for a portfolio, how to do their taxes, and what a successful grant application looks like. And because we're artists, not academics, we can answer students' questions about careers.

▶ *Is there a danger in expecting students to have a mature style by graduation? Won't collectors pressure the artists to keep working in that same style?*

Absolutely. That's the nature of collecting—collectors always want to buy the archetypal work. But while there's a pressure to repeat your style, there's another pressure to grow. An artist who doesn't challenge himself and change will lose the respect of fellow artists. The collectors lag behind in realizing this, but eventually they catch up.

Making art is not about your first show right out of grad school. Sustaining a career is about being always challenged in the studio.

▶ *As an artist, what type of contemporary work is most interesting to you?*

When you've been looking at contemporary art for a

long time, it's rare that you feel like you're seeing something new. We're now in our third generation of conceptual art. It's been interesting to see how things develop in certain veins, but it's so rare to feel you're seeing something you haven't seen before.

▶ *What about when you're evaluating MFA applicants? How do you judge potential?*

You act on your experience and on hunches. Sometimes you bring back something that you dismissed the day before because it stays with you. Other times we see portfolios where everything is too tight a package and you have to wonder what you can teach someone like that.

Admissions is a very difficult process. We have 840 applicants for twenty-six positions. I'm sure that some good applicants fall through the cracks.

▶ *Do you think students are more willing to invest in an MFA now that there seems to be a career path at the end of it?*

The "hot" MFA programs are definitely perceived as a way of entering the market.

▶ *What advice would you give to collectors who are interested in discovering new artists?*

Only buy what you really love. I know that sounds almost fuddy-duddy. Today people think about art as an investment, like the stock market or real estate.

Most collectors follow a sheep mentality. It's very interesting to watch. A student may go from a "hot" MFA

program to a group show that gets a glowing review by Roberta Smith at the *New York Times*. Suddenly the artist is at the Armory Show and getting signed by an "it" gallery. Next thing you know, there's an article about the artist in *Vogue*, and now that's who everyone's buying.

This kind of art market always has corrections—I think we're due for one soon. But the good thing about the market is that it does create an excitement about art. It gets people to take down the Monet poster they bought at the Metropolitan Museum gift shop and put up a piece of original art.

13

Buying Art
Online

Today we're so used to buying household items online that some of us rarely set foot in a store anymore. Buying art online is becoming just as easy. You don't have to spend decades hunting for the right piece to fill out your collection. With a few keystrokes, you can find dealers who handle the artists you like, or you can sign up to receive e-mail alerts whenever the type of art you collect comes up for auction.

The problem is, buying art isn't like ordering a toaster or a set of earmuffs. You can't always tell from a picture what condition the art is in—or whether it's authentic. You have to be especially careful about whom you're dealing with online. Anyone can create a website or list something on eBay.

Fortunately, the Internet is also a great tool for investigating the art market. Collectors use the Internet to research dealers, artists, and prices; make contact with brick-and-mortar auction houses and galleries; and make direct sales on eBay or through online galleries.

Researching Art on the Internet

Let's start by looking at how to research art. Ideally, you should begin any art purchase with research. Before the Internet, the art world was relatively secret and confined to the major art capitals. The Internet gives you easy access to information that used to be available only to experts and top collectors: Who is the artist? Is the seller reputable? Is the art authentic? Am I paying a fair price? Is it legal to own the art?

Learning About the Artist

When you find a new artist you haven't heard of before, you don't have to take the seller's word for how important and desirable the work is. You can find out on your own, often just by Googling the artist's name.

Look for reviews or articles that can help you understand and appreciate the art. If it's older art, does it have art historical importance? Is it part of a major movement? Has the artist been featured in museum shows or important collections? If it's expensive contemporary art, you'll probably want to gauge

how "hot" the artist is. See which peers the artist is usually grouped with. Try to get a sense of how well connected the artist is. Did he go to a "hot" art school? Has she been in important group shows? For better or worse, these external factors are important in the contemporary market. If you're buying for love, you might not want to sully yourself with such crass investment issues. Do it anyway if the piece is expensive. Even when you're buying for love, you want to make sure you're paying a fair price.

Checking Up on the Seller

If you want to find a reputable dealer, or to check up on one you've already found, you can get on the phone and make lots of calls, the way people did before the Internet. Or you can look online to see whether the seller is a member of a major dealers association. (See the Resources section for a list of associations you can rely on.)

If a dealer is a member of a major association, you can buy with confidence. Otherwise, contact a dealer who is— preferably someone in the same field or geographic area. Don't be shy about doing this. People in the art world understand about checking reputations and are usually willing to help. You can find contact information for member galleries on the associations' websites. In general, though, you should call rather than e-mail to get a reference. People are more forthcoming with negative opinions if they're not committing themselves in writing.

If nobody seems to know the seller, check with the Better Business Bureau (www.bbb.org). This step isn't foolproof, because the BBB doesn't get complaints until after there's a problem, but it will help you steer clear of known frauds.

In addition, many popular contemporary artists have their own websites, where you can learn who the authorized dealers are for their work.

Verifying Authenticity

The Internet may have created new opportunities for art scams, but it's also a great tool for unmasking them. You're never going to buy a fake painting when, with a click of a mouse, you can see that the original is hanging in the Prado.

If you're thinking of buying a print by a well-known artist, check the website of the Print Council of America (www.printcouncil.org). Their database can tell you whether your artist has a catalogue raisonné. This scholarly list of all known works by an artist is your first line of defense against fakes. If a piece isn't in it, the work isn't considered authentic. Simple as that.

For something other than a print, use a search engine to look for the name of the artist plus the words "catalogue raisonné." If a catalogue raisonné exists, the Internet can also help you find a university or public library that has a copy. You can often save yourself all this trouble, though, by simply asking the dealer or auction house. Most own or have access to this type of list.

If you're concerned with forgeries for a certain type of art, rather than for a particular artist, you can search Artnet.com or *The Art Newspaper* website for articles about recent forgery scandals. By spending five minutes at your computer, you can save yourself money and grief.

How Much Should It Cost?

How do you know when the seller's asking price for a work of art is fair? For starters, check out the competition.

Art is more expensive in some cities than in others. For example, certain contemporary artists are "hotter" in Los Angeles than in New York, and vice versa. My husband once found a contemporary lithograph he liked in Soho for $2,000, then saw on the Internet that the same piece was priced at $1,000 in a gallery in Kansas City, the artist's hometown. The Kansas City gallery didn't have the same overhead costs (such as rent and salaries) as the Soho gallery, so the price was cheaper.

For a more sophisticated analysis, use a specialized subscription service such as Artnet.com or Artprice.com, which will show you auction records, upcoming sales for the artist, and other key information. This kind of information used to be available only to professionals and top collectors, and it's a huge advantage. You can get a short-term subscription to one of these services for about $20, or you can purchase monthly or annual subscriptions if you think you'll be doing a lot of research. It's worth every penny.

You may find, for example, that some artists cost less at auction than they do at a gallery. That's because artists who aren't firmly established may have little or no resale market. If you're willing to bide your time, you can often pick up bargains on these artists at an auction.

Conversely, a gallery can sometimes be cheaper than an auction house. Bidders get caught up in the excitement and may bid more for a work of art than it would cost retail. By doing research beforehand on gallery prices, you'll know better. For more about using the Internet to research art, see my interview with Bill Fine at the end of the chapter.

Is It Legal to Own?

If you're buying certain types of art, you have to do due diligence to make sure you're not breaking the law. With Native American art, for example, you're not allowed to own anything taken from grave sites or excavated on federal lands, or anything made with parts of endangered animals. Laws vary from region to region. (See Resources for a list of websites to consult about legal issues.)

With antiquities, the situation is even trickier. A few websites (see Resources) can give you general guidelines. The Internet is a critical resource in this field because antiquities laws change all the time.

Nineteenth- and 20th-century art is less of a problem, unless you're buying an expensive one-of-a-kind painting or sculpture. If the piece was in Europe during World War II, you may need to make sure it wasn't looted by the Nazis. The statute of

limitations isn't up! *The Art Newspaper* has an extensive list of dealers, collectors, and others who trafficked in Nazi-looted art. In addition, the FBI has a website devoted to art thefts and forgeries. (See Resources for Web addresses.)

Contacting Brick-and-Mortar Sellers Online

Many galleries and auction houses that you can visit in person also have online options for buying.

Brick-and-Mortar Auction Houses

Scores of reputable auction houses, large and small, now offer the option of online bidding, so you can buy a painting in Hong Kong even if you're in Kentucky. The market is so large that some Internet entrepreneurs have even created on-line businesses that sift through the myriad auctions to help you find what you're looking for.

The disadvantage, of course, is that you can't attend the viewing to see the art in person. A digital image may not be a good representation of the real thing; you may later find that the colors are quite different. The size of a painting can also affect how you feel about it: Something that seemed dramatic when it was three inches high on your computer screen may be too overpowering to live with when it's six feet tall in your living room.

A bigger problem is judging condition from photographs. If you buy at auctions without having seen the art in person,

you're well advised to buy art only if it's in mint condition. Remember, auction sales are final!

Keep in mind also that anybody can create a website for an "auction house." If the name of the establishment is unfamiliar to you, you'll have to do some legwork to ensure that it's reputable. Ask for proof that the business is licensed by the state where it is located, or check with the state. Or call the Better Business Bureau. If you know any reputable dealers in the area, you might also ask if they've heard of the auction house. I know doing this seems like a lot of effort, but so is sorting out identity theft and credit card fraud.

No matter how tempting the items for sale are, don't send any credit card or personal information over the Internet until you're absolutely sure whom you're dealing with.

Brick-and-Mortar Galleries

Many galleries—even upper-end establishments with name artists—sell at least some of their art over the Internet. If you're not yet familiar with many galleries, you can find scores of reputable dealers listed on Artnet and can search for whatever type of art you're looking for. This is the easy way to buy art over the Internet.

As long as you know you're dealing with an established gallery—one that is a member of a major dealers association or has a good reputation in the art world—you can relax. Legitimate dealers stand behind what they sell. Many let you return the art if you find you don't like it in person.

In one respect, the Internet is just like going to a gallery in

person: You'll probably have to ask for prices. Although some websites list prices, many say to call the gallery for pricing. Don't be put off. This isn't a case of "if you have to ask you can't afford it." Dealers may legitimately want to keep prices off the Internet for security or privacy reasons. Just call. Forging relationships with reputable dealers is the smartest thing you can do if you're interested in buying art.

Internet-Only Dealers

Some galleries exist only in cyberspace. While most people who sell online are honest, others make P. T. Barnum look like a pillar of truth-in-advertising. The problem is that anyone can create a Web address. It's much easier to do than renting gallery space, buying inventory, and having government regulators know where to find you. Because of the few bad apples, you have to research the seller carefully before buying from a gallery that exists only online.

See how long the company has been in business—the longer the better. Also, check with the Better Business Bureau to see if anyone has filed a complaint. If you have relationships with established dealers or other art experts, ask them to look at the site too and tell you what they think. Internet "user groups," which are sort of like chat rooms for art enthusiasts, are also helpful for getting the lowdown on an online dealer.

The easiest way to detect a fraud, however, is the too-good-to-be-true test. Frauds appeal to your greed and make

you think you're getting something valuable at a cut-rate price. Such gimmicks are always, always, always red flags.

Be especially careful about sellers in other countries, where you don't have legal recourse. Some scam operators in eastern Europe advertise too-good-to-be-true art they don't actually own, using pictures copied from gallery or auction house websites. After you buy, they mail you an empty package and then claim your art was stolen in transit, leaving you to sort things out with the postal insurance company. Not fun.

Always try to pay with a credit card that offers buyer protection. You might even want to keep a designated credit card that you use only for electronic purchases—and keep the credit limit low, to avoid problems with theft.

eBay

Full disclosure: I adore eBay. It's like having access to the world's greatest flea market at any time of day, no matter where you are. This single website accounts for a huge percentage of all art purchases. Thousands of artworks sell every week.

If you've never used eBay, here's how it works: You go to www.ebay.com and type in whatever kind of art you're looking for. You'll get a list of everything available, with pictures and descriptions you can click on. To bid, you'll need to register and set up an I.D.; then you can place a bid on anything you like. There's a bit of suspense, because someone can always outbid you, and you may have to counterbid. It's a little like attending an auction in person, and a lot of fun.

Now, before I tell you all the things that can go wrong, let me start by saying that eBay does a good job of policing their site. They investigate potential frauds and keep buyers from bidding on art that is illegal to import into their home countries. If you're new to the site, take a look at their safeguards. One of the best features is that all sellers get a "feedback" rating from everyone who buys from them. If a merchant has sold thousands of items and has a highly positive feedback rating, you can feel reasonably comfortable buying.

You have to keep in mind, though, that most people on eBay are amateurs. A scrupulously honest seller may list a fake because he himself was fooled when he bought it. I also know of at least one rug merchant on eBay who sells awful, over-priced oriental rugs, but his customers don't know any better and give him positive feedback. Always evaluate the art for yourself, using the checklists in this book. Try to get a money-back guarantee in case things aren't what they seem to be.

Problem Sellers

A few sellers operate at the edge of the law. They intentionally mislead you into overpaying for worthless art, without actually committing fraud. Here are their telltale signs:

★ *Disclaimers*
 If the description says, "I'm no expert, but I've been told that . . . ," you are getting no guarantee at all. You may not be able to get your money back if the art is less than you expected.

Other disclaimers to watch for are "condition as shown," which means that you're responsible for divining from a teeny photograph whether there's something wrong with the art. Since the art isn't being misrepresented, you have no claim when it shows up faded, dirty, or overrestored.

If the seller has an "About Me" page on eBay, always look before you bid. It may include extra disclaimers not included on the item description, such as "All sales final!" Never buy art sight unseen without an option to return it if there's a problem. Things may look very different in Internet pictures than they do in person. Just ask anyone who's tried computer dating.

★ *Tricky wording*

Some sellers aren't exactly liars, but they deliberately try to mislead you. Recently I saw a listing for a "genuine original lithograph after the famous artist MARC CHAGAL!!!" What "after" means in artspeak is that someone else is imitating the artist's style. The seller was obviously hoping a buyer wouldn't know that. In five flowery paragraphs about the genius of Marc Chagall, nowhere did the seller mention anything about the real artist of this particular lithograph. As a test, I e-mailed him to inquire who it was. He answered, "We don't know."

Earlier this week, I saw a listing for a "Signed William Morris design carpet." You'd think that meant the carpet was made in Pre-Raphaelite artist William Morris's own workshop, right? Nope. It was a new carpet, made in an

Indian factory, from a design that Morris had presumably signed one hundred years ago. When I asked the seller for clarification, he was forthcoming. But most buyers don't ask, they merely assume. And they pay way too much.

Always read the description carefully and e-mail the seller for clarification if you're not sure. As added insurance, type up what you think you're getting, and ask the seller to verify in writing that your description is accurate.

★ *Inflated "retail value" estimates*
Sometimes you'll see a lithograph listed for, say, $100, but the description claims that the retail value is $5,000. Why would anyone sell a valuable item on eBay for a fraction of its worth? Chances are, it's not really valuable. Again, sellers who appeal to your greed—who make you think you're getting a bargain—are always the ones to watch out for.

★ *Excessive shipping and handling fees*
This is a common problem with oriental rugs on eBay. The price of the rug may be low, but if you look at the fine print, you'll see that the seller is charging a "shipping and handling fee" that may be $100 or more than the actual shipping cost. Once you add in this fee, you may not be getting a bargain at all. And what happens if the rug turns out to be of terrible quality? No problem, says the seller— you can return it for a full refund, minus the shipping and handling fee. The seller will be happy to send you a different rug, for *another* shipping and handling fee.

★ *Questionable feedback*

Some sellers have great feedback ratings—as buyers. Check to see if the "100 percent approval rate" is for selling art or buying dish towels. The seller may be perfectly honest, but without feedback from other buyers, you have to use sensible caution. If the seller has chosen to hide his or her feedback, that's a red flag that something is wrong.

★ *Shilling and anonymous bidding*

"Shilling" is an unethical practice, in which someone in cahoots with the seller makes phony bids to drive up prices. For example, an eBay seller may pretend he has no idea what he has. Shucks, he just found this picture in Grandma's attic, along with other things she collected in Paris in the 1920s. From the photo you realize it looks like a Picasso painting. Maybe the seller even says it's signed "P.P." and pretends he has no idea what that means. Smart, educated buyers get hooked big time when they think they know more than the seller. To reel you in, a shill will bid a lot of money to make you think, "Gee, someone else thinks this is valuable too. I'd better get in on the bidding." Don't fall for it.

Be especially wary if the bidding is anonymous. If the seller won't let you see who the bidders are, that's a bright red flag that you may be dealing with a shill.

★ *Hidden provenance*

Yet another danger sign is a seller who claims to have provenance but won't let you see it unless you're the winning

bidder. Provenance is part of what you're buying! You have to see it before, not after—especially if all sales are final.

★ *Cash only*

eBay has a service called PayPal, which charges your credit card or checking account and pays the seller without the seller's ever getting to see your banking information. This is the best way to go with payments. You can also use a service called BidPay, or send a personal check. But sellers who want money transfers or cashier's checks are hard to get refunds from.

One last caveat: When you buy something expensive from an individual seller, you have to make sure the "seller" actually owns the art.

"In New York at least, when you buy from a professional art merchant, you're automatically getting a warranty as to its title [i.e., assurance that the seller legally owns it, and it isn't stolen]," says arts attorney Ronald Spencer. "Auction houses also warrant title. But when you're buying from someone who isn't a professional, this doesn't apply. If I'm a private collector trying to sell you something off of my wall, I'm not required to tell you if there's a problem with the title. You have to *ask* for a warranty. It isn't automatic."

The Benefits of eBay

Now that I've mentioned things that can go wrong, let's look at what can go right. Many reputable sellers post their

wares on eBay. You have access to art from all over the world, not just from around the corner.

Shopping on eBay is also a fun way to buy inexpensive contemporary art. Many artists—especially those who don't live in big cities—are marketing themselves without the benefit of a gallery, often at very modest prices. eBay has an entire category for self-representing artists. Click on it and see what you discover.

You can also find collectors who are reselling second-tier and regional artists that the big auction houses won't handle. These are some of the best bargains in the art world. Often, you can buy for less than a gallery would charge, and you have all the authentication documents you need.

And sometimes people really do sell valuable art at low prices because they don't know what it's worth. This is most likely to happen with artists who aren't household names but who have loyal followings. Savvy collectors are usually quick to pounce on these listings, but if the description doesn't have the artist's name—or misspells it—you may have an opportunity for a bargain.

Essentially, eBay is like the art market as a whole: It has its perils, but you can find wonderful things if you're willing to do your homework.

CHECKLIST FOR BUYING ART ONLINE

Do you have a good sense of who the artist is from articles and reviews you found online?

Have you located a catalogue raisonné (if the artist is important enough to have one) so you can verify that the work is authentic?

Have you checked whether the dealer is a member of a reputable dealers association? If he or she isn't, have you checked with the Better Business Bureau?

Have you read the sales wording carefully to make sure you know exactly what you're getting? If you're not sure, don't assume. Contact the seller and clarify!

Can you get a money-back guarantee? Art you haven't seen in person might be disappointing.

Are you paying in a way that keeps your banking information secure?

Does the art sound too good to be true? Do you think you're getting a great bargain because the seller doesn't know what he has? Unless you're a real expert, you're at risk to lose money.

Do you love what you're buying?

FINDING AND BUYING ART ONLINE

BILL FINE

Bill Fine is President of Artnet.com, a highly regarded Internet site that allows collectors to search for art at hundreds of galleries and find sales records for thousands of artists.

▶ *A lot of top galleries list their art for sale on your website. Was it hard to convince them to venture onto the Internet back when you started Artnet?*

It was ridiculously difficult. People were loath to give us photographs of their art. They worried that they were going to "burn" [overexpose] the work, especially some of the Old Masters dealers.

Some of them still like to do things tactfully and secretly. They want to offer a piece to two or three of their best collectors, and their collectors like the satisfaction of buying something no one else has seen. But the concept of "burning" a work is fading because the market is so good right now.

▶ *It was also a big change to allow individual collectors access to sales records online, wasn't it?*

There's a big move toward transparency in the art market. Wall Street people are starting to look at art as an alternative asset class, so they're insisting on more openness. The younger generation of collectors now expects to see comps [records of comparable sales] to make sure they're getting a fair price.

Having this information online is great for new collec-

tors, who are sometimes put off by going to galleries or are afraid to ask questions.

▶ *At Artnet, you don't actually get involved in the sales yourself. You just put buyers and dealers together, right?*

That's right. A few years ago there were many "consignment portals" on the Internet that were supposed to eliminate the middleman—in this case, the dealer. It was a bad idea. Dealers are more than just middlemen. They often know more than museum curators because so much passes through their hands.

The best thing a collector can do is build a relationship with a good dealer. If you have a problem with something you've bought, you can get your money back. If you want to resell, most dealers want to be your first call. I'm a big believer in buying from dealers.

The ones on Artnet are the best in the world. They aren't looking for a single transaction. They're looking for a collector.

▶ *How did you vet the dealers on your site?*

I was executive VP at Brandt Publishing, which owns *The Magazine Antiques* and *Art in America*, so I basically just knew which ones were good—and I knew which ones to avoid. I know where the bodies are buried!

▶ *Speaking of magazines, in addition to a gallery network and price database, you also started an art magazine on your site. Wasn't that awfully ambitious?*

We burned a lot of money on the magazine for a lot of years, but it's an important way for people to find out about new and upcoming artists.

The Web is pretty much a search-based application. Most people on the Web are looking for a specific artist. You already know how to look for Picasso. You just Google him, and there he is. But you can't do that with a new artist you've never heard of before.

The magazine lets people find out about these new artists. We go to the big art fairs, to the Venice Biennale—we're all over the world. One advantage we have is that we can scan an image and get it up on the Web for a nano-fraction of what it costs a printed magazine. That means we can have a lot more images.

That's especially good for collectors who live in smaller cities and might not be able to get to New York or London to see new art. Learning is all about seeing the work. You don't have to be a Rhodes scholar to be a collector. I know it sounds simplistic, but the more art you see, the smarter you get.

14

Art in Your Home

Having an art collection gives you the chance to play curator. Once you've bought a few pieces, your home becomes your own mini-museum. But you also start having museum-like responsibilities, such as insurance, security, conservation, and deciding how best to display your art.

Conserving Your Art

"It's not impossible to preserve art in a home environment," says conservator Margaret Holben Ellis, Director of the Thaw Center of Conservation at the Morgan Library and a professor at New York University's Institute of Fine Arts. "I collect art

too, and I live with my art—I don't keep it in a vault. But the old adage 'most accidents happen in the home' is certainly true for art as well."

Major Damage-Causing Culprits

★ *Light*
Everyone likes bright, sunny, rooms, but your art doesn't. Light—especially direct sunlight—can cause it to fade. The changes are so gradual that you're not likely to notice them, and by the time you do notice, it's too late.

"There are three variables in terms of light: the intensity of the light, the type of light (ultraviolet is the worst), and how long the art is exposed. You can control all three," says Holben Ellis.

"Draw the curtains. Turn pictures against the wall if you're going away for a while. And always use UV-filter Plexiglas to frame works on paper. It won't prevent damage altogether, but it helps. The more you can control each of the three light variables, the longer you can keep your art from fading."

Beware of using those little clip-on spotlights that attach to the top of paintings. Conservators hate them with a passion. If you put one over an oil painting, you'll get a heat spot on one area of your canvas. This can dry out the paint, and you might start to see a crackle pattern. "There are some excellent fiber optic ones now that are cooler, but

that's not usually something you're going to find at your local frame store," says Holben Ellis.

★ Humidity

Excessive humidity is bad for your art, particularly works on paper, so avoid hanging art in areas such as kitchens or bathrooms. If you have an open kitchen that leads into your living room, try to keep art as far away from the cooking area as you can.

If you close up your house for the summer, store your art someplace climate controlled. Otherwise, you could have an unhappy surprise when you return. In one instance, a collector found his valuable drawing completely covered by moss!

★ Jostling

Most damage to art happens in transit. That's why museums rarely lend out their most delicate art. Always use bubble wrap or insulating packing materials, and be sure that professional movers have experience with fine art.

You also want to keep art from being jostled in your home. Putting something fragile in a narrow hallway or a heavily trafficked area is asking for trouble. Sculpture needs to go where it's not going to get bumped or knocked over. Consider putting smaller sculptures in glass cases (which also deters theft).

★ Temperature Swings

Art can adapt to warm or cold environments, but sudden temperature changes can cause paint or wood to crack. Although you don't need to have museum-quality climate control at home, try to avoid extremes. Don't let your house bake in the heat all day and then turn the air conditioner on Big Snowflake when you get home. The more constant the temperature, the better.

Even with a steady thermostat, certain parts of the house can have big temperature swings. Hanging art over a fireplace is a bad idea—even though everybody does it—because the previously cold wall suddenly gets very hot. The same is true for the wall above a radiator. Why not put a mirror there instead?

Attics and basements are the worst places to store your art. They can be cold, humid, damp, moldy, and home to innumerable squirrels. When you need to store something away, use a closet or armoire.

If all of this seems like too much to remember, use this simplistic-but-helpful guideline: Never put fine art anyplace you wouldn't keep a parakeet. You won't go too far wrong.

Proper Framing

Framing isn't merely decoration. It's an important way of protecting your art. Any significant work on paper should be framed with acid-free materials and UV-protective glass to keep it from degrading or fading.

If you overspent on art and don't have the budget for professional framing, avoid the temptation to put your art in a cheap store-bought frame "for now." Temporary solutions have a way of becoming permanent. Instead, go to an art supply store and buy archival-quality materials to frame the art yourself. It's not hard—artists do it all the time. The store's staff can usually show you how. (If you've bought an especially rare, old, or fragile piece, however, hire a professional. It may need special care.)

With paintings, however, framing is optional. If you look at historic pictures of the homes of famous artists, you'll often see that they hung their paintings without frames, or even propped them against the wall on shelves. The no-frame look gives any room an artsy, bohemian feel. If you need to cut corners on framing costs, cut them here.

Cleaning and Routine Care

With art, it pays to be a lazy housekeeper. In most instances, you should limit your cleaning to very gentle dusting—if that. Overcleaning can damage your art and diminish its value.

In older pieces in particular, connoisseurs like to see evidence of age. That's why they use an elegant word like *patina* rather than saying "discoloration and grime." If you scrub an antique bronze statue until it shines like new, connoisseurs will shriek that you've ruined it. (Antique furniture collectors are even worse. They actually *like* embedded dirt and peeling paint, as long as it's authentic.)

Art experts take the long-term view. A conservator can always remove dirt later, but no one can replace the original finish you just scratched off with a Brillo pad. So sit back and relax.

Care of Oriental Rugs

Oriental rugs are hardy and will last a lifetime if properly cared for. For starters, always put padding under a rug to help protect the underside.

Vacuuming seems as if it would be harmful to a rug, but having grit embedded in the knots is worse. A gentle weekly vacuuming is fine for most wool rugs (but not silk ones) as long as the suction isn't so high that the rug gets sucked into the machine. If the rug is small, you can simply shake it outside to get the dust out. Either method gets out grit and discourages moths. Whatever you do, don't hang the rug over a clothesline and beat it with a broom the way you see people doing in the movies. That's terrible for the rug!

Every few years, you should send your oriental rugs to be professionally cleaned. Don't try to save money by doing the major cleaning yourself unless you really know what you're doing. Cleaning products meant for wall-to-wall carpeting can ruin an oriental carpet, and if a rug isn't properly dried, it can start to rot. Then how much money have you saved? To find a reputable cleaner, ask your local dealer or consult the Association of Specialists in Cleaning and Restoration (see the Resources section). This is *not* a job for the local dry cleaner.

For everyday spills, cold soda water applied right away

with a white cloth usually does the trick. If the stain is resistant, ask your local rug dealer for advice.

Some rugs are too delicate for everyday use. If you have a silk rug or an antique that's been worn to the knots, don't put it on the floor to get walked on. It won't last. Instead, drape it over furniture or hang it on the wall.

To hang a rug without damaging it, sew a strip of sturdy fabric along the back and put a curtain rod through it. Never nail a rug directly to the wall, because that can cause threads to snap and will warp the shape of the rug.

Cleaning Framed Prints

When you're cleaning the glass or sides of a frame, don't spritz cleaning solution directly on the surface. It can seep through the cracks and damage your artwork. Instead, spray cleaning solution onto a cloth and then wipe.

Restoration

Taking your art to a professional restorer can make it look like new, but it might be more valuable if you left it alone. Too much restoration is considered a condition problem in its own right. You really need a restorer only in these instances:

* Your art has been damaged, such as in a fire or flood or in transit.
* Your art has a condition problem that is going to get

worse. For example, if a painting has mold, or an oriental rug is starting to fray, you want to get help now to prevent further damage later.

★ The condition of your art substantially diminishes its aesthetic appeal.

★ Your art was improperly restored, and you want to correct the problem.

Wanting the art to look "perfect" isn't necessarily a good reason to hire a restorer. Any process that involves repainting, reweaving, or creating a new component (such as replacing a part that's broken off of a statue) will make the work less original and possibly less valuable.

When you do need a restorer, ask your local dealer or auction house, or even the curatorial staff at a museum, to recommend someone. They deal with restorers all the time and know which ones are good. (You can also check the Resources section for organizations that can help you find the right conservator.)

Appraisals and Insurance

Once you've been buying art for a while, the value starts to add up. Call your home insurance agent to make sure you're still covered. At some point, you might need a rider or special insurance for your art. If you have pieces that are especially valuable or delicate, you may even want to talk to an insurance company that specializes in fine art.

Insurance companies usually want a written appraisal of your art before they'll write a policy. You can find contact information for appraisers in the Resources section, but first ask your insurance agent which appraisers the company recognizes as experts. Some companies insist that an appraiser have a certain license or be a member of a particular organization. Ask beforehand so you don't end up paying for two appraisals.

If you want an appraisal for your own purposes, keep in mind that the appraiser must be someone with no financial interest in the art. Dealers may know more about the market than anyone, but for appraisal purposes, you want someone who isn't looking to buy or sell.

How much is your art worth? It depends on what type of appraisal you ask for. There are two main types.

A *fair market value appraisal* is an estimate of what your art is currently worth on the open market—its fair market value. It is used in inheritance and divorce proceedings to divide property equitably, and it can also determine the tax deduction for art donated to charity. Fair market value is *not* the value you want to use for insurance.

A *replacement value appraisal* is an estimate of how much you'd have to pay if your art were destroyed and you had to buy something comparable. Replacement value is typically higher than fair market value, because it takes additional costs (such as shipping and framing) into account. This is the appraisal you want to use for insurance.

Be sure to ask for the right kind of appraisal. Accidentally using fair market value for insurance—or replacement value in a divorce settlement—can cost you a lot of money.

Record Keeping

What kind of documentation do you need to keep for your art collection? "First of all, it's important to keep an inventory, whether it's a paper file or a computer [spreadsheet] program you bought for $99. Insurance companies are *obsessed* with documentation," says Renee Vara, former National Fine Art Specialist for Chubb.

You also need to keep your original sales receipts. For new contemporary art, that's as good as an authentication statement. (If you've thrown them away, contact the gallery for duplicates.) For older art, to keep any documents that prove authenticity and provenance. Guard these like gold. In many cases, you can't get a duplicate certificate of authenticity, for the obvious reason that the duplicate could be used to sell a fake.

Keep a copy of the auction house catalog, or any guarantees you got from the dealer, in case there's a problem later on.

For insurance purposes, keep copies of any appraisal you've had done. You might want to keep these somewhere besides your home, such as in a safe-deposit box, because a fire or flood could destroy them along with your art.

How to Display Your Art

If you're interested in buying art, you probably also care about how it looks in your home. There are more options than most people realize. You're not condemned to live in a cold white

box just because you have an art collection. You live in a house, not the Mary Boone Gallery.

Don't be afraid to put pictures on a colorful wall. Victorian art was hung on top of busy wallpaper. The Barnes Collection of 19th- and 20th-century painting was hung on Tuscany-yellow walls, along with displays of antique hinges. Old Masters in museums are routinely shown on top of velvet or silk brocade. The possibilities are endless.

For inspiration, look back at earlier eras. Although you don't want to feel you're living in a period room, earlier design fashions can help you think outside the white box.

Art Placement

When we think about art for our home, we tend to assume that every blank wall ought to have something on it. Sometimes, though, one spectacular piece of art is all a room needs. A dramatic painting, a room-size oriental rug, or an unexpectedly large sculpture can give the impression of an art collection even if it's the only piece of art in the room. If you have a limited budget, consider buying one major piece rather than lots of mediocre ones.

If you're assembling a group of small pictures, keeping the same amount of space between the pictures will create a unified look, whether you're arranging them symmetrically or free-form. You could also install a narrow shelf and prop your artworks against the wall. It's easy and casual but can also look elegant. If you have enough pictures, consider rotating your display, so you see your art with fresh eyes.

Speaking of eyes, hang your art where you can see it. This sounds obvious, but many people hang art so high they have to crane their necks to look at it. Instead, hang pictures at eye level. If you're short or in a wheelchair, hang art where *you* can see it. It's your house. As long as your art is where you can see it and take pleasure from it—and it isn't getting damaged—it's in the right place.

Changing Tastes

You may find that as you develop your eye for art, you start to outgrow your earlier tastes. Even museums have this problem. (That's why they have basements.) If an artwork doesn't give you pleasure anymore, don't rush to sell it. Put it away for a while and see if you miss it or if it delights you when you take it out again. Sometimes all that's "wrong" with a piece is overfamiliarity. If you do find that you've moved on, don't berate yourself for making a bad purchase. Congratulate yourself on expanding your tastes.

Reselling Your Art

Eventually you may want to resell your art, either because your tastes have changed, or because it has increased in value and you want to take a profit. Where do you start?

First start with research. Check a price guide or online service, such as Artnet.com or Artprice.com, to find out if other

works by your artist have sold recently, and for how much. You may also want a professional appraisal if there's any chance the art may be more valuable than you think (i.e., to make sure that your Rembrandt-esque artist isn't really Rembrandt himself.)

Once you have a ballpark idea of the art's value, your decision on where to sell should be based on three factors:

★ Whether a resale market already exists for your artist. (An auction house usually will insist on this.)
★ How quickly you need to sell.
★ How easily a dealer or auctioneer—or you!—can find buyers.

You have a lot of options to choose from:

Dealers

The dealer who sold you the art is your obvious first choice. But unless you have easy-to-sell, blue-chip, or "hot" art that's gone up in value, the dealer may offer less than what you paid. (When you're buying from dealers, you pay them *retail* prices. When you're selling to dealers, they pay you *wholesale*.) If the gallery does not want to buy the piece back, many dealers will let you trade in the art for something else. They may also offer to take it on consignment, which means the gallery will sell it for you in exchange for a commission; this can take a long time, but you may get something closer to retail price.

Auction Houses

Don't assume that auction houses are only for multi-million-dollar Monets. Most of them also have divisions for lower-priced art, such as prints and vintage posters. You can find a list of experts in the back of an auction catalog or on the Internet. Send them a note with a photo of your art. If they're interested, they'll examine it in person and give you an estimate of how much the work is likely to fetch. You can also insist on a minimum price, called a *reserve,* so that you don't end up selling for less than you're willing to. The only downside to auctions—and it's a big one—is that the work may not sell at all. Try to find an auctioneer who's had previous success selling art similar to yours.

eBay

If art world professionals don't seem interested in reselling your art, you can always sell it on your own. Rather than taking out a classified ad or holding a garage sale, consider eBay, where you'll have access to millions of potential buyers, not just people in your neighborhood. The fees are modest, and you can set a minimum reserve price, just as you would at an auction house. For your own security, always make sure payment clears before you ship art, and always ship the piece insured, at the buyer's expense.

Before you sell anything anywhere, though, consider whether the art market as a whole is overpriced or downsizing. *The Art Newspaper* and other publications (see Resources) can give you a

general idea. If you don't need money right away, try to sell when the market is giddy. In a recession, when cash-strapped collectors begin selling off their treasures, you want to show up with your checkbook, not with your own work to sell.

CHECKLIST FOR DISPLAYING AND CONSERVING ART AT HOME

Is your art hanging where you can see and enjoy it?

Is it protected from light, heat, and being bumped?

If it's an oriental rug, does it have padding underneath? Are you rotating the rug to even out the amount of wear and sunlight it gets? If it's a silk rug, is it off the floor?

If you have a work on paper, is it framed with acid-free materials and UV-protective glass?

Do you have an inventory of your art for insurance and inheritance purposes? Do you have an up-to-date appraisal?

Do you have a folder with your original bills of sale and any appraisals?

Does your home-owners policy cover your art collection, or do you need special insurance for your art?

Are you enjoying your art?

ART AND INTERIOR DESIGN

JEFFREY BILHUBER
Jeffrey Bilhuber is a top New York interior designer.

▶*What makes you cringe when you see how people have displayed art in their homes?*

I can think of two "violators" immediately. The first is art hung too high. I see that in one out of two projects. People hang art above the sight line [eye level] because they haven't had proper advice. They seem to think the closer art is to the ceiling, the more important it is!

The second violator is art that's overlit. I see this all the time—I call it "barn door" lighting. Sometimes clients have worked with an expensive lighting consultant to make the picture "pop" right off the wall. I can't figure out why. Would they want to have the sofa "pop" off the floor?

▶*If there are violators, does that mean there are hard-and-fast rules for placing art?*

There are really no rules, though some places are clearly better than others. People need to liberate themselves about where they can put art. What's the first thing people do when they buy something? They drive a nail in the wall right over the sofa and hang it there.

Don't install it right away. Prop it against the wall for a while in different places. Where you put art speaks volumes about your personality, much more than where you put a lamp or a chair.

▶*I think people worry they'll make a mistake if they try to be innovative.*

At the end of the day, it's just a nail in the wall. People often think they need to replaster or repaint if they move a picture, but there's an easy trick: a little bar of hard white Ivory soap will fill any nail hole, and it adapts to every wall pigment.

▶ *I notice that you sometimes hang art very low. I'm thinking of a particular room where you put a painting next to the sofa rather than above it.*

I like to hang art in a more personal, more artful way. I often hang it three, six, or even twelve inches lower than expected because I like to analyze it from both standing and seated positions. Unless you have a gallery-like space, 75 percent of the time you're looking at art it's from the seated position.

▶ *Is it sometimes difficult for you to incorporate an existing art collection into your décor?*

Art isn't decoration! It's autobiographical. If my clients love what they have, I'll work with it. I have an *obligation* to work with it. I may place it in an unexpected way or an unexpected room, but I'll work with it.

▶ *And you don't worry about how to put contemporary art with traditional furniture, or vice versa?*

Modern art in a traditional room is much more interesting than modern with modern or traditional with traditional. The mix is what's exciting. The best thing about an 18th-century Chippendale commode is a Rothko hanging right above it!

Glossary

appraisal An estimate of the value of artwork. A *fair market value appraisal* tells you how much the art is worth on the open market. A *replacement value appraisal* tells you how much you'd have to pay if your art were destroyed and you had to buy something comparable. Be sure you know which type of appraisal you're getting. The replacement appraisal is typically higher.

attribution Who the artist is, or who experts think the artist is. A piece "by" an artist has an implied guarantee of authenticity. A work "attributed to" an artist may be authentic, but you're not getting a guarantee. A work that's "school of" or "after" an artist wasn't made by the artist (unless the experts are wrong); it was made by someone else in the style of the artist.

authentication board Designated experts who review questionable artworks to determine whether they're authentic.

The opinion of the board is critical to the salability of the art.

blue-chip art Well-established art with solid investment potential.

catalogue raisonné A scholarly list of every known work by an artist, compiled by an art historian. Nearly every well-known artist has one. Prolific artists may have more than one—for example, separate catalogues raisonnés for different decades or for different media, such as sculpture or painting. If a work is not listed in a catalogue raisonné, you need very strong proof from another source—such as the artist's authentication board—that the work is genuine. Unless you're buying new contemporary art, a gallery's own certificate of authenticity isn't usually enough.

estimate An auction house's guess about how much a work of art will sell for. Sometimes estimates are unrealistically high because sellers insist on a top price. Sometimes they're artificially low, to encourage people to bid. Estimates are not the same as appraisals.

limited edition An edition consisting of a predetermined number of copies. Modern artists and photographers often decide in advance how many total copies they are going to issue. Artists usually destroy their printing blocks so that no more copies can be made. Photographers, however, almost never destroy their negatives; thus they can make more than one "limited" edition and so can their heirs. Early editions tend to have a higher value than later ones.

monoprint A print that's one of a kind. No other copies exist.

patina Signs of natural aging that become visible on the surface of a work of art over time.

primary market The market in which a work of art is being sold for the first time ever. The art has never been owned before.

provenance The history of ownership of a work of art. Artwork that has been in a museum or a famous collection or was owned by a celebrity will command higher prices than comparable artwork with less lofty provenance.

Ideally, you want to have a history that goes all the way back to the creation of the art, along with original sales receipts. Not all art has provenance. Anything that was originally inexpensive and produced for the masses—such as Japanese prints or propaganda posters—may legitimately have no provenance. But if you're buying original one-of-a-kind art that has a gap in provenance in the 1930s or 1940s, beware. If the art was in Europe at the time, it may have been looted by the Nazis, and heirs of the original owners could still stake a claim to it.

reserve The lowest minimum price a seller will accept for a work of art that he or she consigns to auction. If the bidding fails to reach the reserve price, the work is "passed" and goes unsold. A reserve must, by law, be lower than the low estimate.

secondary market The resale market for art, such as an auction house or a gallery.

signature The name of the artist written with his or her own hand. For a work to be considered "signed by" the artist,

the artist must personally have written his or her name on the work. An artwork need not be signed to be authentic. Some trendy contemporary artists have decreed that putting a signature on the front of an artwork is "amateurish," and they refuse to do it—though they may sign on the back if a collector insists. A missing signature becomes a problem only if the artist makes a point of signing all of his or her authentic work.

Artists issuing limited-edition prints sometimes write their names on the printing plate itself. A signature "signed in plate" is not the same as an actual signature handwritten on the individual print.

title Proof that the seller is the true owner and that the work is not stolen. In some states, any gallery or auction house automatically guarantees this, by law, for every sale. If in doubt, ask. If you purchase artwork that has been stolen, you'll have to give the art back and seek restitution from the person who sold it to you. That's why it's a good idea to buy from reputable sellers who will still be in business later.

vet To thoroughly evaluate a work of art to determine its authenticity. At certain art shows and auctions, experts have vetted every object. Buying a vetted object makes the object easier to resell.

vintage In the context of photography, an older print that was made close to the time the negative was taken. In the context of posters, an older poster that was made to advertise something.

Resources

Where to Buy Art

Reputable Dealers

All dealers in the major associations have been fully vetted by their peers. Many of these associations host their own art fairs, where you can buy with confidence from member dealers. This list is by no means exhaustive. There are many specialty associations, and most major cities also have their own dealers associations, which are excellent. Check the phone book or Internet for information.

ANTIQUE TRIBAL ART DEALERS ASSOCIATION: www.atada.org

THE ANTIQUES COUNCIL: www.antiquescouncil.com

ART DEALERS ASSOCIATION OF AMERICA: www.artdealers.org
575 Madison Avenue / New York, NY 10022 / phone: 212-940-8590

ASSOCIATION OF INTERNATIONAL PHOTOGRAPHY ART DEALERS:
www.aipad.com
1609 Connecticut Avenue, N.W., Suite 200 / Washington, DC 20009
e-mail: AIPAD@aol.com

INTERNATIONAL FINE PRINT DEALERS ASSOCIATION: www.ifpda.org
5 Gramercy Park South, Suite 7A / New York, NY 10003
phone: 212-674-6095 / e-mail: ifpda@printdealers.com

INTERNATIONAL VINTAGE POSTER DEALERS ASSOCIATION:
www.ivpda.com

SAN FRANCISCO TRIBAL: www.sftribal.com

Major Auction Houses

Staff experts at the following auction houses vet the art for sale
(though you still have to check the catalog to make sure what guar-
antees you're getting). Many of these businesses have branches in
different international cities.

BONHAMS AND BUTTERFIELDS: www.butterfields.com

CHRISTIE'S: www.christies.com

DOYLE NEW YORK: www.doylenewyork.com

PHILLIPS DE PURY & COMPANY: www.phillipsdepury.com
Specializes in contemporary art.

SOTHEBY'S: www.sothebys.com

SWANN GALLERIES AUCTIONEERS: www.swanngalleries.com
Specializes in rare books and works on paper.

TEPPER GALLERIES: www.teppergalleries.com

WADDINGTON'S: www.waddingtons.ca

WES COWAN'S HISTORIC AMERICANA AUCTIONS:
www.historicamericana.com
Specializes in Native American art and antiques.

Art Fairs and Shows

Contemporary Art

AFFORDABLE ART FAIR
20 West 22nd Street, Suite 1512 / New York, NY 10010
phone: 212-255-2003 / e-mail: info@aafnyc.com
Contemporary art priced between $100 and $5,000. Affordable Art Fairs also take place in the United Kingdom and Australia. One is planned for San Francisco.

THE ARMORY SHOW: www.thearmoryshow.com
Prestigious, high-end art show held in Manhattan.

ART BASEL/MIAMI BEACH: www.artbaselmiamibeach.com
Prestigious, high-end art fair held in Miami.

P.S. 1 GREATER NEW YORK ART SHOW: www.ps1.org
Major career-making show for new artists.

WHITNEY BIENNIAL: www.whitney.org
Influential, and usually controversial, exhibit of top contemporary artists.

Other Shows and Fairs

BRIMFIELD ANTIQUE SHOWS: www.brimfieldshow.com
The biggie for antiques collectors.

HIGHWAY 127, "THE WORLD'S LONGEST YARD SALE":
www.127sale.com
Massive, multistate yard sale that takes place along Highway 127—in Tennessee, Kentucky, Georgia, and Alabama—in August.

OUTSIDER ART FAIR: www.sanfordsmith.com
Major show of Outsider art, held in Manhattan.

SANTA FE INDIAN MARKET: www.swaia.org
Major show of Native American art, every August.

Major Art Schools for Finding New Talent

This list is not exhaustive. Many flagship state universities have extensive art programs, as do some liberal arts colleges.

ART STUDENT'S LEAGUE, New York, NY
CALIFORNIA INSTITUTE OF THE ARTS, Valencia, CA
CARNEGIE MELLON UNIVERSITY, Pittsburgh, PA
COLUMBIA UNIVERSITY SCHOOL OF THE ARTS, New York, NY
CONCORDIA UNIVERSITY, Montreal, Canada
COOPER UNION, New York, NY
CRANBROOK ACADEMY OF ART, Bloomfield Hills, MI
GOLDSMITH'S COLLEGE, London, UK
HUNTER COLLEGE OF THE CITY UNIVERSITY OF NEW YORK,
 New York, NY
INTERNATIONAL CENTER FOR PHOTOGRAPHY–BARD COLLEGE MFA
 PROGRAM, New York, NY
OTIS COLLEGE OF ART AND DESIGN, Los Angeles, CA
PARSON'S SCHOOL OF DESIGN, New York, NY
PRATT INSTITUTE, Brooklyn, NY
RHODE ISLAND SCHOOL OF DESIGN, Providence, RI
ROCHESTER INSTITUTE OF TECHNOLOGY, Rochester, NY
SCHOOL OF THE ART INSTITUTE OF CHICAGO, Chicago, IL
SCHOOL OF VISUAL ARTS, New York, NY
YALE UNIVERSITY, New Haven, CT

Professional Help

Appraisers

A good appraiser can determine fair market value and replacement value for your art. This is important for insurance and inheritance purposes, as well as resale.

AMERICAN SOCIETY OF APPRAISERS: www.appraisers.org
P.O. Box 17265 / Washington, DC 20041 / phone: 703-478-2228
toll-free: 800-ASA-VALU / e-mail: asainfo@appraisers.org

APPRAISERS ASSOCIATION OF AMERICA: www.appraisersassoc.org

CANADIAN PERSONAL PROPERTY APPRAISERS GROUP:
www.cppag.com

INTERNATIONAL SOCIETY OF APPRAISERS: www.isa-appraisers.org
1131 S.W. Seventh Street, Suite 105 / Renton, WA 98055
phone: 206-241-0359 / e-mail: isa@isa-appraisers.org

ORIENTAL RUG RETAILERS OF AMERICA: www.orrainc.com

Conservation and Repairs

AMERICAN INSTITUTE FOR CONSERVATION OF HISTORIC AND
ARTISTIC WORKS: aic.stanford.edu
Maintains a database where you can match your needs to a restorer.

ASSOCIATION OF RESTORERS: www.assoc-restorers.com

Theft, Smuggling, Fraud, and Fakes

BETTER BUSINESS BUREAU: www.bbb.org
Provides information about consumer complaints of businesses.

FEDERAL BUREAU OF INVESTIGATION: www.fbi.gov
National Stolen Art File / MTU, Room 3247
935 Pennsylvania Avenue, N.W. / Washington, DC 20535
phone: 202-324-4192
Official source for information on stolen or forged art.

FINDLAW: http://lp.findlaw.com
Easy-to-use database of current law on multiple subjects, including art law.

INDIAN ARTS AND CRAFTS BOARD
U.S. Department of Interior / 1849 C Street, N.W.
MS 2058-MIB / Washington, DC 20240
phone: 202-208-3773 / toll free: 888-ART-FAKE
e-mail: iacb@ios.doi.gov
Helps ensure authenticity of Native American art.

INTERPOL: www.interpol.int
Information on international art thefts.

UNESCO/UNIDROIT: www.unidroit.org
International Institute for the Unification of Private Law
Densely worded United Nations site regarding international conventions in art and antiquities sales.

Researching Art

Art Price Databases and References

These references provide up-to-date information on auction prices for thousands of artists. By examining what similar works have sold for, you should be able to gauge whether you're paying a fair price. Keep in mind that dealers charge markups, and legitimately so.

ARTNET.COM
Online subscription service with auction prices. Also has an extensive list of vetted dealers, with information on what they have for sale, plus an excellent online magazine.

ARTPRICE.COM
Online subscription service with auction price records.

GORDON'S ART REFERENCE: www.gordonsart.com
Price database for fine art. Also available in CD ROM and book formats.

THE HISLOP'S OFFICIAL INTERNATIONAL PRICE GUIDE TO FINE ART
(New York: House of Collectibles, Crown Publishing Group, 2002)
A premier price guide that's portable enough to take with you to auctions and galleries.

MEI MOSES FINE ART INDICES: www.meimosesfineartindex.org
These now-famous indices track the growth of the art market and are used by a variety of investors and analysts.

Art Magazines and Newspapers

These excellent publications are available on newsstands and in bookstores, unless otherwise indicated.

ANTIQUES AND THE ARTS WEEKLY
Weekly tabloid, known among art world insiders as The Newtown Bee. *Required reading for antiques collectors.*

ART & ANTIQUES
Glossy, richly illustrated magazine, not to be confused with Antiques and the Arts Weekly.

ART & AUCTION
Specializes in the art market.

ARTDAILY.COM (online only): www.artdaily.com
Online publication with the latest news from the art market.

ART IN AMERICA
Also publishes an annual resource guide about galleries, artists, and museums, in August.

ARTFORUM
Perhaps the most cutting-edge publication for contemporary art.

ARTNET MAGAZINE (online only): www.artnet.com
Online magazine featuring reviews, market information, art world gossip, and more.

ARTNEWS
One of the oldest and best-read magazines on fine art.

THE ART NEWSPAPER: www.theartnewspaper.com
The Wall Street Journal *of the art world. The online site has extensive information about Nazi-looted art.*

CANADIAN ART
Covers the art scene in Canada.

FLASH ART
Covers contemporary art, with extensive, worldwide exhibition reviews.

GALLERY GUIDE: www.galleryguide.org
Excellent resource for finding out about exhibits and art for sale. Has regional editions.

THE MAGAZINE ANTIQUES
One of the most respected publications in the field.

MAINE ANTIQUE DIGEST
Don't let the name fool you. This publication also covers art and has a national readership.

Daily newspapers with good arts coverage include the *New York Times, Los Angeles Times, Wall Street Journal,* and *Washington Post.*

Specialized Publications

ART ON PAPER
AMERICAN INDIAN ART MAGAZINE
APERTURE (photography)
FOLK ART (magazine of the American Folk Art Museum)
TRIBAL ARTS MAGAZINE

Additional Websites and Books

Prints

PRINT COUNCIL OF AMERICA: www.printcouncil.org
Organization of curators and other print experts. The website has authoritative information about prints and which artists have a catalogue raisonné.

HOW PRINTS LOOK, by William M. Ivins Jr.
(Boston: Beacon Press, 1987)
A guide to identifying different types of prints, by a former curator at the Metropolitan Museum.

How to Identify Prints, by Bamber Gascoigne
(New York: Thames and Hudson, 2004)

Prints and Printmaking, by Antony Griffiths
(Berkeley: University of California Press, 1996)
A guide to understanding and identifying print processes, by the curator of prints and drawings at the British Museum.

Oriental Rugs

Association of Specialists in Cleaning and Restoration:
www.ascr.org
First aid for your rugs.

Vintage Posters

International Poster Gallery: www.internationalposter.com
Website has excellent history of vintage posters.

Forgeries

The Expert Versus the Object: Judging Fakes and False
Attributions in the Visual Arts, edited by Ronald Spencer
(New York: Oxford University Press, 2004)

False Impressions: The Hunt for Big-Time Art Fakes, by Thomas
Hoving
(New York: Simon & Schuster, 1996)
A page-turning account of art forgery throughout history.

ACKNOWLEDGMENTS

This book would not have been possible without the generous assistance of the dealers, curators, and other experts who graciously offered me their time and expertise: Maxwell Anderson, Helen Allen, Steve Begner, Jeffrey Bilhuber, Donna Carlson, Robert Chisholm, Marjorie Cohn, Joshua Dimondstein, Catherine Edelman, Donald Ellis, Bill Fine, Peter Galassi, Patty Gerstenblith, Nancy Harrison, John Hill, Margaret Holben Ellis, Ed Jaster, Mark Kambourian, Jon Kessler, Robert Klein, Mark Kostabi, Jim Lapides, Gail Levin, Gerald Monroe, Michael Moses, Tina Oldknow, Michael Rosenfeld, Bruce Shackelford, Richard Solomon, Ronald Spencer, Carolyn Staley, Christopher Steiner, Delia Sullivan, Mark Topalian, David Tunick, Renee Vara, and Jennifer Vorbach.

I especially want to thank my agent, Betsy Amster, and my editors at Three Rivers Press, Brandi Bowles, Genoveva Llosa, and Kathryn McHugh, without whom *The Intrepid Art Collector* would still be just a pile of notes in a box under my couch.

Index

About the Author

Arts journalist LISA HUNTER is a former editor and publicist for major New York museums. She has a degree in fine arts from Barnard College, Columbia University, and has been collecting art for over twenty years.